Hans Neumann and Gabriel Rivera-Barraza

NUEVO NEW YORK

DAMIANI

Contents

New York has always been a city of immigrants and has been proudly shaped by those that have come here from all corners of the world. Throughout our history, waves of immigrants from Latin America have chosen to call New York home.

Nuevo New York is a much-needed compilation of the stories that reveal the profound influence that Latinos have played in creating the city's rich cultural and artistic life. Many of the subjects in this book are famous, with recognizable faces and names; others are lesser-known figures in the fields of fashion, design, and the arts. These individuals and many others like them are making their mark on New York.

There are many individuals with the creative credentials to warrant their stories being told in a book like *Nuevo New York*. This inspirational publication offers a glimpse of the careers and personal stories of successful and driven New Yorkers responsible for ushering in a new wave of talent and creativity. Collectively, they have laid a path for a generation that will, no doubt, continue to be innovative, challenge ideas, and contribute to this magnificent city with a unique international and Latin perspective.

Through these pages, each character brings his or her own experiences to the rich cultural collage that makes up New York City. Gabriel Rivera-Barraza and Hans Neumann reveal powerful stories that offer a nuanced and updated perspective on the American dream.

This book benefits from the love of many of the people who believe in the potential of Latinos and our diverse cultural heritage. They share their memories and journeys to show what contemporary New York is all about.

I am honored to be involved with this project, and I salute the authors and all of those who have worked to make this amazing book a reality. And to those new generations waiting for their time to shine: carry on and enjoy the journey. Much remains to be done.

Ben Rodriguez-Cubeñas

Introduction

We began the *Nuevo New York* project four years ago with a simple idea. Each of us came to New York City from Latin America—Gabriel from Mexico and Hans from Peru—more than a decade ago to chase our dreams. After years of working in the fashion and art industries as a brand consultant and a photographer, respectively, we noticed both the rising prominence of Latin Americans in their fields and their relative lack of recognition. With so many talented Latinos moving to New York to launch their careers—people who inspired us and the many artists and entrepreneurs in our community—we decided it was time to pay homage to the people and the culture that help make New York City singular.

Nuevo New York is our way of acknowledging those who came before us. All the influential personalities gathered here have made essential contributions to the worlds of art and fashion. This book not only honors their achievements, but also strives to inspire anyone who would like to follow in their footsteps. All eighty of the interviewees have extraordinary stories to tell.

Latin Americans have long helped to shape the social, political, and artistic tenor of New York City. Whether newly immigrated or American-born, they bring an incredible amount of diversity, creativity, and vigor to their endeavors. Despite this, we are just now beginning to see new doors opening for the Latin American community in creative industries. As both the market and the talent in the arts and fashion worlds become increasingly diverse, so the platforms for expression are expanding and incorporating new voices. We hope to highlight these voices in order to help throw open the doors of opportunity.

The stories in *Nuevo New York* serve as examples of how to integrate into this extraordinary city without forgetting where you come from or where you are going. They are here to comfort you, guide you, and inspire you to keep chasing that *nuevo* American dream, whatever it may mean to you.

Hans Neumann Gabriel Rivera-Barraza

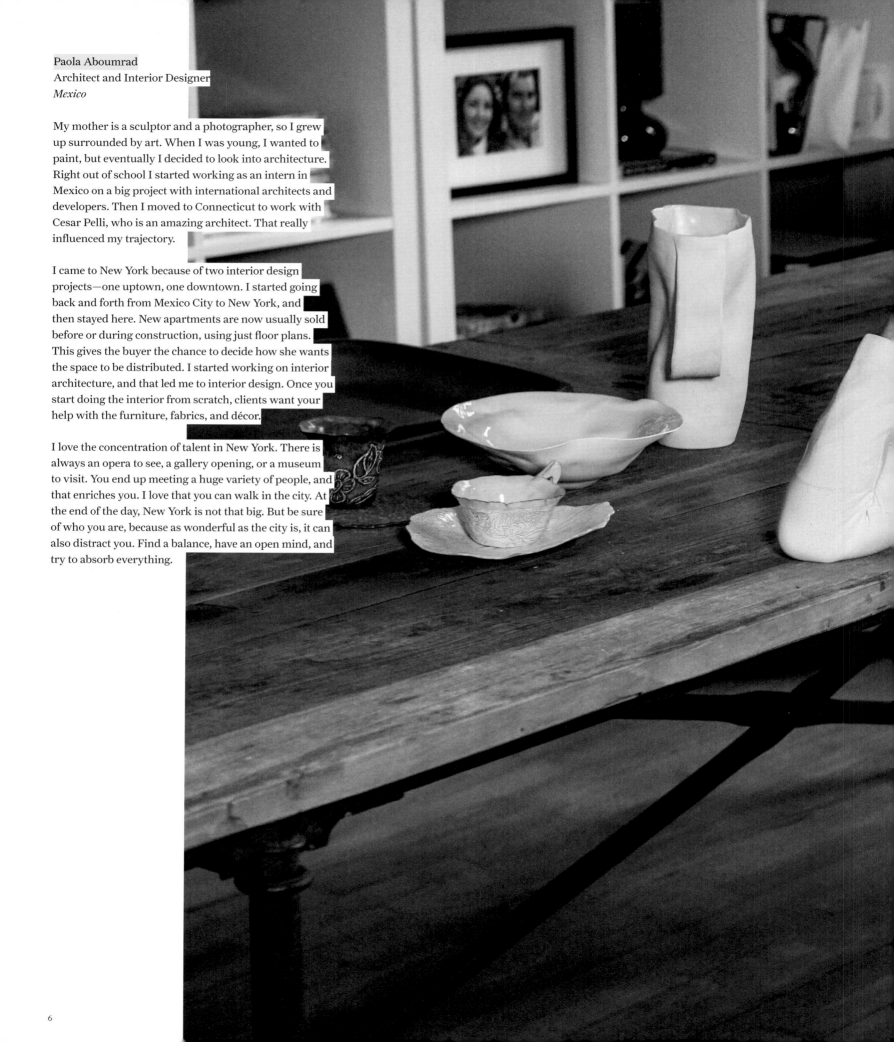

Paola Aboumrad
Architect and Interior Designer
Mexico

My mother is a sculptor and a photographer, so I grew up surrounded by art. When I was young, I wanted to paint, but eventually I decided to look into architecture. Right out of school I started working as an intern in Mexico on a big project with international architects and developers. Then I moved to Connecticut to work with Cesar Pelli, who is an amazing architect. That really influenced my trajectory.

I came to New York because of two interior design projects—one uptown, one downtown. I started going back and forth from Mexico City to New York, and then stayed here. New apartments are now usually sold before or during construction, using just floor plans. This gives the buyer the chance to decide how she wants the space to be distributed. I started working on interior architecture, and that led me to interior design. Once you start doing the interior from scratch, clients want your help with the furniture, fabrics, and décor.

I love the concentration of talent in New York. There is always an opera to see, a gallery opening, or a museum to visit. You end up meeting a huge variety of people, and that enriches you. I love that you can walk in the city. At the end of the day, New York is not that big. But be sure of who you are, because as wonderful as the city is, it can also distract you. Find a balance, have an open mind, and try to absorb everything.

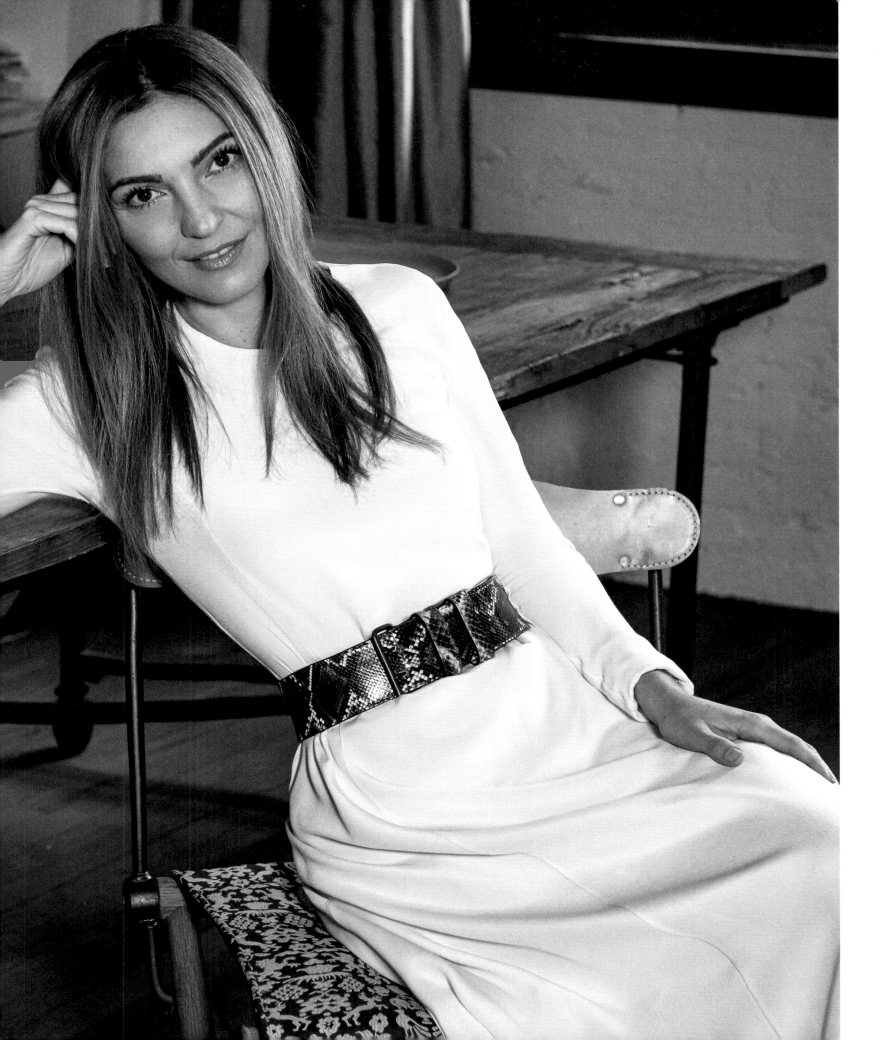

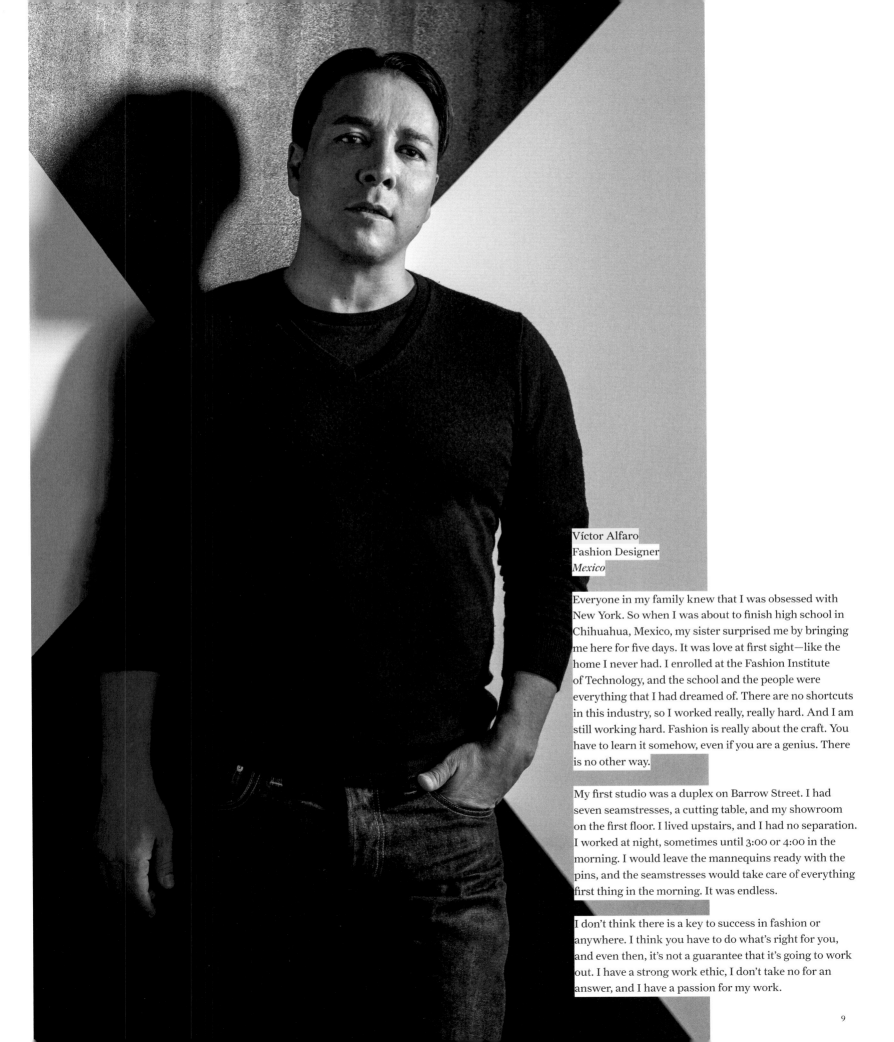

Víctor Alfaro
Fashion Designer
Mexico

Everyone in my family knew that I was obsessed with New York. So when I was about to finish high school in Chihuahua, Mexico, my sister surprised me by bringing me here for five days. It was love at first sight—like the home I never had. I enrolled at the Fashion Institute of Technology, and the school and the people were everything that I had dreamed of. There are no shortcuts in this industry, so I worked really, really hard. And I am still working hard. Fashion is really about the craft. You have to learn it somehow, even if you are a genius. There is no other way.

My first studio was a duplex on Barrow Street. I had seven seamstresses, a cutting table, and my showroom on the first floor. I lived upstairs, and I had no separation. I worked at night, sometimes until 3:00 or 4:00 in the morning. I would leave the mannequins ready with the pins, and the seamstresses would take care of everything first thing in the morning. It was endless.

I don't think there is a key to success in fashion or anywhere. I think you have to do what's right for you, and even then, it's not a guarantee that it's going to work out. I have a strong work ethic, I don't take no for an answer, and I have a passion for my work.

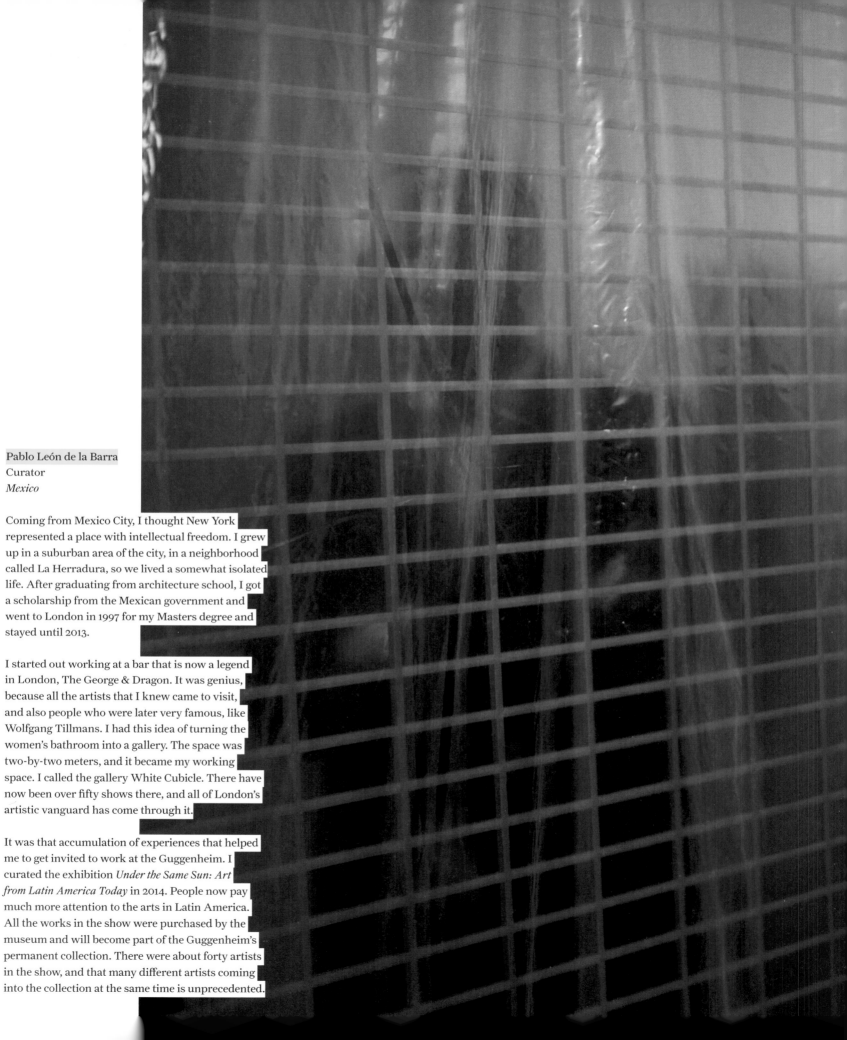

Pablo León de la Barra
Curator
Mexico

Coming from Mexico City, I thought New York represented a place with intellectual freedom. I grew up in a suburban area of the city, in a neighborhood called La Herradura, so we lived a somewhat isolated life. After graduating from architecture school, I got a scholarship from the Mexican government and went to London in 1997 for my Masters degree and stayed until 2013.

I started out working at a bar that is now a legend in London, The George & Dragon. It was genius, because all the artists that I knew came to visit, and also people who were later very famous, like Wolfgang Tillmans. I had this idea of turning the women's bathroom into a gallery. The space was two-by-two meters, and it became my working space. I called the gallery White Cubicle. There have now been over fifty shows there, and all of London's artistic vanguard has come through it.

It was that accumulation of experiences that helped me to get invited to work at the Guggenheim. I curated the exhibition *Under the Same Sun: Art from Latin America Today* in 2014. People now pay much more attention to the arts in Latin America. All the works in the show were purchased by the museum and will become part of the Guggenheim's permanent collection. There were about forty artists in the show, and that many different artists coming into the collection at the same time is unprecedented.

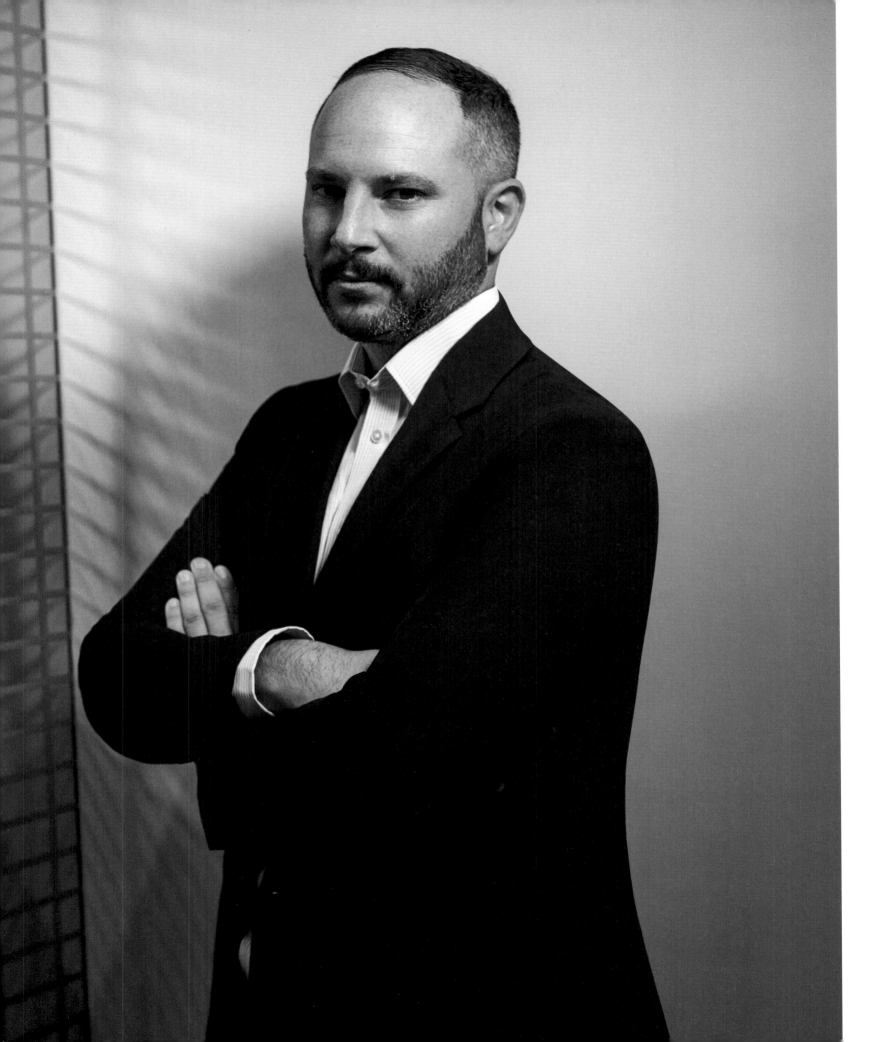

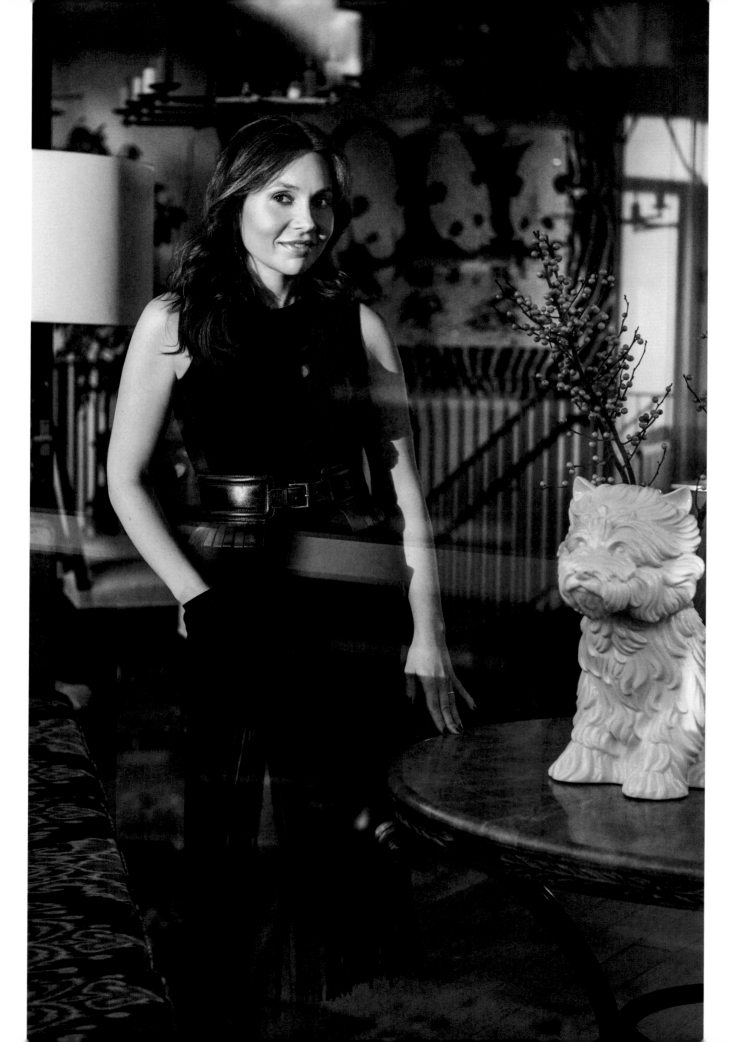

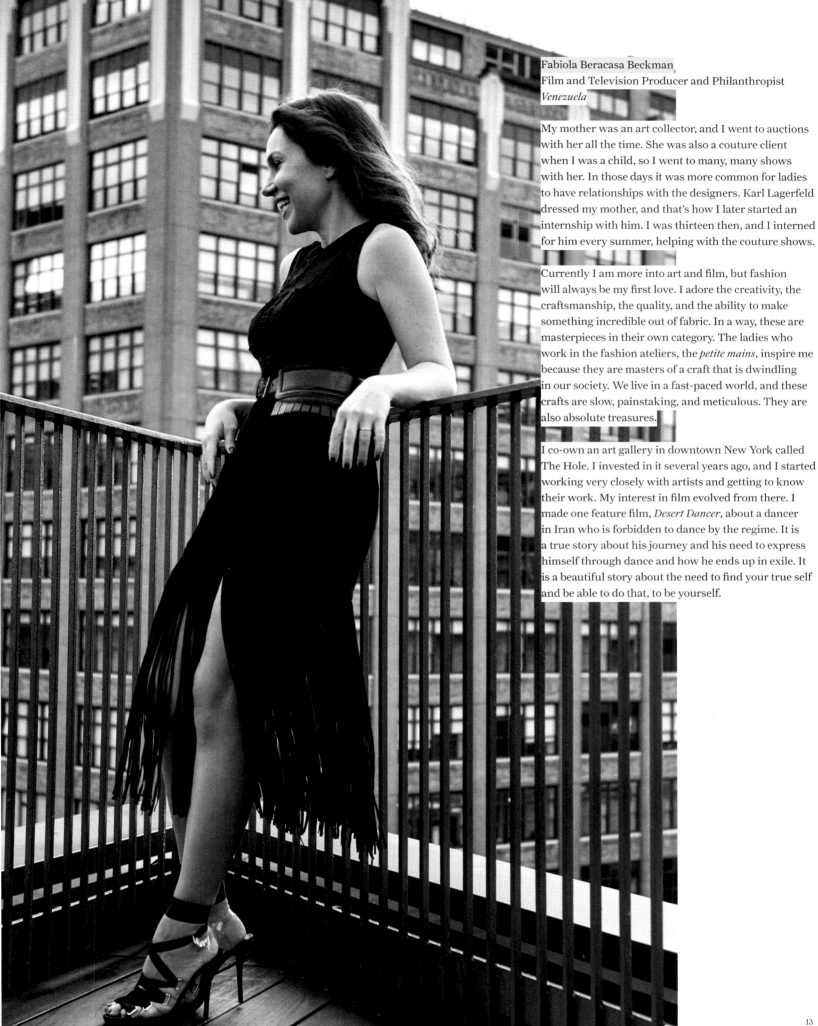

Fabiola Beracasa Beckman
Film and Television Producer and Philanthropist
Venezuela

My mother was an art collector, and I went to auctions with her all the time. She was also a couture client when I was a child, so I went to many, many shows with her. In those days it was more common for ladies to have relationships with the designers. Karl Lagerfeld dressed my mother, and that's how I later started an internship with him. I was thirteen then, and I interned for him every summer, helping with the couture shows.

Currently I am more into art and film, but fashion will always be my first love. I adore the creativity, the craftsmanship, the quality, and the ability to make something incredible out of fabric. In a way, these are masterpieces in their own category. The ladies who work in the fashion ateliers, the *petite mains*, inspire me because they are masters of a craft that is dwindling in our society. We live in a fast-paced world, and these crafts are slow, painstaking, and meticulous. They are also absolute treasures.

I co-own an art gallery in downtown New York called The Hole. I invested in it several years ago, and I started working very closely with artists and getting to know their work. My interest in film evolved from there. I made one feature film, *Desert Dancer*, about a dancer in Iran who is forbidden to dance by the regime. It is a true story about his journey and his need to express himself through dance and how he ends up in exile. It is a beautiful story about the need to find your true self and be able to do that, to be yourself.

13

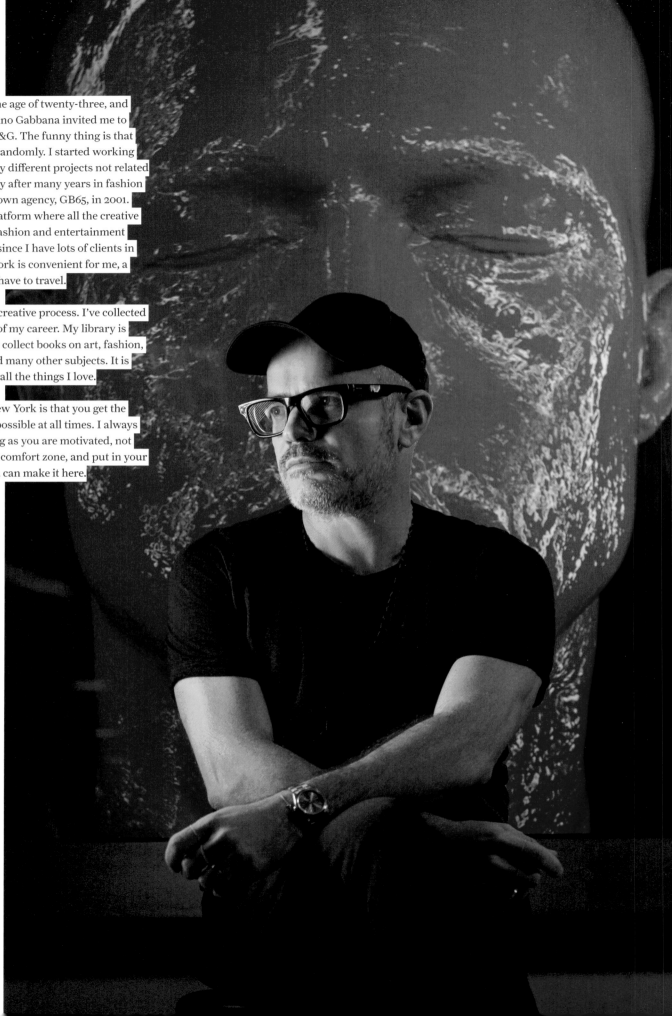

Giovanni Bianco
Creative Director
Brazil

I first moved to Milan at the age of twenty-three, and Domenico Dolce and Stefano Gabbana invited me to work for their new line, D&G. The funny thing is that fashion came to me quite randomly. I started working on graphic design for many different projects not related to fashion at all. It was only after many years in fashion that I decided to form my own agency, GB65, in 2001. New York is the central platform where all the creative and artistic minds in the fashion and entertainment industries converge. And since I have lots of clients in Europe and Brazil, New York is convenient for me, a good compromise when I have to travel.

Books are essential in my creative process. I've collected them since the beginning of my career. My library is growing all the time, and I collect books on art, fashion, design, entertainment, and many other subjects. It is great to be surrounded by all the things I love.

What I love most about New York is that you get the feeling that everything is possible at all times. I always keep my eyes open. As long as you are motivated, not afraid of going out of your comfort zone, and put in your best effort all the time, you can make it here.

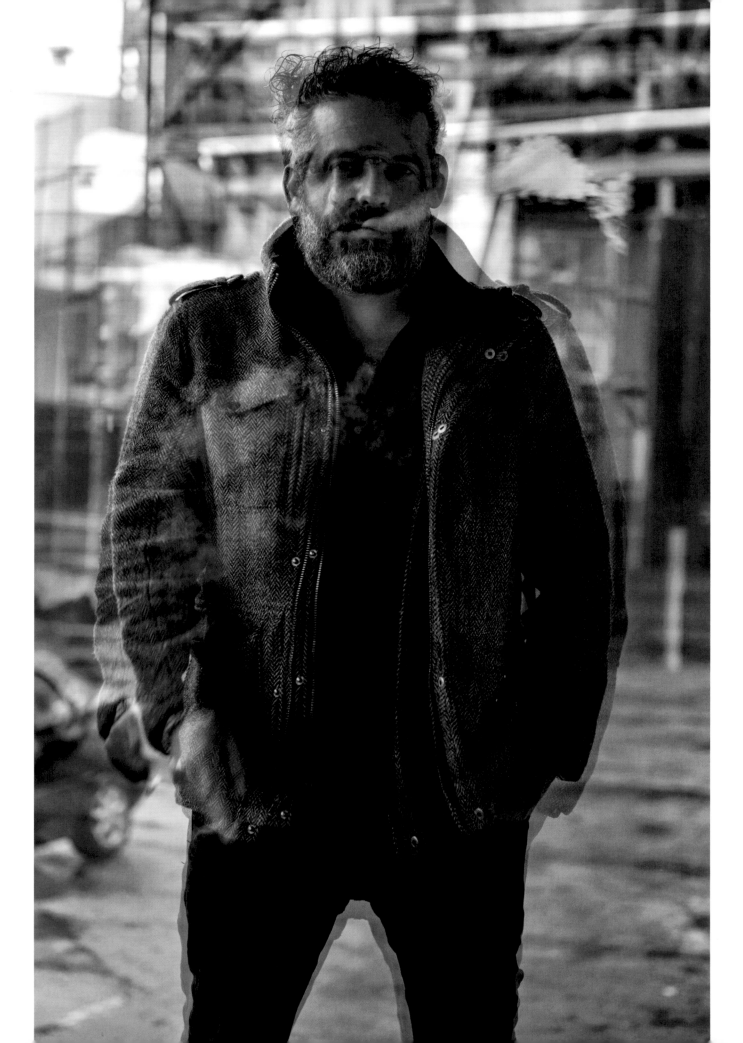

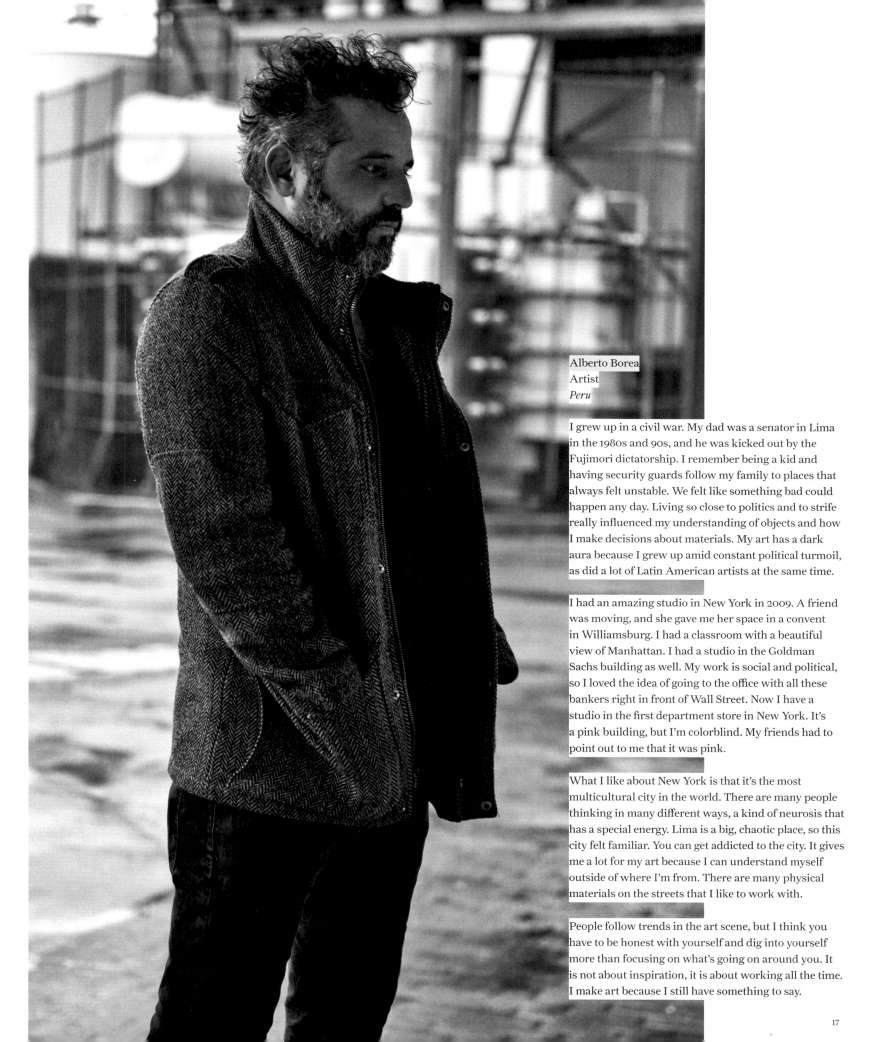

Alberto Borea
Artist
Peru

I grew up in a civil war. My dad was a senator in Lima in the 1980s and 90s, and he was kicked out by the Fujimori dictatorship. I remember being a kid and having security guards follow my family to places that always felt unstable. We felt like something bad could happen any day. Living so close to politics and to strife really influenced my understanding of objects and how I make decisions about materials. My art has a dark aura because I grew up amid constant political turmoil, as did a lot of Latin American artists at the same time.

I had an amazing studio in New York in 2009. A friend was moving, and she gave me her space in a convent in Williamsburg. I had a classroom with a beautiful view of Manhattan. I had a studio in the Goldman Sachs building as well. My work is social and political, so I loved the idea of going to the office with all these bankers right in front of Wall Street. Now I have a studio in the first department store in New York. It's a pink building, but I'm colorblind. My friends had to point out to me that it was pink.

What I like about New York is that it's the most multicultural city in the world. There are many people thinking in many different ways, a kind of neurosis that has a special energy. Lima is a big, chaotic place, so this city felt familiar. You can get addicted to the city. It gives me a lot for my art because I can understand myself outside of where I'm from. There are many physical materials on the streets that I like to work with.

People follow trends in the art scene, but I think you have to be honest with yourself and dig into yourself more than focusing on what's going on around you. It is not about inspiration, it is about working all the time. I make art because I still have something to say.

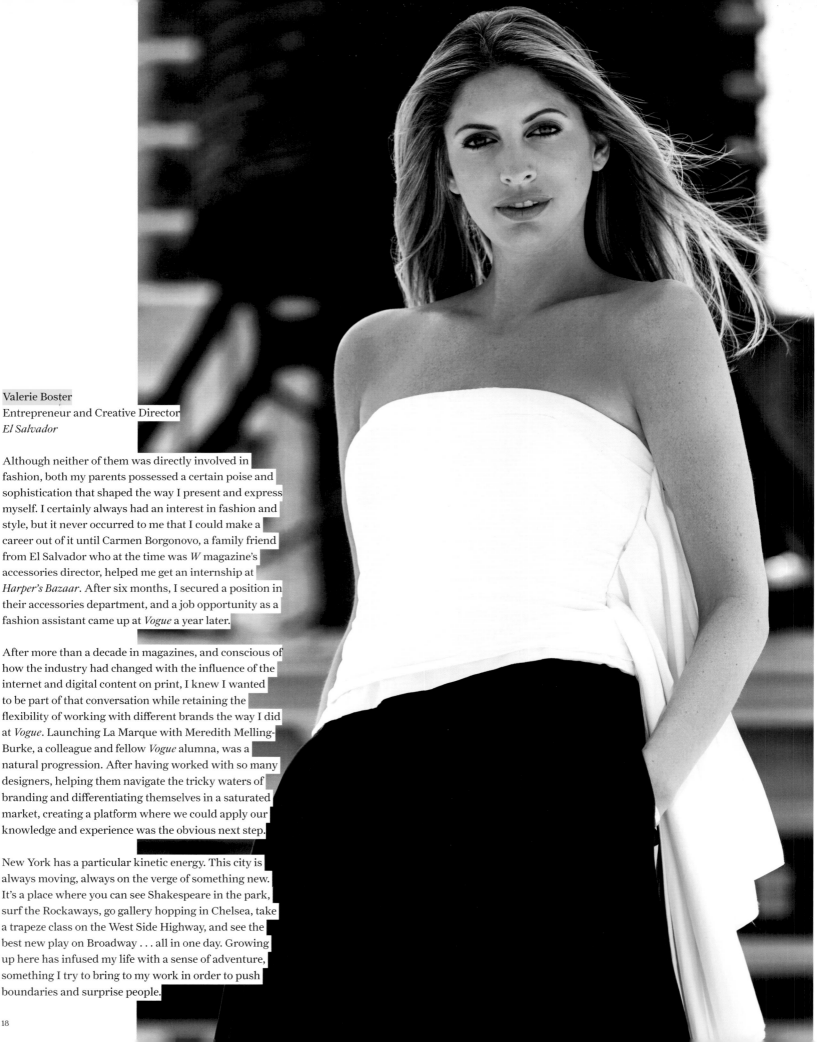

Valerie Boster
Entrepreneur and Creative Director
El Salvador

Although neither of them was directly involved in fashion, both my parents possessed a certain poise and sophistication that shaped the way I present and express myself. I certainly always had an interest in fashion and style, but it never occurred to me that I could make a career out of it until Carmen Borgonovo, a family friend from El Salvador who at the time was *W* magazine's accessories director, helped me get an internship at *Harper's Bazaar*. After six months, I secured a position in their accessories department, and a job opportunity as a fashion assistant came up at *Vogue* a year later.

After more than a decade in magazines, and conscious of how the industry had changed with the influence of the internet and digital content on print, I knew I wanted to be part of that conversation while retaining the flexibility of working with different brands the way I did at *Vogue*. Launching La Marque with Meredith Melling-Burke, a colleague and fellow *Vogue* alumna, was a natural progression. After having worked with so many designers, helping them navigate the tricky waters of branding and differentiating themselves in a saturated market, creating a platform where we could apply our knowledge and experience was the obvious next step.

New York has a particular kinetic energy. This city is always moving, always on the verge of something new. It's a place where you can see Shakespeare in the park, surf the Rockaways, go gallery hopping in Chelsea, take a trapeze class on the West Side Highway, and see the best new play on Broadway . . . all in one day. Growing up here has infused my life with a sense of adventure, something I try to bring to my work in order to push boundaries and surprise people.

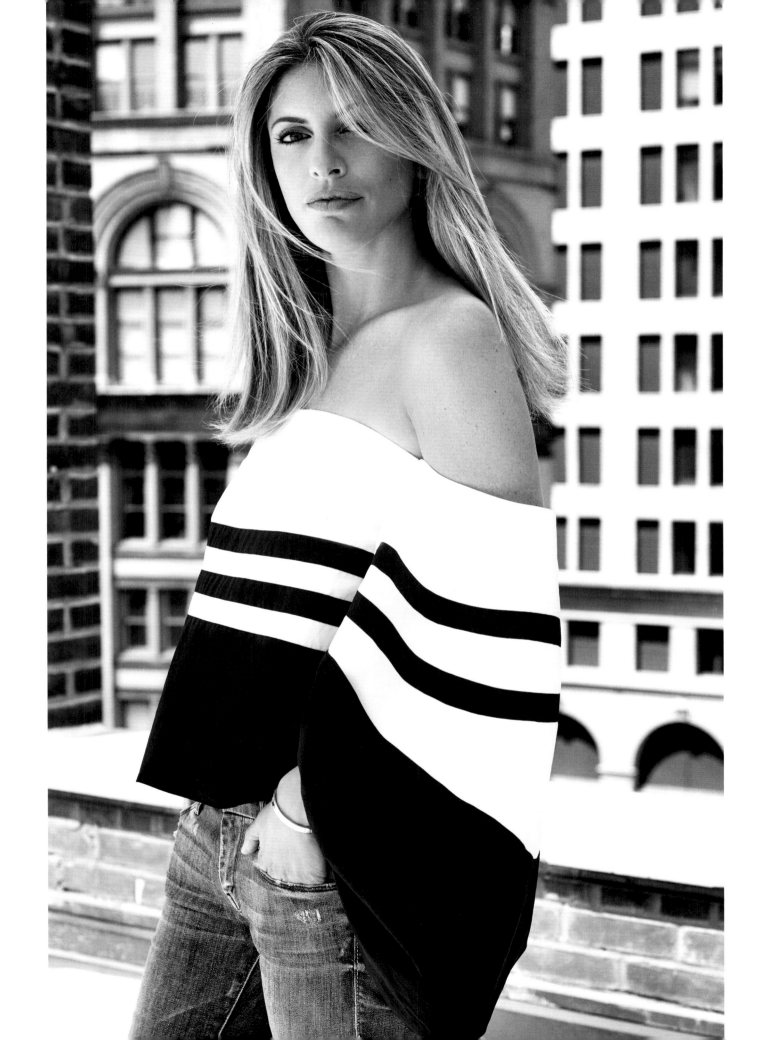

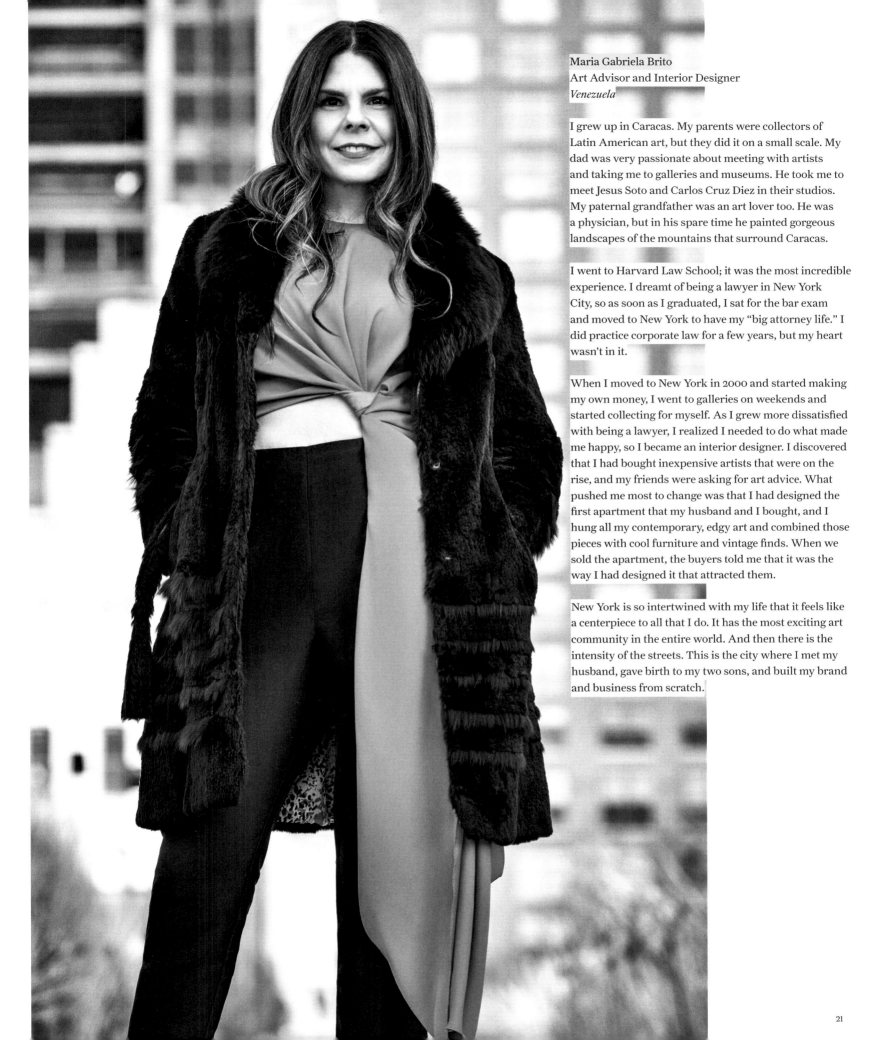

Maria Gabriela Brito
Art Advisor and Interior Designer
Venezuela

I grew up in Caracas. My parents were collectors of Latin American art, but they did it on a small scale. My dad was very passionate about meeting with artists and taking me to galleries and museums. He took me to meet Jesus Soto and Carlos Cruz Diez in their studios. My paternal grandfather was an art lover too. He was a physician, but in his spare time he painted gorgeous landscapes of the mountains that surround Caracas.

I went to Harvard Law School; it was the most incredible experience. I dreamt of being a lawyer in New York City, so as soon as I graduated, I sat for the bar exam and moved to New York to have my "big attorney life." I did practice corporate law for a few years, but my heart wasn't in it.

When I moved to New York in 2000 and started making my own money, I went to galleries on weekends and started collecting for myself. As I grew more dissatisfied with being a lawyer, I realized I needed to do what made me happy, so I became an interior designer. I discovered that I had bought inexpensive artists that were on the rise, and my friends were asking for art advice. What pushed me most to change was that I had designed the first apartment that my husband and I bought, and I hung all my contemporary, edgy art and combined those pieces with cool furniture and vintage finds. When we sold the apartment, the buyers told me that it was the way I had designed it that attracted them.

New York is so intertwined with my life that it feels like a centerpiece to all that I do. It has the most exciting art community in the entire world. And then there is the intensity of the streets. This is the city where I met my husband, gave birth to my two sons, and built my brand and business from scratch.

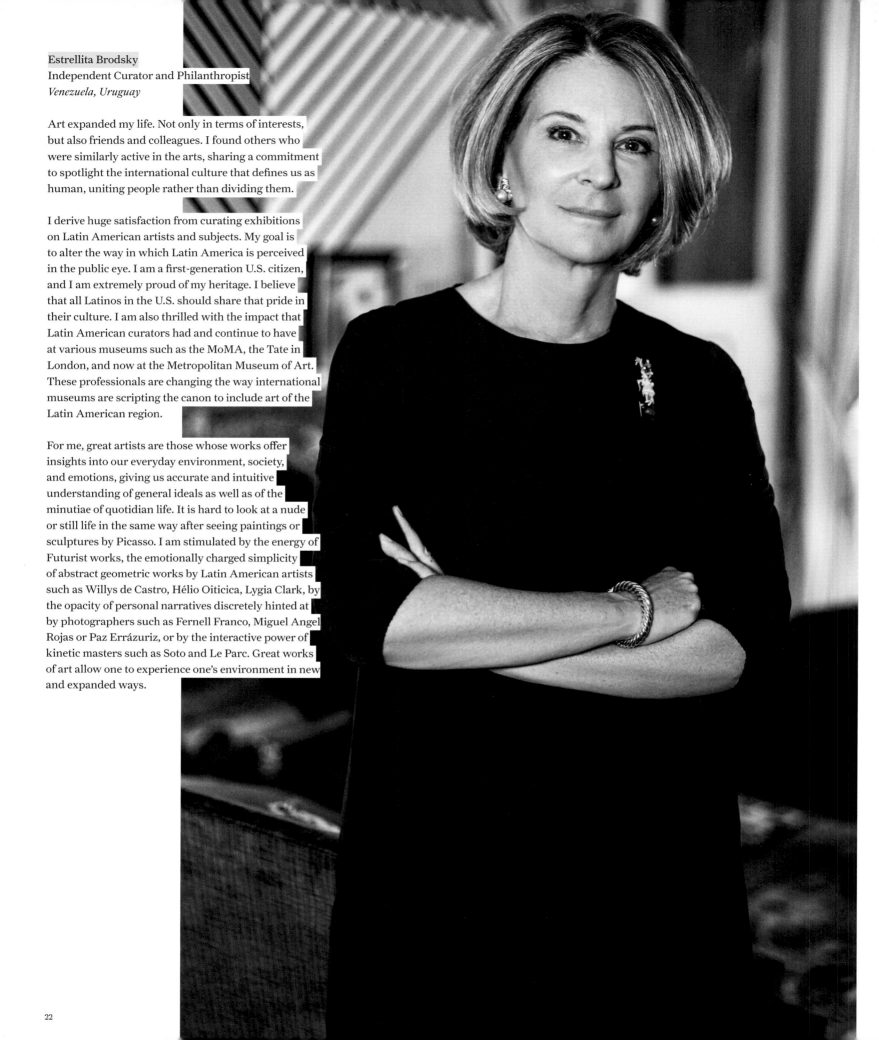

Estrellita Brodsky
Independent Curator and Philanthropist
Venezuela, Uruguay

Art expanded my life. Not only in terms of interests, but also friends and colleagues. I found others who were similarly active in the arts, sharing a commitment to spotlight the international culture that defines us as human, uniting people rather than dividing them.

I derive huge satisfaction from curating exhibitions on Latin American artists and subjects. My goal is to alter the way in which Latin America is perceived in the public eye. I am a first-generation U.S. citizen, and I am extremely proud of my heritage. I believe that all Latinos in the U.S. should share that pride in their culture. I am also thrilled with the impact that Latin American curators had and continue to have at various museums such as the MoMA, the Tate in London, and now at the Metropolitan Museum of Art. These professionals are changing the way international museums are scripting the canon to include art of the Latin American region.

For me, great artists are those whose works offer insights into our everyday environment, society, and emotions, giving us accurate and intuitive understanding of general ideals as well as of the minutiae of quotidian life. It is hard to look at a nude or still life in the same way after seeing paintings or sculptures by Picasso. I am stimulated by the energy of Futurist works, the emotionally charged simplicity of abstract geometric works by Latin American artists such as Willys de Castro, Hélio Oiticica, Lygia Clark, by the opacity of personal narratives discretely hinted at by photographers such as Fernell Franco, Miguel Angel Rojas or Paz Errázuriz, or by the interactive power of kinetic masters such as Soto and Le Parc. Great works of art allow one to experience one's environment in new and expanded ways.

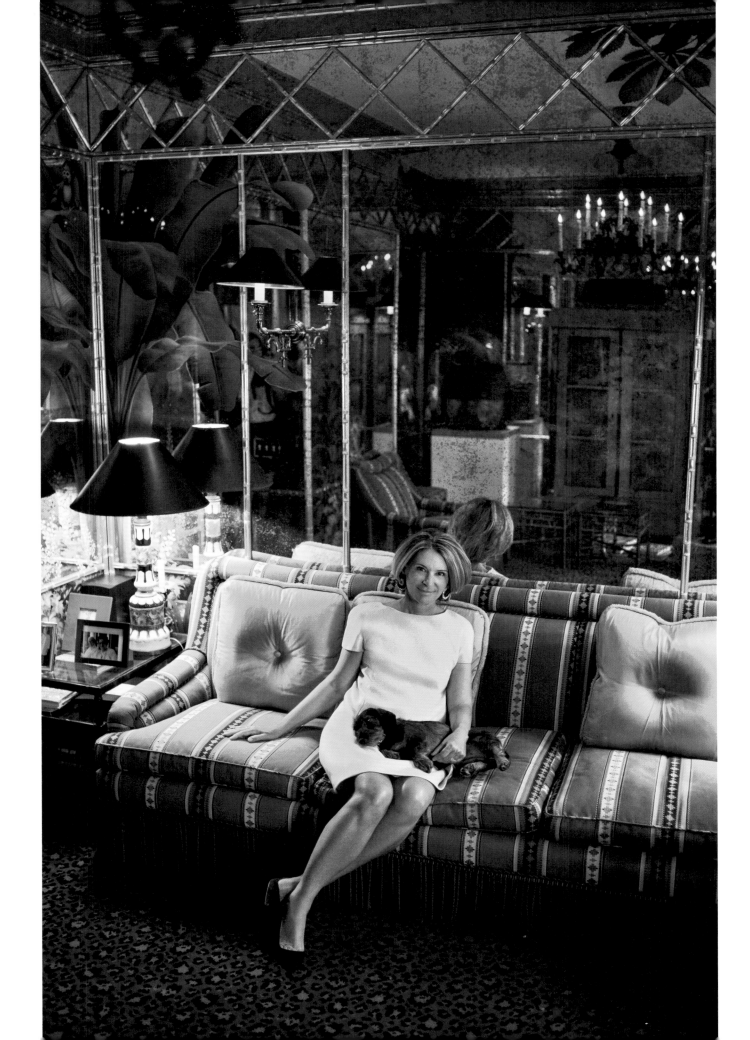

Carlos Campos
Fashion Designer
Honduras

My mom was a seamstress. She had two tailor shops in Honduras. I was in the shop from the age of eight, cleaning up the leftover pieces of fabric. One Christmas we were very sad because my dad was sick and my mom was struggling to make ends meet. My mom said, "We are going to sleep early today, you know?" And then, out of nowhere, my brother arrived and said, "Come on! Why are you so sad? I am going to make you an outfit and we are going out tonight." So he went to the sewing machine and made me a pair of pants and a shirt that had a piece of the same fabric from the pants across the chest. It was the coolest outfit ever. In five hours of hard work and passion, my brother taught me so much about life.

When I came here at fourteen years old, I got a job doing alterations. This guy took pity on me because I was so young. He said, "You know? I have a warehouse over there. It has a bathroom. You can stay over there, instead of going all the way to Brooklyn." I turned that place into a penthouse. I painted it, fixed it up. I basically grew up there. I made it my home, and it was beautiful.

I came to New York with no plan, no family. But I am living the American dream. What I love about this city—and I think it will sound cliché—is the energy of the people. Everyone here has a dream.

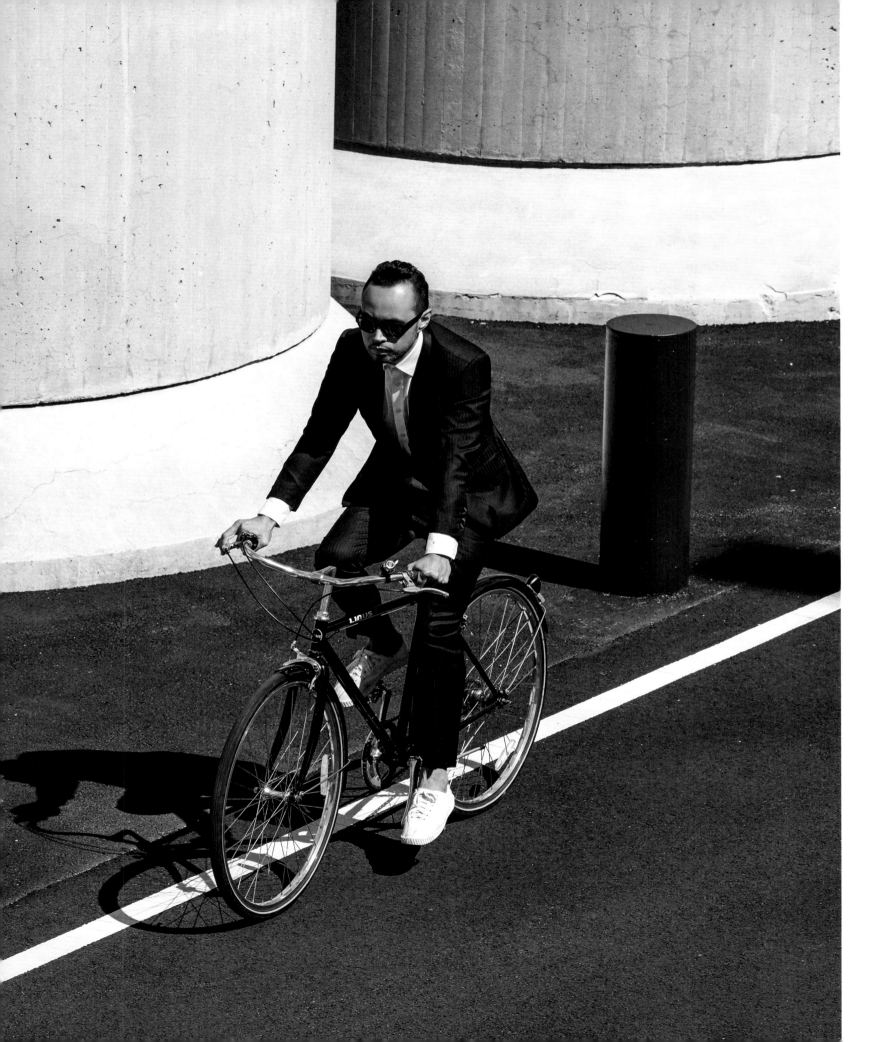

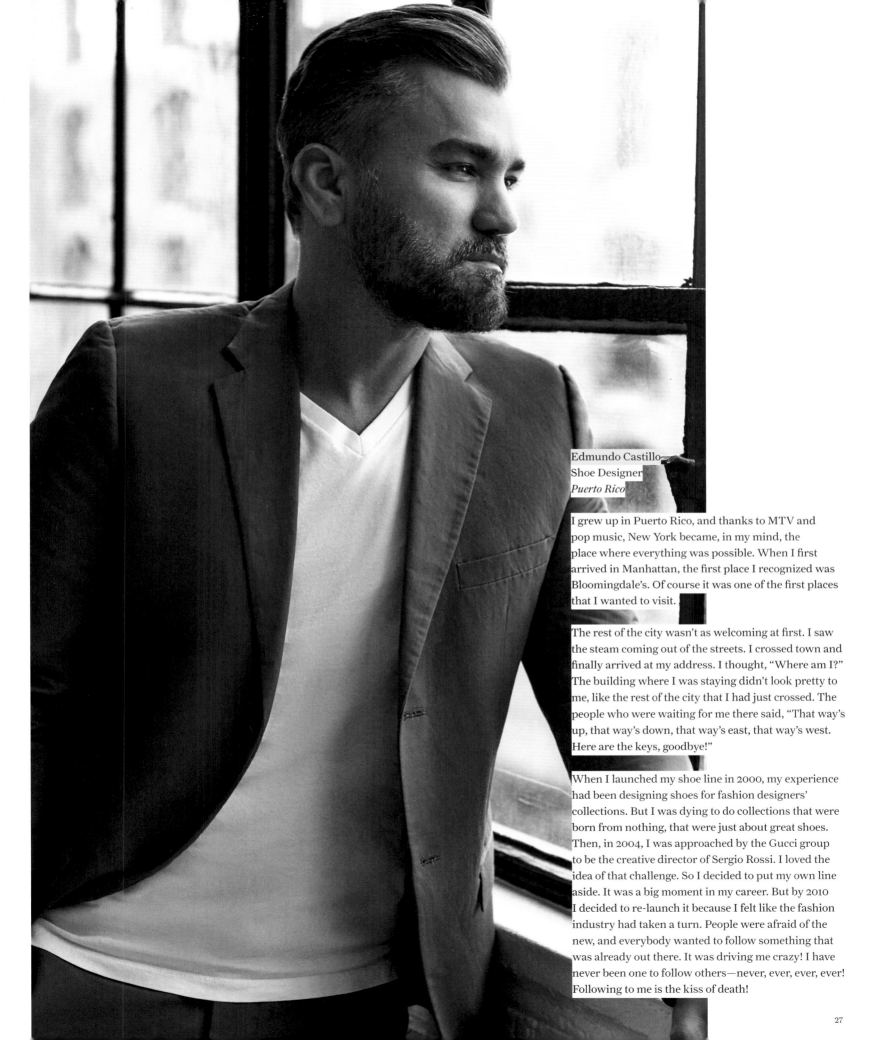

Edmundo Castillo
Shoe Designer
Puerto Rico

I grew up in Puerto Rico, and thanks to MTV and pop music, New York became, in my mind, the place where everything was possible. When I first arrived in Manhattan, the first place I recognized was Bloomingdale's. Of course it was one of the first places that I wanted to visit.

The rest of the city wasn't as welcoming at first. I saw the steam coming out of the streets. I crossed town and finally arrived at my address. I thought, "Where am I?" The building where I was staying didn't look pretty to me, like the rest of the city that I had just crossed. The people who were waiting for me there said, "That way's up, that way's down, that way's east, that way's west. Here are the keys, goodbye!"

When I launched my shoe line in 2000, my experience had been designing shoes for fashion designers' collections. But I was dying to do collections that were born from nothing, that were just about great shoes. Then, in 2004, I was approached by the Gucci group to be the creative director of Sergio Rossi. I loved the idea of that challenge. So I decided to put my own line aside. It was a big moment in my career. But by 2010 I decided to re-launch it because I felt like the fashion industry had taken a turn. People were afraid of the new, and everybody wanted to follow something that was already out there. It was driving me crazy! I have never been one to follow others—never, ever, ever, ever! Following to me is the kiss of death!

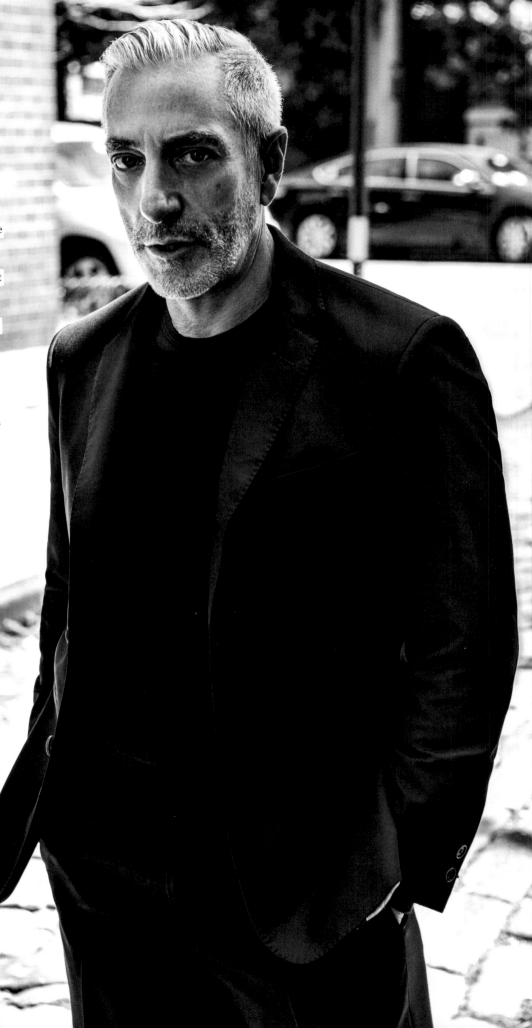

Paul Cavaco
Creative Director
Cuba

I was born in 1952, and I lived in the South Bronx, which was fairly Latin at the time. All the people who lived in my building were like family. It taught me how to navigate a lot of different characters. When you are Latin there is no generational thing. Everyone eats together and dances together. I think that is why, when I am working on a project now, the people I work with become my family. I have so much affection for everyone I work with. We are doing it together.

I met my wife, Kezia Keeble, in 1972 or 1973 at a Buddhist meeting. She would come to the meetings with a pair of flared dark denim jeans and a see-through Saint Laurent blouse with a printed bra underneath it. People loved her in the streets and the subway and always wanted to talk to her. I would go out on shoots with her and watch her style. She was very hands-on and had a beautiful eye. She once sent me to Bruce Weber, and I put the clothes together for a shoot. He looked at what I did and said, "This guy is really good—he should do this for a living." Bruce was the first person to believe in me.

Kezia used to always say to me, "Do the thing that is in front of you." If I got a job I would take it. I never questioned it; what mattered to me was doing the job well. Being a guy at a time when there were very few guys working in the industry, you could be considered camp. And they would say, "Oh, he is Latin, he is going to do it glitzy." I had so many things working against me, so I had to be good. I knew I wanted a *Vogue* cover. I was pretty old when I got it—I was in my 40s when I worked for American *Vogue*—but I wanted to have that acknowledgment that I was *that* good.

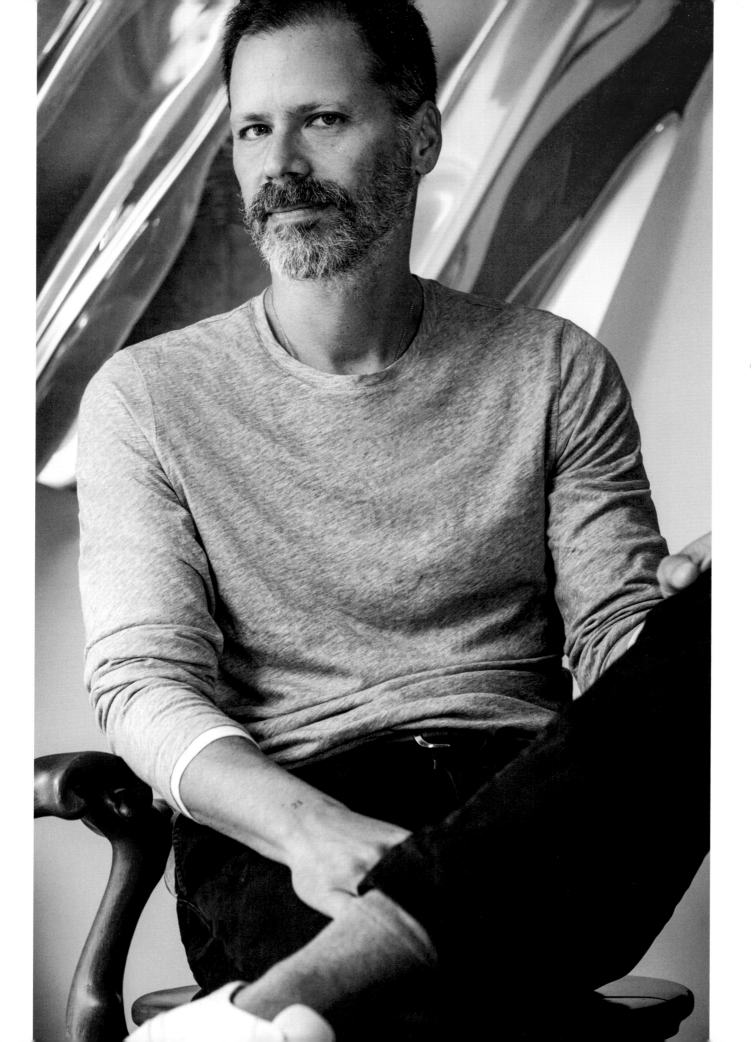

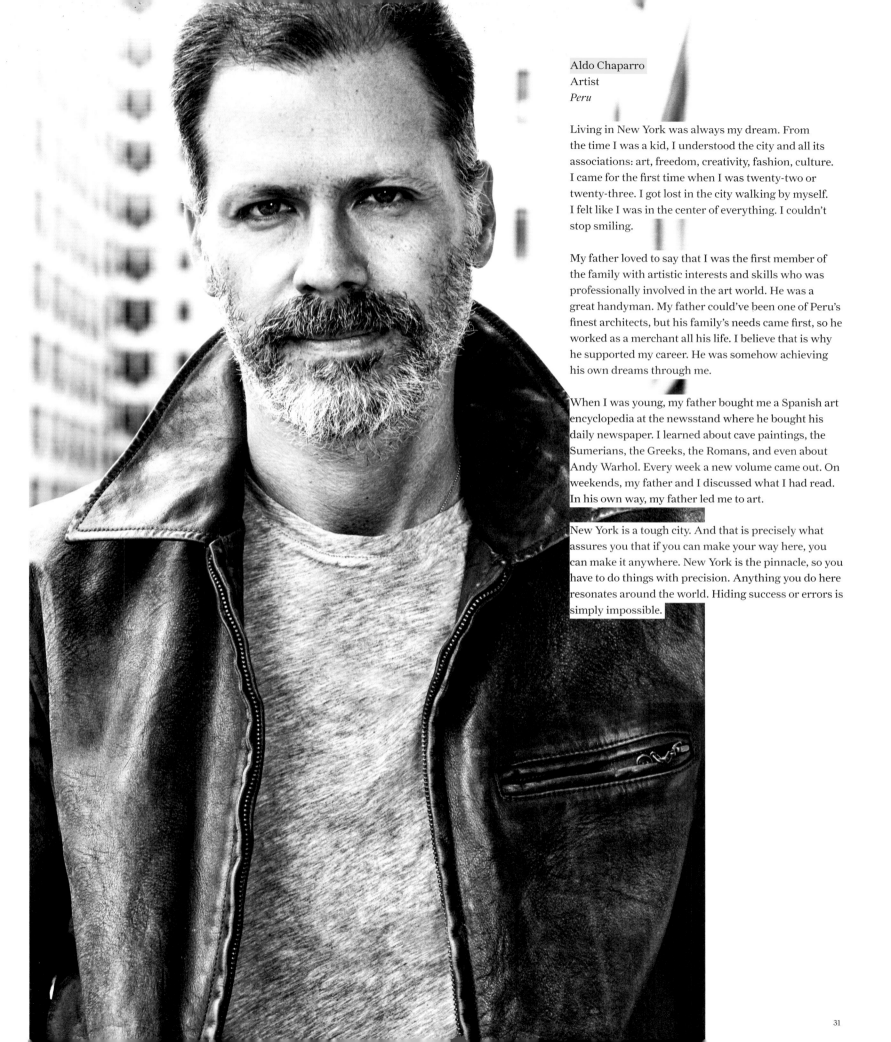

Aldo Chaparro
Artist
Peru

Living in New York was always my dream. From the time I was a kid, I understood the city and all its associations: art, freedom, creativity, fashion, culture. I came for the first time when I was twenty-two or twenty-three. I got lost in the city walking by myself. I felt like I was in the center of everything. I couldn't stop smiling.

My father loved to say that I was the first member of the family with artistic interests and skills who was professionally involved in the art world. He was a great handyman. My father could've been one of Peru's finest architects, but his family's needs came first, so he worked as a merchant all his life. I believe that is why he supported my career. He was somehow achieving his own dreams through me.

When I was young, my father bought me a Spanish art encyclopedia at the newsstand where he bought his daily newspaper. I learned about cave paintings, the Sumerians, the Greeks, the Romans, and even about Andy Warhol. Every week a new volume came out. On weekends, my father and I discussed what I had read. In his own way, my father led me to art.

New York is a tough city. And that is precisely what assures you that if you can make your way here, you can make it anywhere. New York is the pinnacle, so you have to do things with precision. Anything you do here resonates around the world. Hiding success or errors is simply impossible.

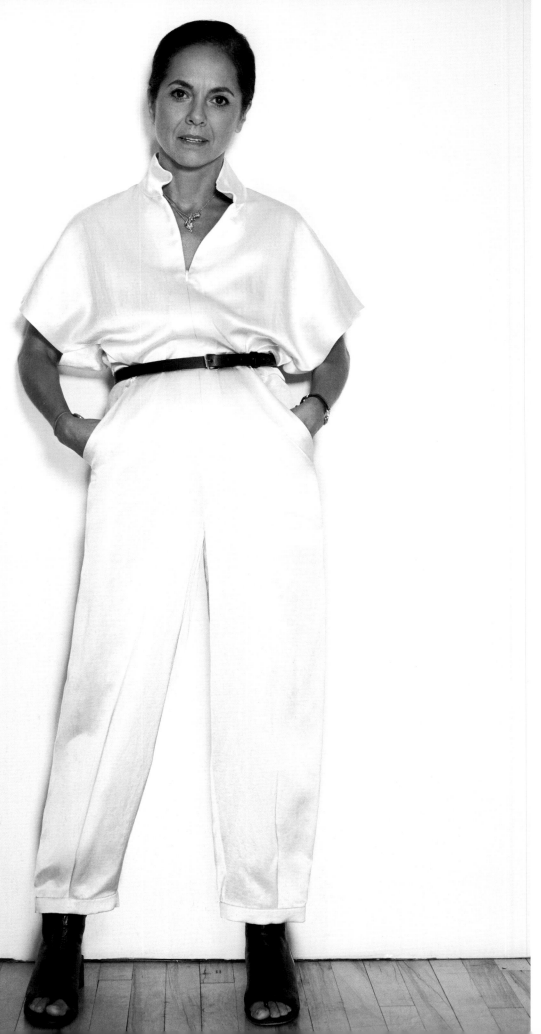

Maria Cornejo
Fashion Designer
Chile

My father left Chile first, after the coup d'état. Then my family was taken out by the United Nations and went to Peru, and later we became political refugees and got asylum in England.

I came to New York first in 1996 from Paris. My husband, who is a photographer, was here working a lot for Italian *Vogue* and other magazines like *The Face* and *I.D.* I had just had a child. When I arrived here, I wasn't sure what I was going to do. I liked the way people were wearing clothes. It is great to see that people are wearing clothes from boutiques every day. The whole idea of American sportswear is to make things that are wearable.

After working for a big company in London and with designer John Richmond, I just wanted to find my own way of working. So in 1998 I started my own line.

Michelle Obama has worn my designs. The thing I really love about her is that she is doing interesting things with the clothes. She is not just standing there being photographed. One time she was wearing one of my jackets and she looked amazing. She looked like herself— she looked really cool. I think as a woman, and being of a similar age, she is really a role model.

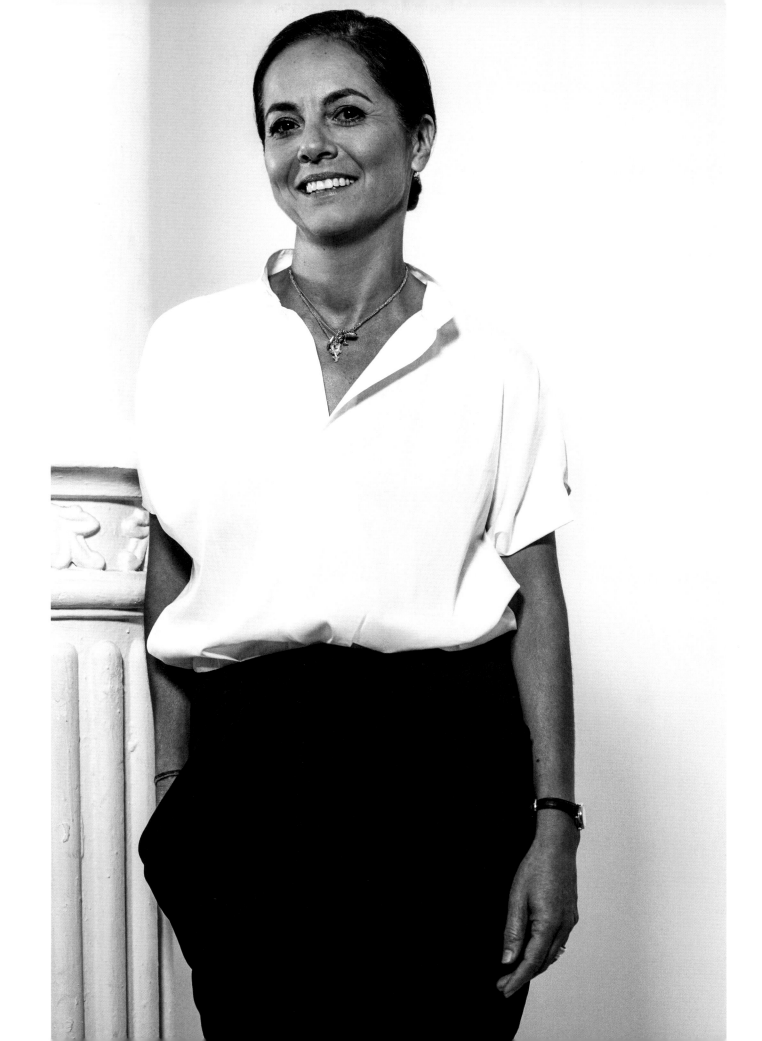

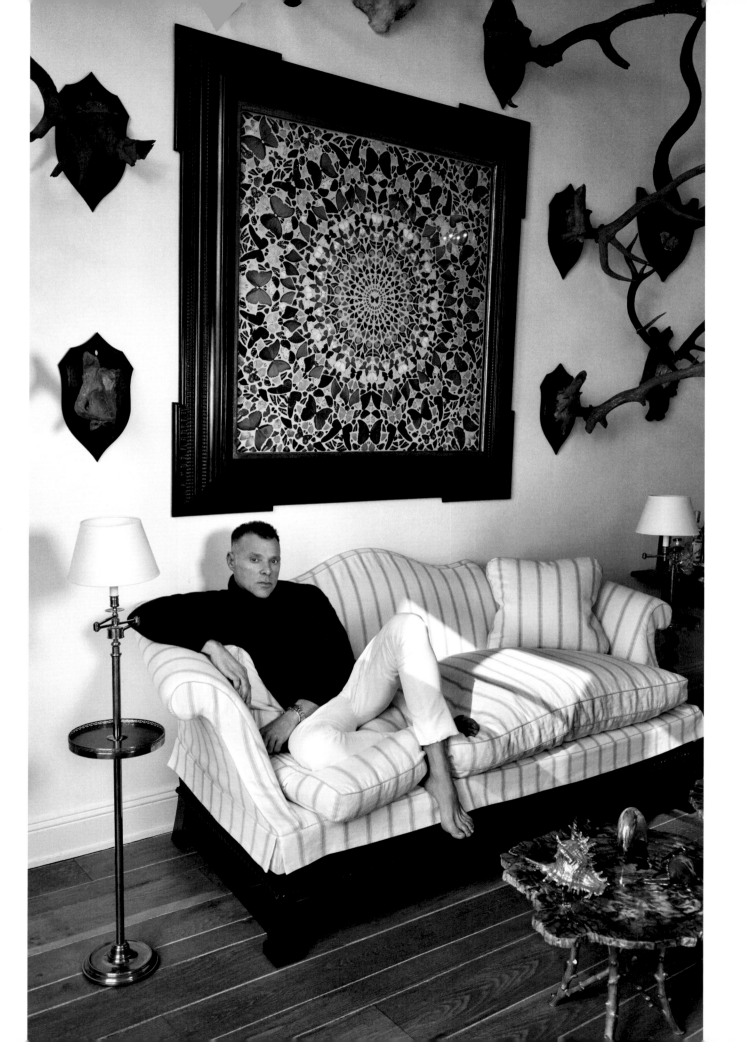

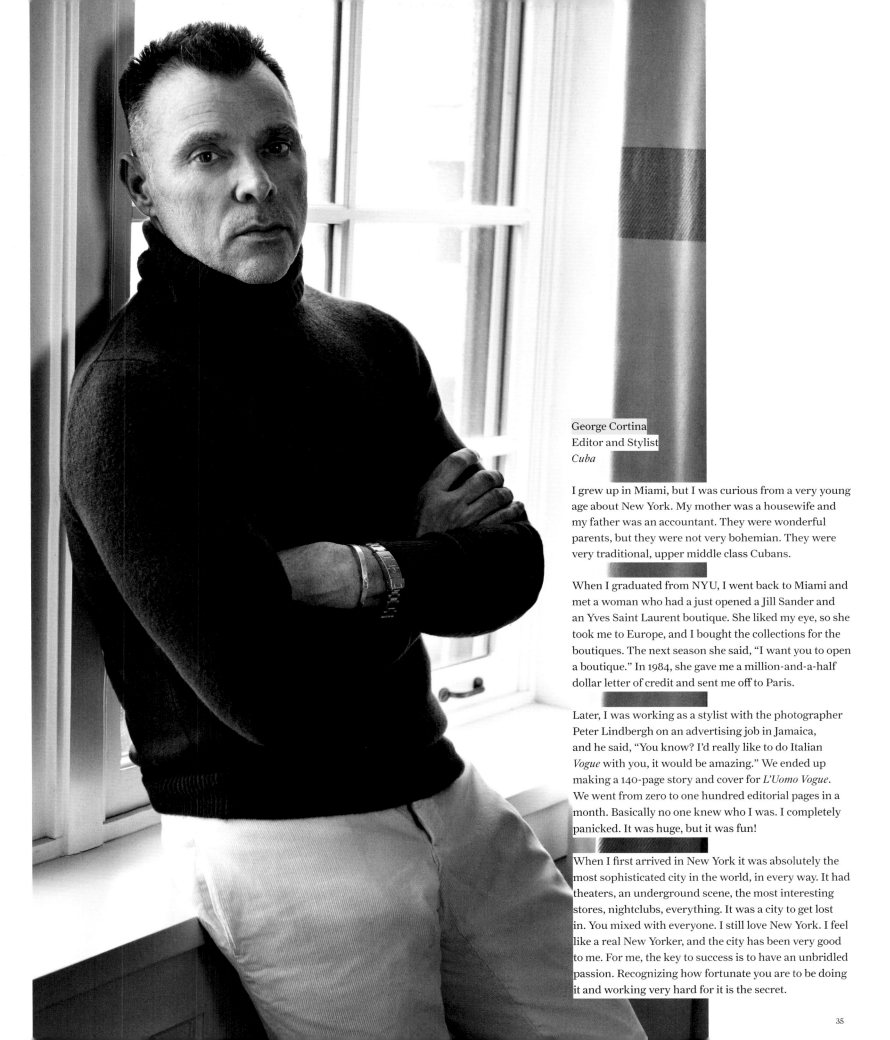

George Cortina
Editor and Stylist
Cuba

I grew up in Miami, but I was curious from a very young age about New York. My mother was a housewife and my father was an accountant. They were wonderful parents, but they were not very bohemian. They were very traditional, upper middle class Cubans.

When I graduated from NYU, I went back to Miami and met a woman who had a just opened a Jill Sander and an Yves Saint Laurent boutique. She liked my eye, so she took me to Europe, and I bought the collections for the boutiques. The next season she said, "I want you to open a boutique." In 1984, she gave me a million-and-a-half dollar letter of credit and sent me off to Paris.

Later, I was working as a stylist with the photographer Peter Lindbergh on an advertising job in Jamaica, and he said, "You know? I'd really like to do Italian *Vogue* with you, it would be amazing." We ended up making a 140-page story and cover for *L'Uomo Vogue*. We went from zero to one hundred editorial pages in a month. Basically no one knew who I was. I completely panicked. It was huge, but it was fun!

When I first arrived in New York it was absolutely the most sophisticated city in the world, in every way. It had theaters, an underground scene, the most interesting stores, nightclubs, everything. It was a city to get lost in. You mixed with everyone. I still love New York. I feel like a real New Yorker, and the city has been very good to me. For me, the key to success is to have an unbridled passion. Recognizing how fortunate you are to be doing it and working very hard for it is the secret.

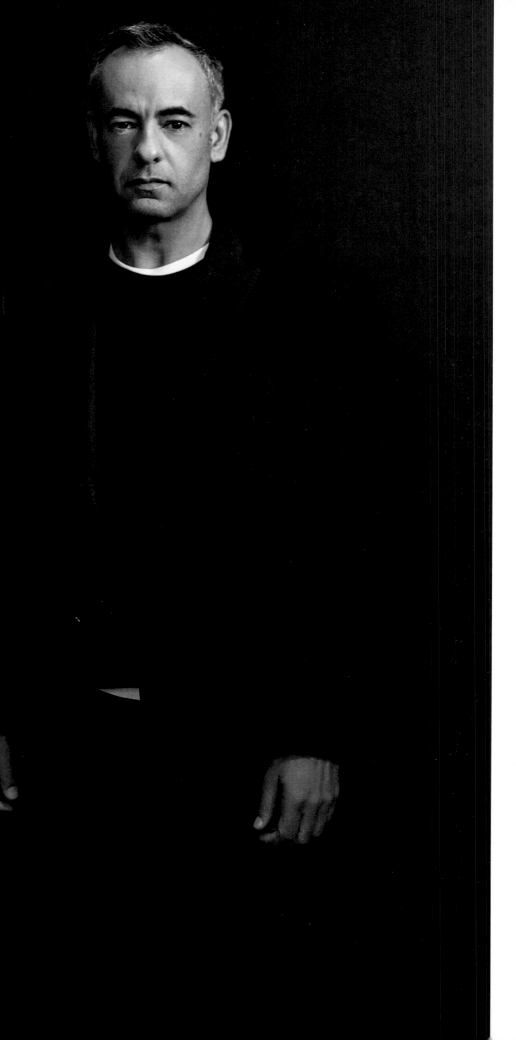

Francisco Costa
Fashion Designer
Brazil

When I was growing up in Brazil, my mom manufactured children's sweaters. She started out sewing herself, but over time her business became a small company that employed a lot of women in the area—at one point there were about 215 employees, which was a lot in our small town. We had a very rigorous schedule. My siblings and I would go to school, have lunch, and then we all had to go to the factory. We all learned that somehow all of us had to be doing something all the time.

I didn't go to college. I enrolled in a Polytechnic school in knitting and manufacturing, and I took accounting at the same time. I ended up coming to New York City to learn English, and started taking classes at the Fashion Institute of Technology at night. I had the most amazing time at FIT. Public school was all I could afford, and I think I learned more than everybody else because I took advantage of the school. The library is fantastic, the museum is fantastic, the exhibits are fantastic, and the teachers were great.

Much later, when I was working with Oscar de la Renta, I went to a psychic. He said I was going to work with Calvin Klein. It sounded absurd to me, but a few years later, after I worked with Tom Ford at Gucci, I was hired to be the creative director at Calvin Klein.

Calvin was everything for an American brand. There was some intimidation, I think, surrounding who Calvin was: he was cool, super-modern, and sexy. It was very tough because he built this remarkable longevity with his brand. It is just an amazing combination of lifestyle, beauty, and sassiness. I have always tried to be very respectful of this incredible home that he built.

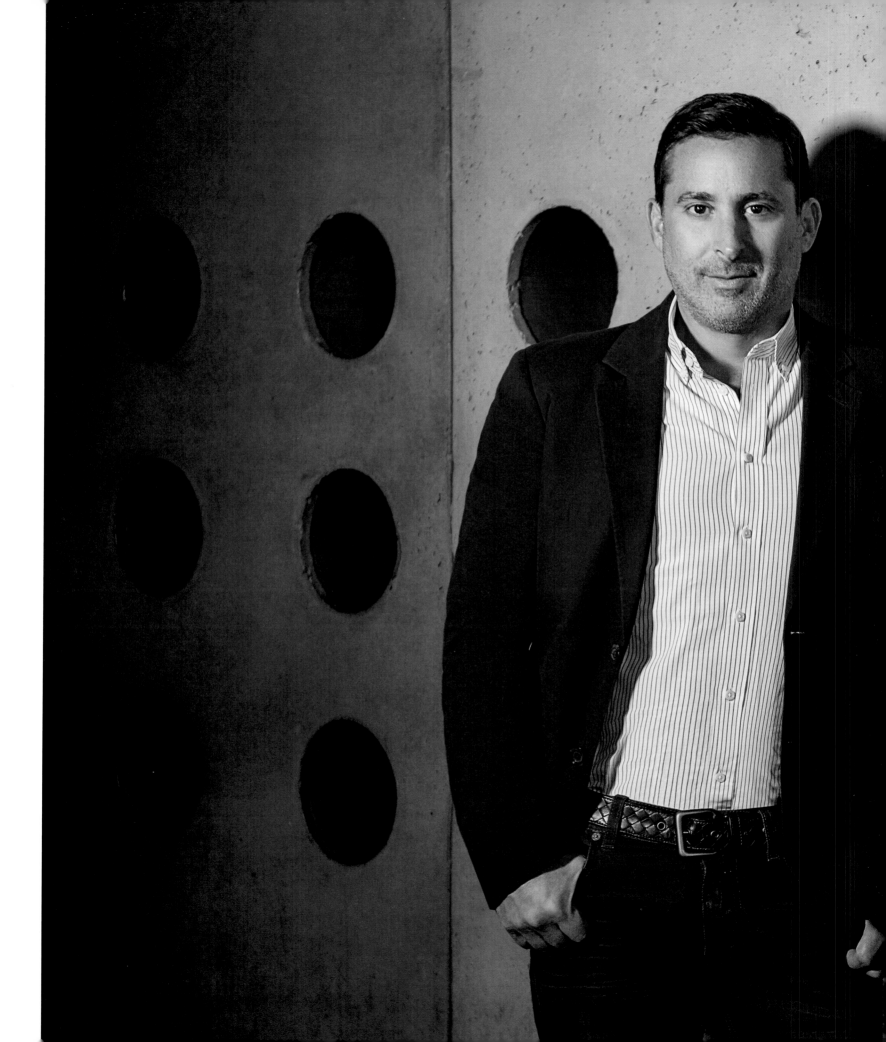

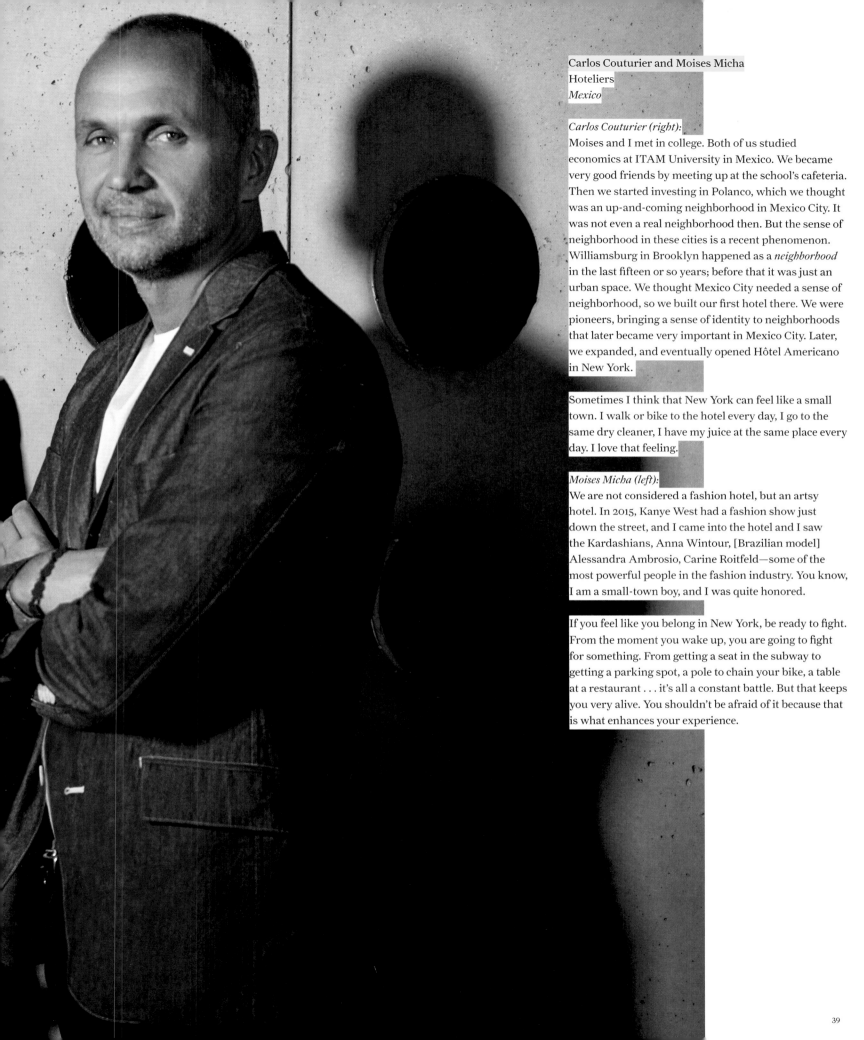

Carlos Couturier and Moises Micha
Hoteliers
Mexico

Carlos Couturier (right):
Moises and I met in college. Both of us studied economics at ITAM University in Mexico. We became very good friends by meeting up at the school's cafeteria. Then we started investing in Polanco, which we thought was an up-and-coming neighborhood in Mexico City. It was not even a real neighborhood then. But the sense of neighborhood in these cities is a recent phenomenon. Williamsburg in Brooklyn happened as a *neighborhood* in the last fifteen or so years; before that it was just an urban space. We thought Mexico City needed a sense of neighborhood, so we built our first hotel there. We were pioneers, bringing a sense of identity to neighborhoods that later became very important in Mexico City. Later, we expanded, and eventually opened Hôtel Americano in New York.

Sometimes I think that New York can feel like a small town. I walk or bike to the hotel every day, I go to the same dry cleaner, I have my juice at the same place every day. I love that feeling.

Moises Micha (left):
We are not considered a fashion hotel, but an artsy hotel. In 2015, Kanye West had a fashion show just down the street, and I came into the hotel and I saw the Kardashians, Anna Wintour, [Brazilian model] Alessandra Ambrosio, Carine Roitfeld—some of the most powerful people in the fashion industry. You know, I am a small-town boy, and I was quite honored.

If you feel like you belong in New York, be ready to fight. From the moment you wake up, you are going to fight for something. From getting a seat in the subway to getting a parking spot, a pole to chain your bike, a table at a restaurant . . . it's all a constant battle. But that keeps you very alive. You shouldn't be afraid of it because that is what enhances your experience.

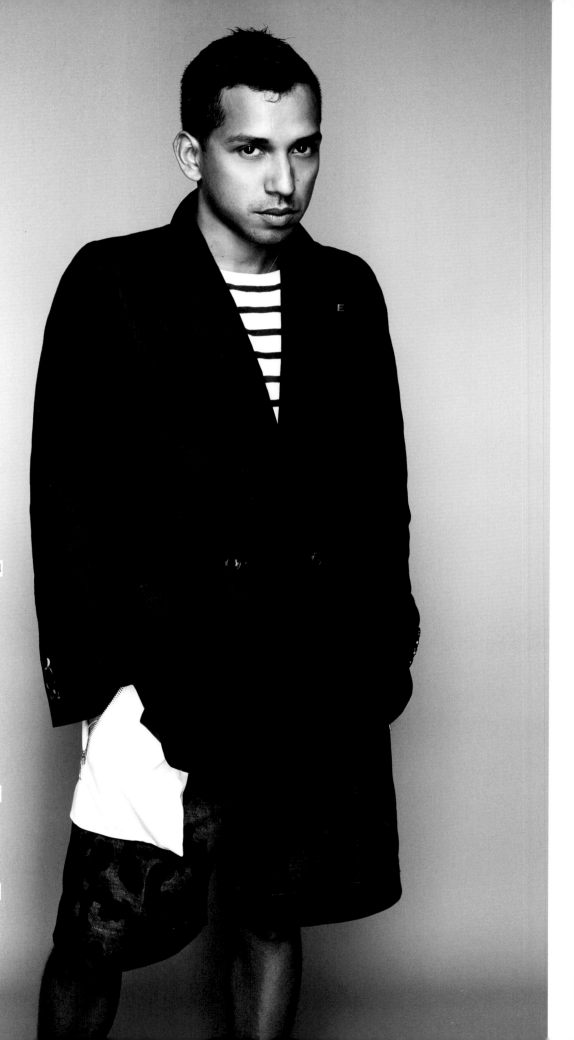

Miguel Enamorado
Fashion Director
Honduras

When we lived in Honduras, my mom was always traveling to the U.S. She loved to sew. There's a belted polka dot dress that she made that, to this day, I can remember very clearly. It really piqued my interest in making clothes. I would take the scraps from whatever she made and would sew pieces for my sisters' dolls from them, always trying to recreate what I had seen her do.

My family moved to Miami when I was eleven. I came to New York to go to college at the Fashion Institute of Technology. I was working at Club Monaco in the stylist-lending program, and a friend was offered a job in LA with the Swedish stylist Maria Virgin on an advertising job for a car manufacturer. I went down to meet her in my vintage fur-collared coat, what I thought was the most fashionable thing I could wear, and it got me the job. I came back and quit my job to start working with her full-time.

What I love most about New York is that it gives back as much as it takes. If you are really hungry to make your dreams come true, it feeds you the tools and energy to achieve it. Talent will open the door, but being well prepared, working hard, and doing it all with a smile is really the truest formula for staying and moving ahead

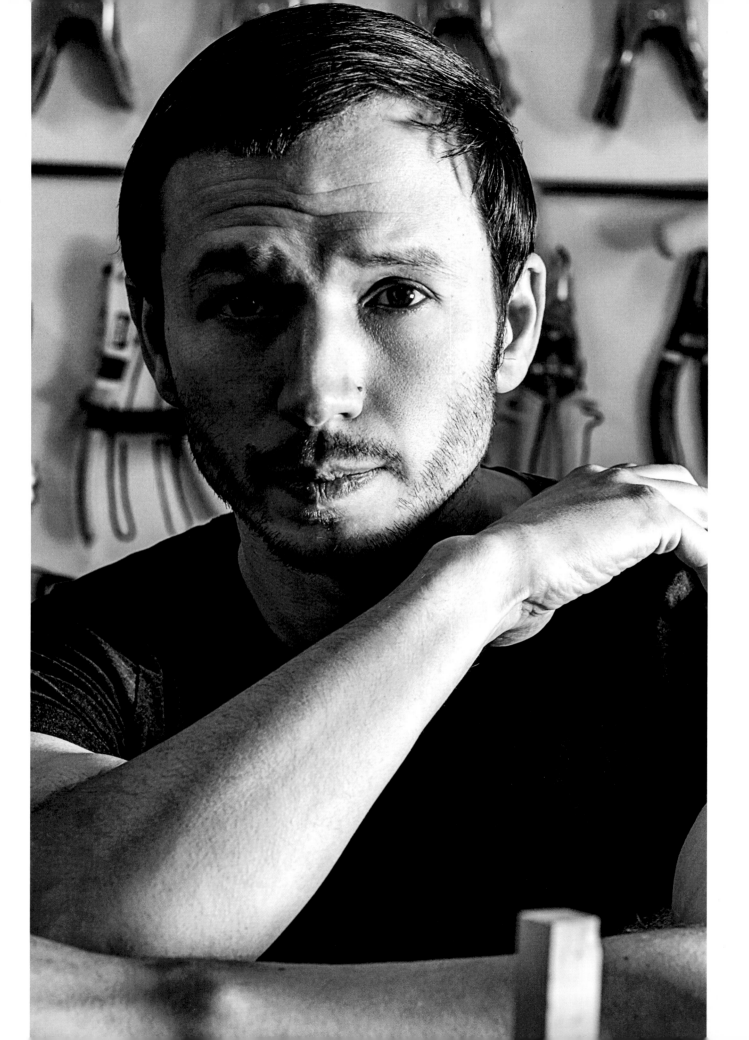

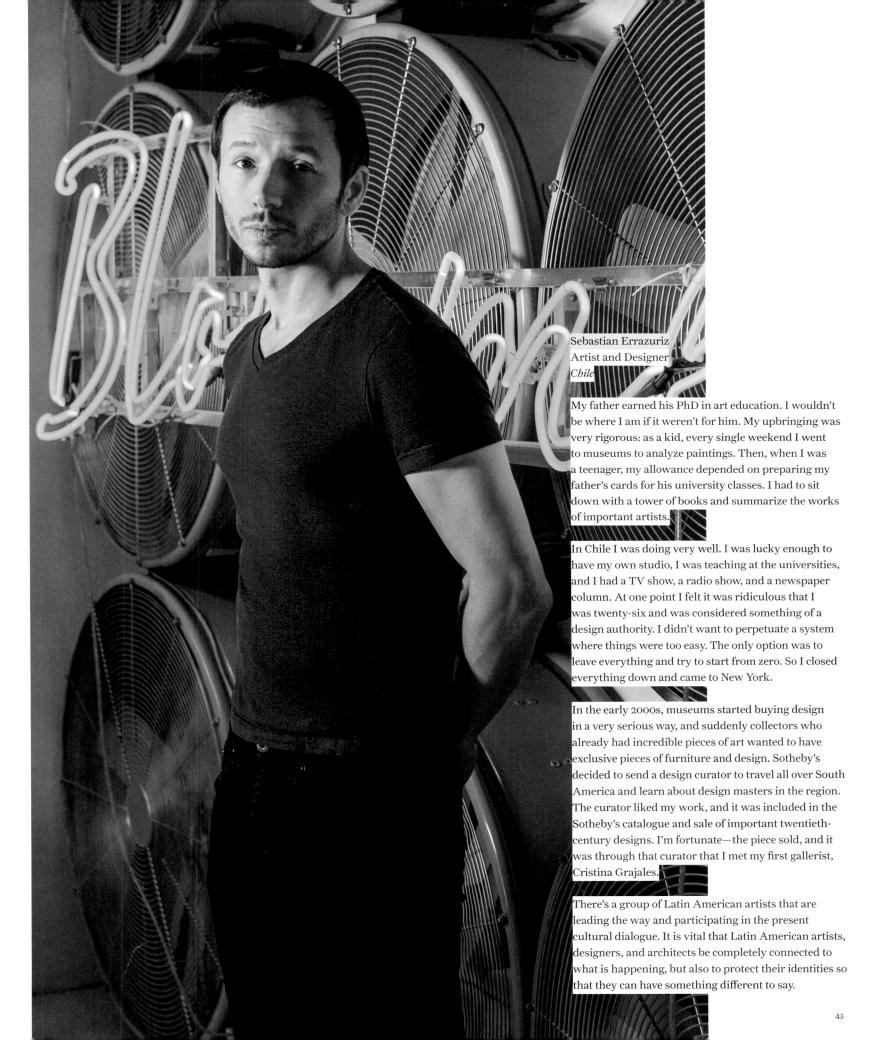

Sebastian Errazuriz
Artist and Designer
Chile

My father earned his PhD in art education. I wouldn't be where I am if it weren't for him. My upbringing was very rigorous: as a kid, every single weekend I went to museums to analyze paintings. Then, when I was a teenager, my allowance depended on preparing my father's cards for his university classes. I had to sit down with a tower of books and summarize the works of important artists.

In Chile I was doing very well. I was lucky enough to have my own studio, I was teaching at the universities, and I had a TV show, a radio show, and a newspaper column. At one point I felt it was ridiculous that I was twenty-six and was considered something of a design authority. I didn't want to perpetuate a system where things were too easy. The only option was to leave everything and try to start from zero. So I closed everything down and came to New York.

In the early 2000s, museums started buying design in a very serious way, and suddenly collectors who already had incredible pieces of art wanted to have exclusive pieces of furniture and design. Sotheby's decided to send a design curator to travel all over South America and learn about design masters in the region. The curator liked my work, and it was included in the Sotheby's catalogue and sale of important twentieth-century designs. I'm fortunate—the piece sold, and it was through that curator that I met my first gallerist, Cristina Grajales.

There's a group of Latin American artists that are leading the way and participating in the present cultural dialogue. It is vital that Latin American artists, designers, and architects be completely connected to what is happening, but also to protect their identities so that they can have something different to say.

Emilia Fanjul Pfeifler
Co-founder, The Drawing Room
Cuba

I loved having a public relations agency in New York. It was such a fun office. It was on Broadway between Houston and Prince. We kept it very downtown raw, very simple. I had fun seeing it evolve. What I liked about PR was the fact that I got to work with all different kinds of people, from the person who was just starting out making t-shirts to companies like Burberry and Saks Fifth Avenue and Hermès. I covered the whole gamut. No two days were ever the same. But then I had my son, and I felt strongly about being around for him. PR is very time consuming. It's answering to a lot of people and dealing with egos.

Recently, I launched a company with one of my closest childhood friends. We started doing very simple trunk shows, which was fine, but we were doing them from my apartment. So we finally found a space on 72nd Street between Park and Madison and called it The Drawing Room. It's a beautiful, old world, tiny studio. It's like a revolving door; we have all different kinds of brands coming in, ones that aren't typically found on Fifth and Madison Avenues. We are curating what we want, and it's not just fashion, it's lifestyle.

New York is so active, and everyone is involved in so many different things. I feed off that energy and it's energy for my kids too: their education, what they do after school, what they see every single day walking down the street, the questions they ask by literally walking out the front door. That's what makes New York so great.

Teresita Fernández
Artist
Cuba

My parents came to the U.S. as teenagers, in 1959, immediately after the Cuban Revolution. I am a first generation Cuban-American, born in Miami. I grew up in a Cuban immigrant community, with Spanish-speaking parents, so it's an important part of my history. My parents were not involved in the arts at all, but all of the women in my family were trained in Cuba as haute couture seamstresses, so even though they were not involved in the arts per se, I was surrounded by women making things, and there was a very high level of production around me. What they were doing was very influential because it gave me access to materials and freedom to make things.

In college at Florida International University, I took sculpture classes, and I started making very big metal sculptures. It was then when I knew that this is what I wanted to do as a profession, and as my life work, not just something that I was interested in, but something that was important to me. This is what I've always done and it is a big part of my identity. It is not something that came into my life and transformed it, it is just who I am, it is part of my life.

I don't believe that thinking and experiencing are different things. There is a whole conceptual framework to the work that I develop, but the experiential aspect of the work is really the way that you understand it. I am interested in how viewers can understand something by engaging with it, which of course is a very different kind of knowledge than reading about it. My intention is that my work will be unraveled.

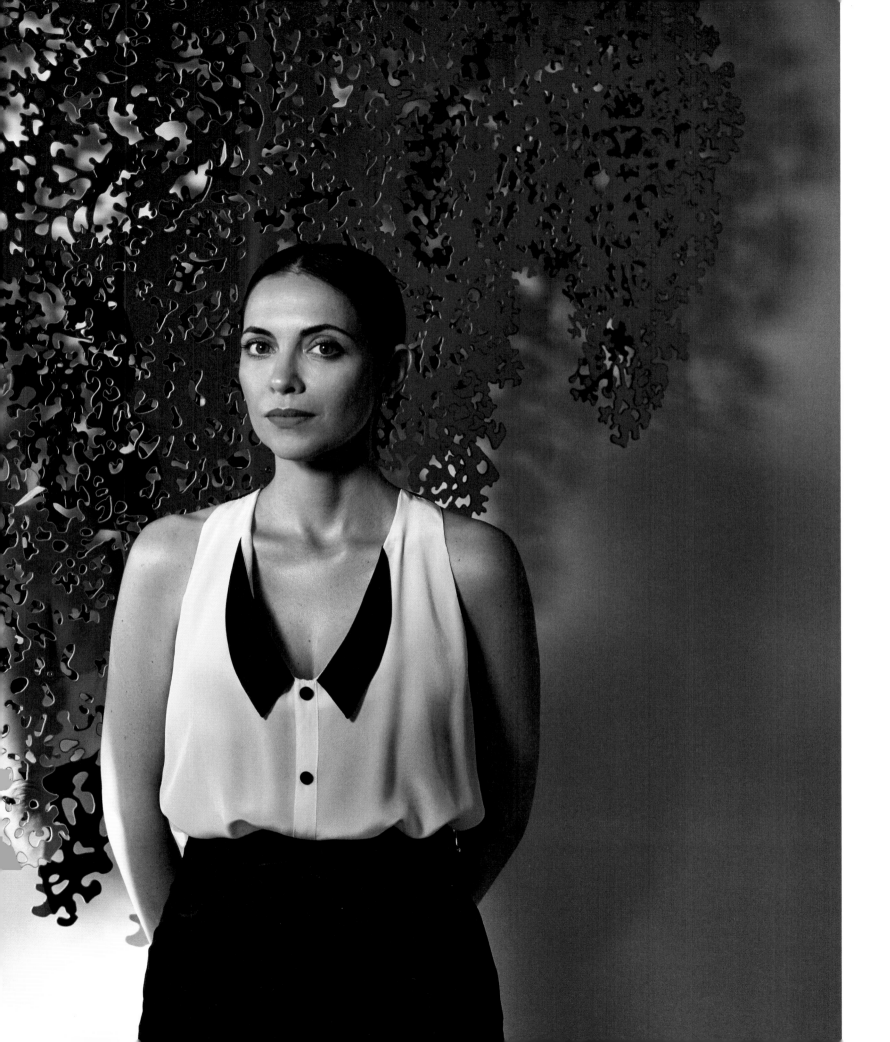

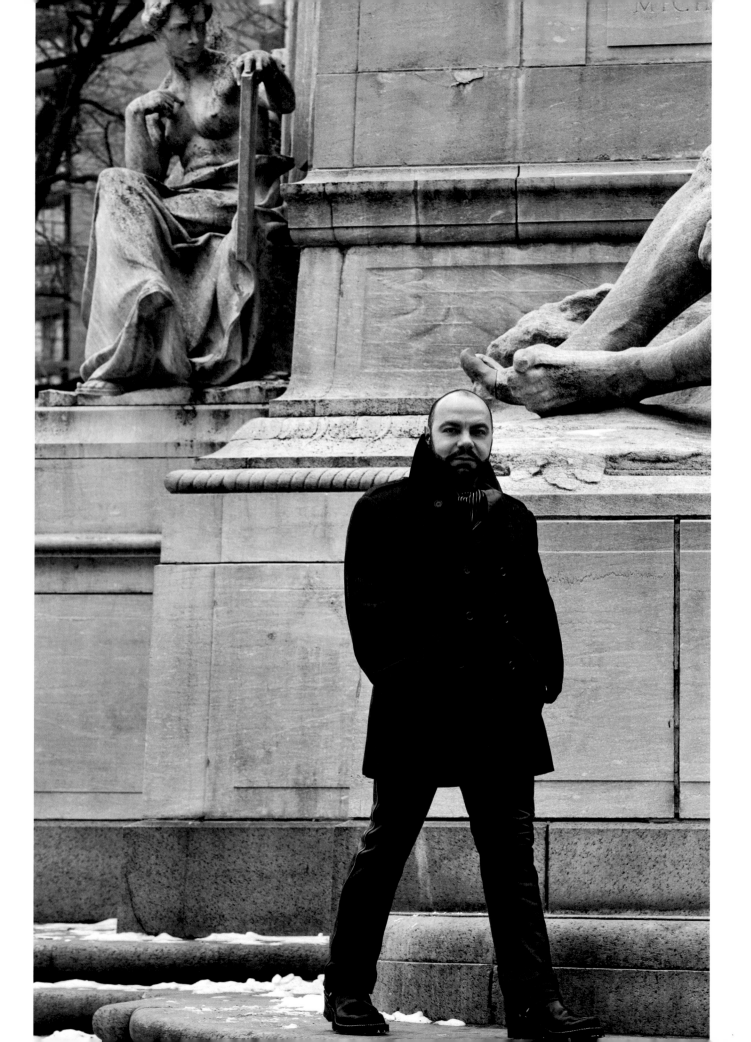

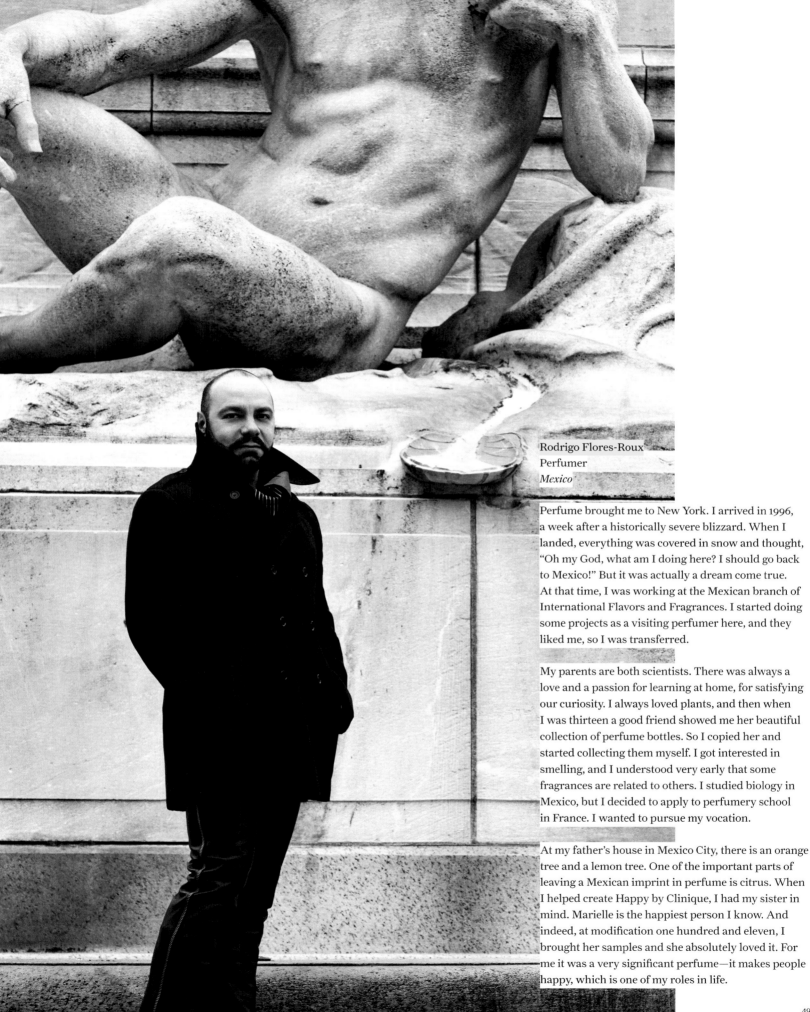

Rodrigo Flores-Roux
Perfumer
Mexico

Perfume brought me to New York. I arrived in 1996,
a week after a historically severe blizzard. When I
landed, everything was covered in snow and thought,
"Oh my God, what am I doing here? I should go back
to Mexico!" But it was actually a dream come true.
At that time, I was working at the Mexican branch of
International Flavors and Fragrances. I started doing
some projects as a visiting perfumer here, and they
liked me, so I was transferred.

My parents are both scientists. There was always a
love and a passion for learning at home, for satisfying
our curiosity. I always loved plants, and then when
I was thirteen a good friend showed me her beautiful
collection of perfume bottles. So I copied her and
started collecting them myself. I got interested in
smelling, and I understood very early that some
fragrances are related to others. I studied biology in
Mexico, but I decided to apply to perfumery school
in France. I wanted to pursue my vocation.

At my father's house in Mexico City, there is an orange
tree and a lemon tree. One of the important parts of
leaving a Mexican imprint in perfume is citrus. When
I helped create Happy by Clinique, I had my sister in
mind. Marielle is the happiest person I know. And
indeed, at modification one hundred and eleven, I
brought her samples and she absolutely loved it. For
me it was a very significant perfume—it makes people
happy, which is one of my roles in life.

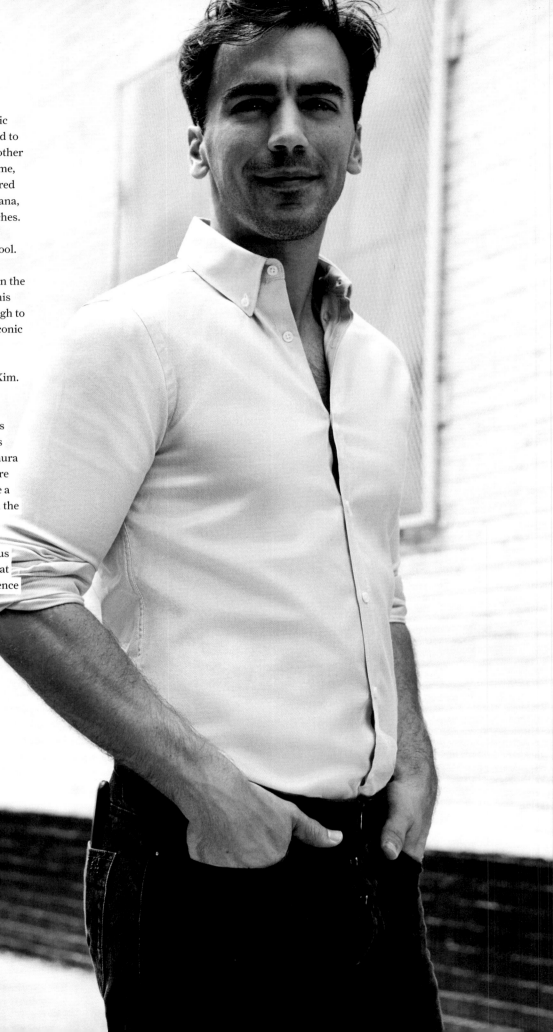

Fernando Garcia
Fashion Designer
Dominican Republic

I grew up traveling between the Dominican Republic and Spain. Both of my parents were always attracted to the arts—my father studied architecture and my mother painted. I actually studied architecture at Notre Dame, but I turned to fashion when Oscar de la Renta offered me an incredible opportunity. I met him in Punta Cana, through a friend, and he looked at some of my sketches. He encouraged me to come to New York to do an internship at his fashion house when I finished school.

So I did this. I learned sewing and patternmaking on the job and eventually became a principal designer on his team. During my time with Oscar, I was lucky enough to be closely involved with making some of the most iconic eveningwear pieces in the collection.

I recently started my own line, Monse, with Laura Kim. We met at Oscar de la Renta. Because Oscar liked a small team, Laura and I got to know each other very well and learned how to work with each other's aesthetics. It became instinctual to get one another's approval before showing an idea to Oscar. When Laura and I were in the position of finding out who we were outside of a major fashion house, we decided to take a leap and explore that on our own, which resulted in the creation of Monse.

Working at a revered house and with Oscar taught us many things, one of which was designing clothes that women can really wear. Listen to those with experience and always have fun at work.

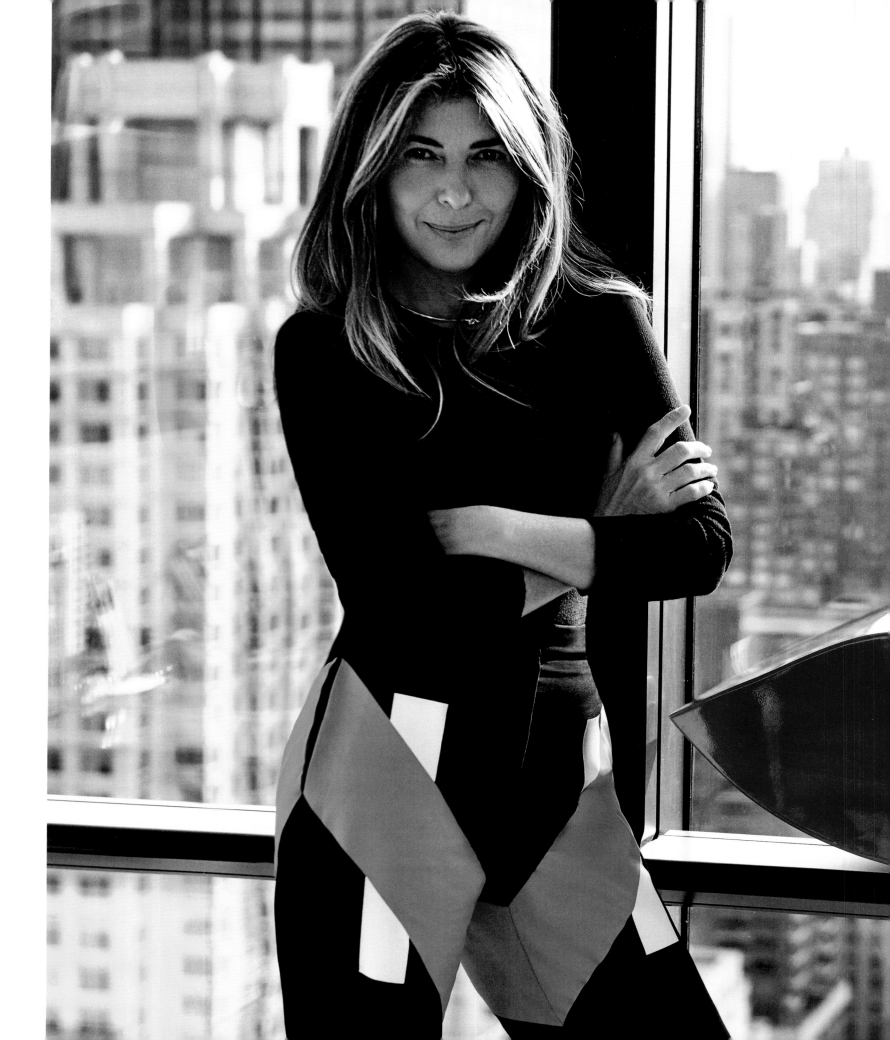

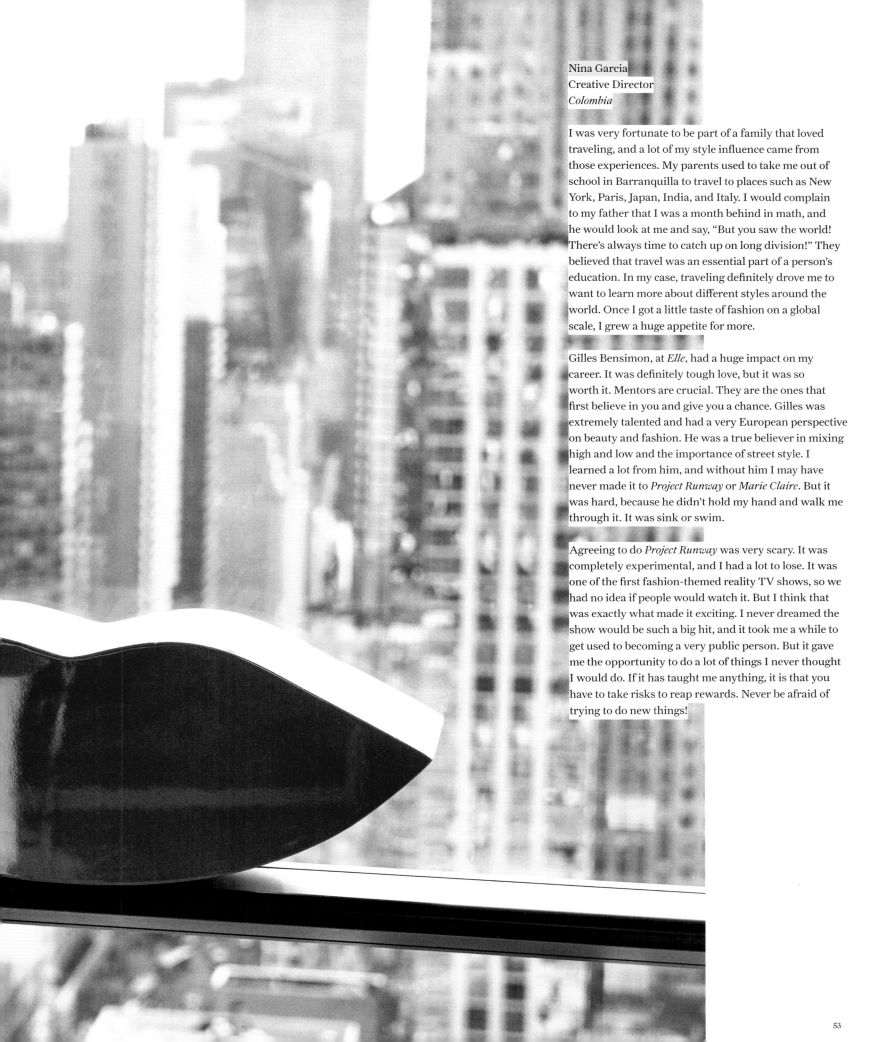

Nina Garcia
Creative Director
Colombia

I was very fortunate to be part of a family that loved traveling, and a lot of my style influence came from those experiences. My parents used to take me out of school in Barranquilla to travel to places such as New York, Paris, Japan, India, and Italy. I would complain to my father that I was a month behind in math, and he would look at me and say, "But you saw the world! There's always time to catch up on long division!" They believed that travel was an essential part of a person's education. In my case, traveling definitely drove me to want to learn more about different styles around the world. Once I got a little taste of fashion on a global scale, I grew a huge appetite for more.

Gilles Bensimon, at *Elle*, had a huge impact on my career. It was definitely tough love, but it was so worth it. Mentors are crucial. They are the ones that first believe in you and give you a chance. Gilles was extremely talented and had a very European perspective on beauty and fashion. He was a true believer in mixing high and low and the importance of street style. I learned a lot from him, and without him I may have never made it to *Project Runway* or *Marie Claire*. But it was hard, because he didn't hold my hand and walk me through it. It was sink or swim.

Agreeing to do *Project Runway* was very scary. It was completely experimental, and I had a lot to lose. It was one of the first fashion-themed reality TV shows, so we had no idea if people would watch it. But I think that was exactly what made it exciting. I never dreamed the show would be such a big hit, and it took me a while to get used to becoming a very public person. But it gave me the opportunity to do a lot of things I never thought I would do. If it has taught me anything, it is that you have to take risks to reap rewards. Never be afraid of trying to do new things!

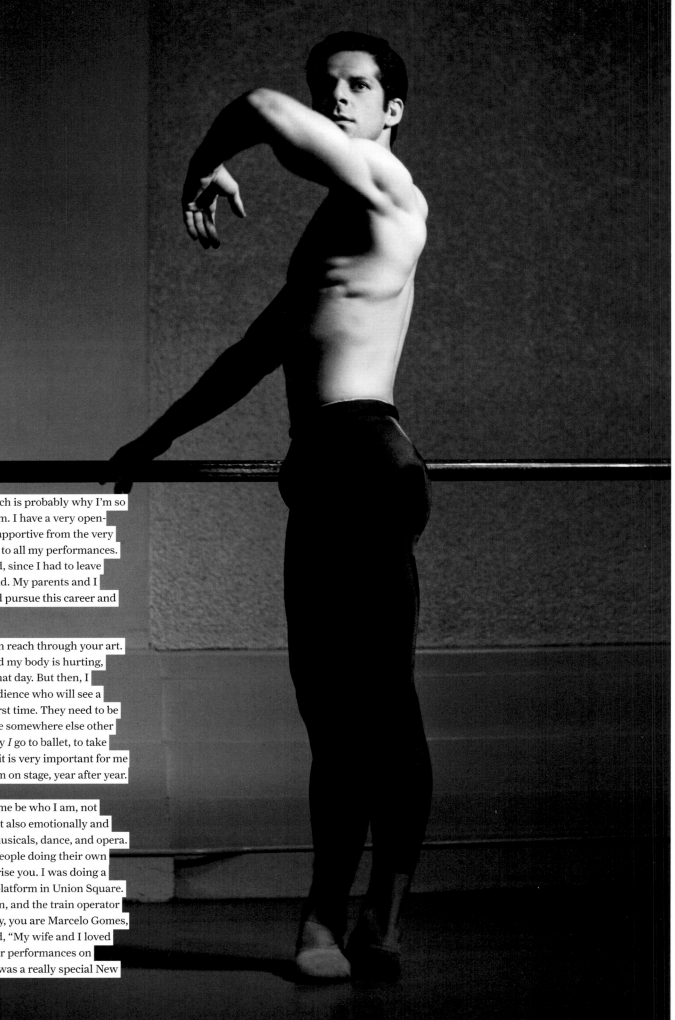

Marcelo Gomes
Ballet Dancer
Brazil

My sister used to dance, which is probably why I'm so passionate about this art form. I have a very open-minded family. They were supportive from the very beginning; they would come to all my performances. At the same time, it was hard, since I had to leave home so early to study abroad. My parents and I sacrificed a lot so that I could pursue this career and get to where I am now.

You never know who you can reach through your art. Sometimes I feel so tired, and my body is hurting, and I feel like I can't dance that day. But then, I think of the people in the audience who will see a ballet performance for the first time. They need to be transported—they want to be somewhere else other than in their lives. That's why *I* go to ballet, to take myself outside of my life. So it is very important for me to think about that when I am on stage, year after year.

New York has really helped me be who I am, not just in terms of my career but also emotionally and intellectually—the theater, musicals, dance, and opera. As much as you encounter people doing their own thing, this city can still surprise you. I was doing a photo shoot on the subway platform in Union Square. A train pulled into the station, and the train operator called me over and said, "Hey, you are Marcelo Gomes, right?" I said yes, and he said, "My wife and I loved you in *Othello*! We watch your performances on YouTube all the time!" That was a really special New York City moment.

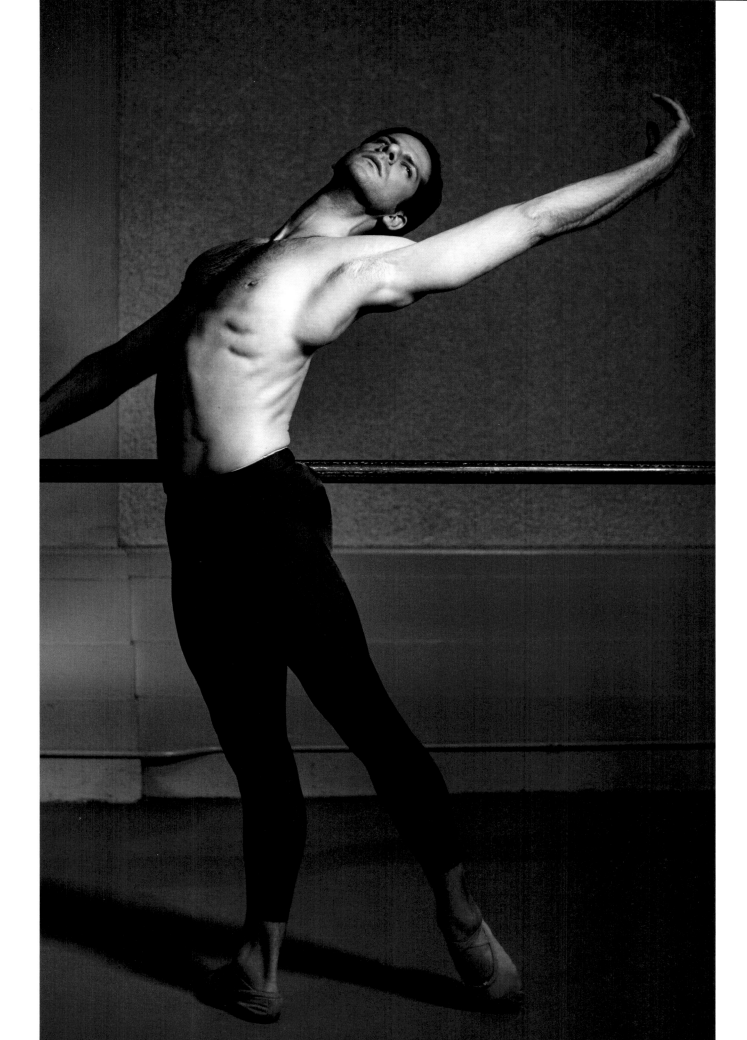

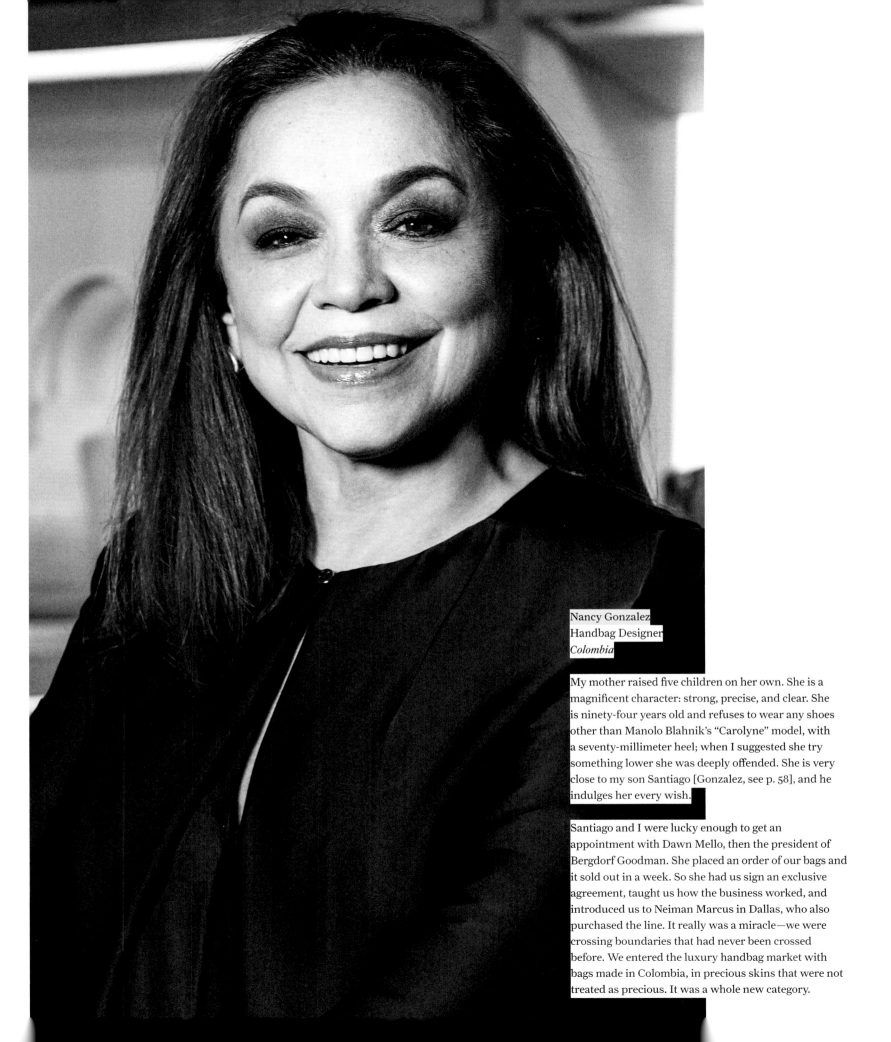

Nancy Gonzalez
Handbag Designer
Colombia

My mother raised five children on her own. She is a magnificent character: strong, precise, and clear. She is ninety-four years old and refuses to wear any shoes other than Manolo Blahnik's "Carolyne" model, with a seventy-millimeter heel; when I suggested she try something lower she was deeply offended. She is very close to my son Santiago [Gonzalez, see p. 58], and he indulges her every wish.

Santiago and I were lucky enough to get an appointment with Dawn Mello, then the president of Bergdorf Goodman. She placed an order of our bags and it sold out in a week. So she had us sign an exclusive agreement, taught us how the business worked, and introduced us to Neiman Marcus in Dallas, who also purchased the line. It really was a miracle—we were crossing boundaries that had never been crossed before. We entered the luxury handbag market with bags made in Colombia, in precious skins that were not treated as precious. It was a whole new category.

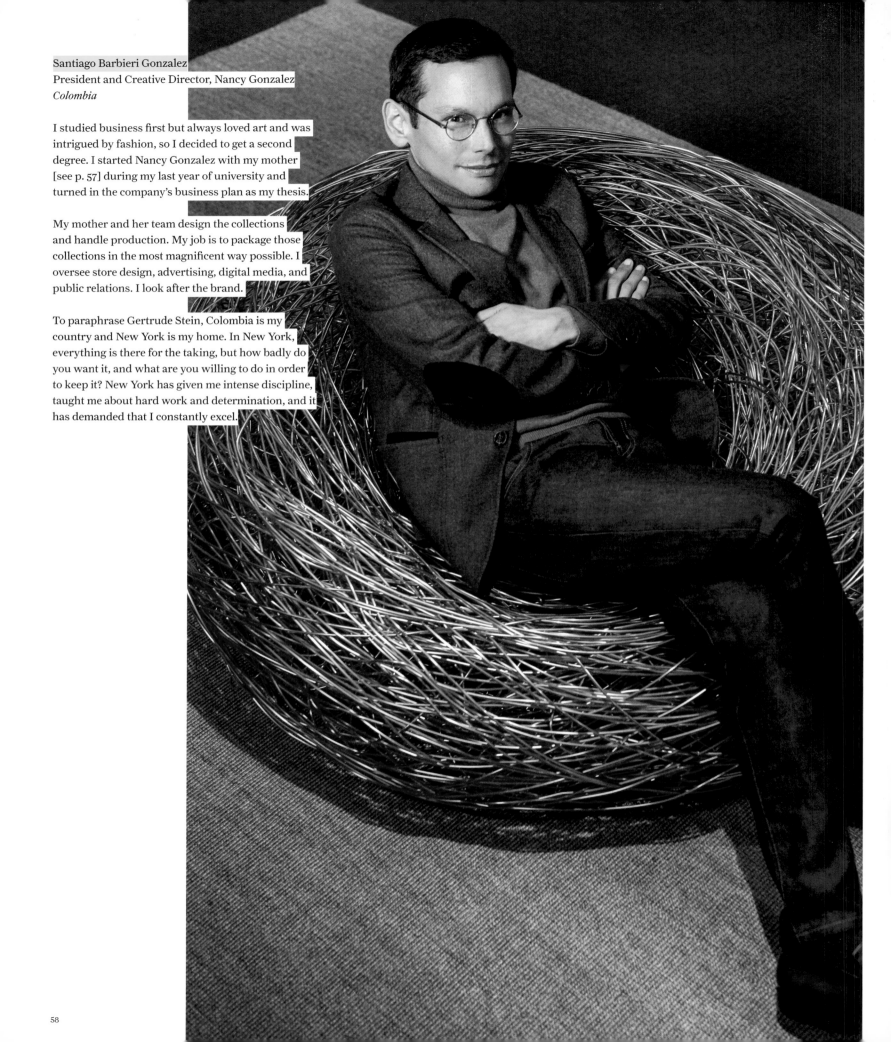

Santiago Barbieri Gonzalez
President and Creative Director, Nancy Gonzalez
Colombia

I studied business first but always loved art and was intrigued by fashion, so I decided to get a second degree. I started Nancy Gonzalez with my mother [see p. 57] during my last year of university and turned in the company's business plan as my thesis.

My mother and her team design the collections and handle production. My job is to package those collections in the most magnificent way possible. I oversee store design, advertising, digital media, and public relations. I look after the brand.

To paraphrase Gertrude Stein, Colombia is my country and New York is my home. In New York, everything is there for the taking, but how badly do you want it, and what are you willing to do in order to keep it? New York has given me intense discipline, taught me about hard work and determination, and it has demanded that I constantly excel.

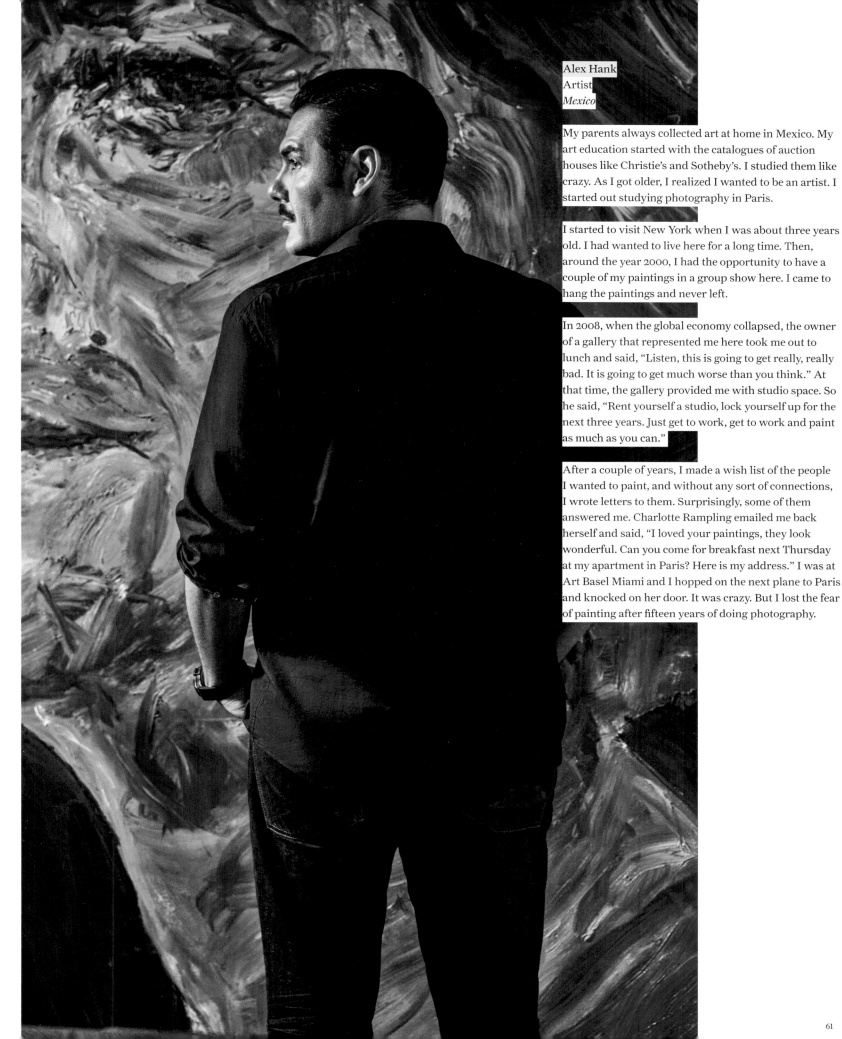

Alex Hank
Artist
Mexico

My parents always collected art at home in Mexico. My art education started with the catalogues of auction houses like Christie's and Sotheby's. I studied them like crazy. As I got older, I realized I wanted to be an artist. I started out studying photography in Paris.

I started to visit New York when I was about three years old. I had wanted to live here for a long time. Then, around the year 2000, I had the opportunity to have a couple of my paintings in a group show here. I came to hang the paintings and never left.

In 2008, when the global economy collapsed, the owner of a gallery that represented me here took me out to lunch and said, "Listen, this is going to get really, really bad. It is going to get much worse than you think." At that time, the gallery provided me with studio space. So he said, "Rent yourself a studio, lock yourself up for the next three years. Just get to work, get to work and paint as much as you can."

After a couple of years, I made a wish list of the people I wanted to paint, and without any sort of connections, I wrote letters to them. Surprisingly, some of them answered me. Charlotte Rampling emailed me back herself and said, "I loved your paintings, they look wonderful. Can you come for breakfast next Thursday at my apartment in Paris? Here is my address." I was at Art Basel Miami and I hopped on the next plane to Paris and knocked on her door. It was crazy. But I lost the fear of painting after fifteen years of doing photography.

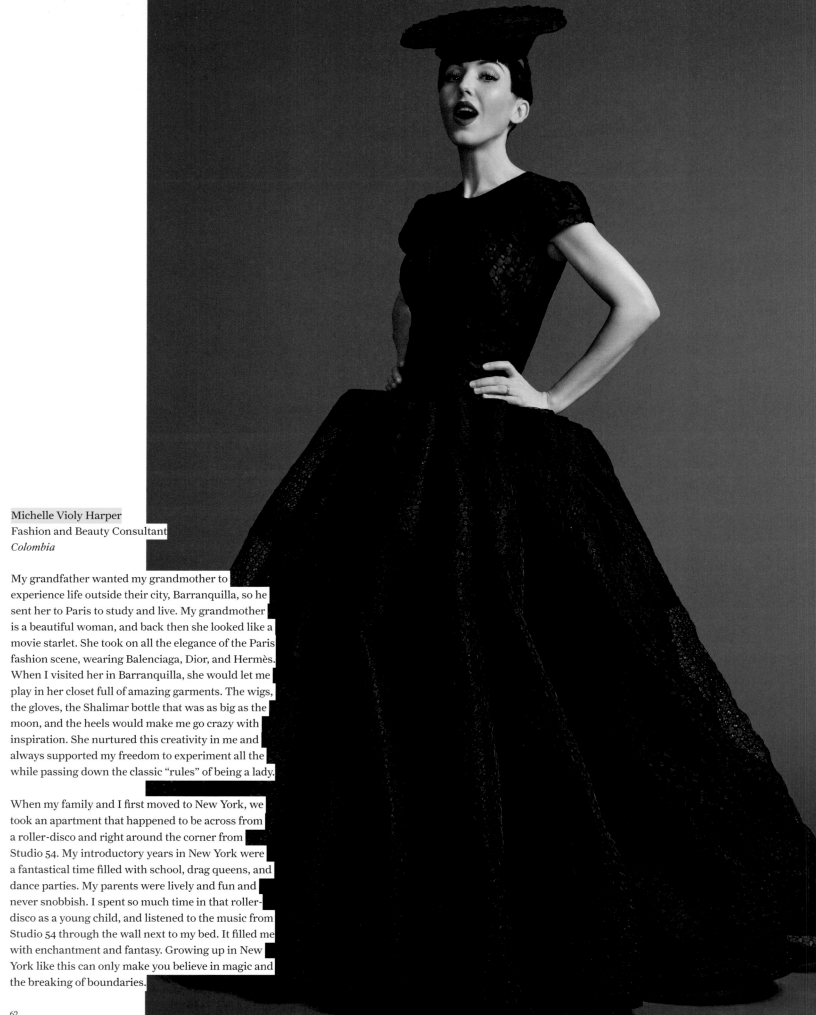

Michelle Violy Harper
Fashion and Beauty Consultant
Colombia

My grandfather wanted my grandmother to experience life outside their city, Barranquilla, so he sent her to Paris to study and live. My grandmother is a beautiful woman, and back then she looked like a movie starlet. She took on all the elegance of the Paris fashion scene, wearing Balenciaga, Dior, and Hermès. When I visited her in Barranquilla, she would let me play in her closet full of amazing garments. The wigs, the gloves, the Shalimar bottle that was as big as the moon, and the heels would make me go crazy with inspiration. She nurtured this creativity in me and always supported my freedom to experiment all the while passing down the classic "rules" of being a lady.

When my family and I first moved to New York, we took an apartment that happened to be across from a roller-disco and right around the corner from Studio 54. My introductory years in New York were a fantastical time filled with school, drag queens, and dance parties. My parents were lively and fun and never snobbish. I spent so much time in that roller-disco as a young child, and listened to the music from Studio 54 through the wall next to my bed. It filled me with enchantment and fantasy. Growing up in New York like this can only make you believe in magic and the breaking of boundaries.

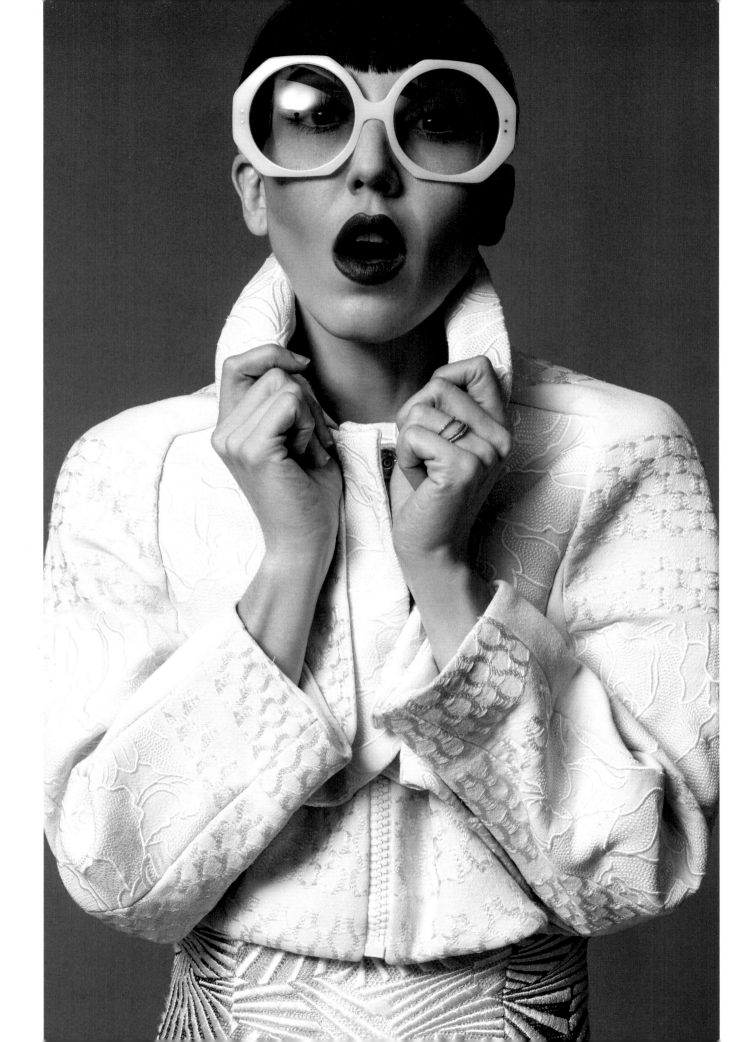

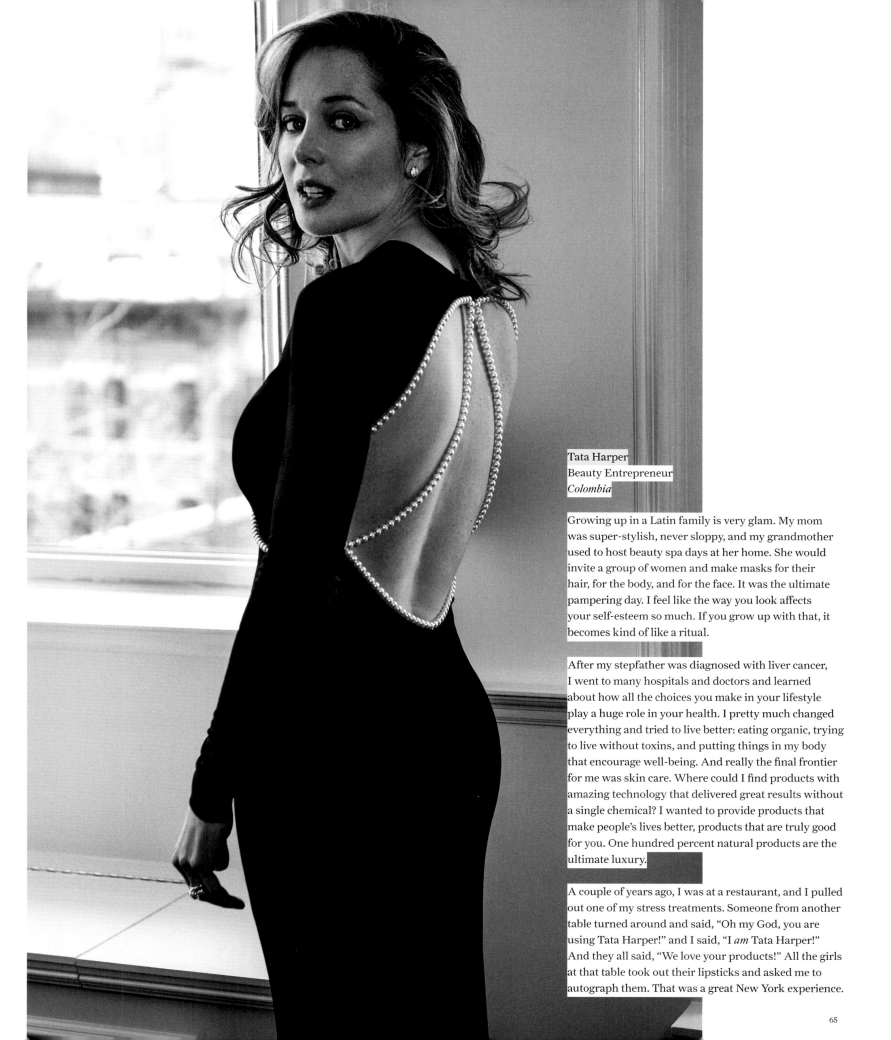

Tata Harper
Beauty Entrepreneur
Colombia

Growing up in a Latin family is very glam. My mom was super-stylish, never sloppy, and my grandmother used to host beauty spa days at her home. She would invite a group of women and make masks for their hair, for the body, and for the face. It was the ultimate pampering day. I feel like the way you look affects your self-esteem so much. If you grow up with that, it becomes kind of like a ritual.

After my stepfather was diagnosed with liver cancer, I went to many hospitals and doctors and learned about how all the choices you make in your lifestyle play a huge role in your health. I pretty much changed everything and tried to live better: eating organic, trying to live without toxins, and putting things in my body that encourage well-being. And really the final frontier for me was skin care. Where could I find products with amazing technology that delivered great results without a single chemical? I wanted to provide products that make people's lives better, products that are truly good for you. One hundred percent natural products are the ultimate luxury.

A couple of years ago, I was at a restaurant, and I pulled out one of my stress treatments. Someone from another table turned around and said, "Oh my God, you are using Tata Harper!" and I said, "I *am* Tata Harper!" And they all said, "We love your products!" All the girls at that table took out their lipsticks and asked me to autograph them. That was a great New York experience.

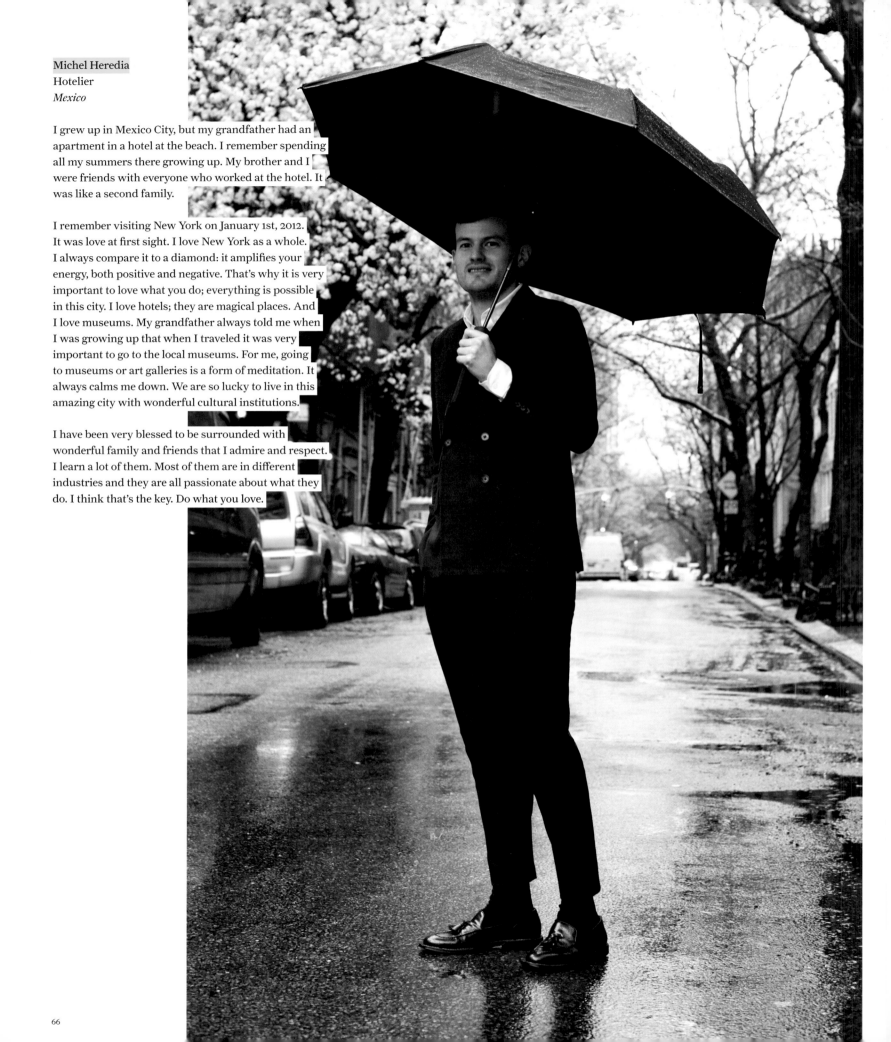

Michel Heredia
Hotelier
Mexico

I grew up in Mexico City, but my grandfather had an apartment in a hotel at the beach. I remember spending all my summers there growing up. My brother and I were friends with everyone who worked at the hotel. It was like a second family.

I remember visiting New York on January 1st, 2012. It was love at first sight. I love New York as a whole. I always compare it to a diamond: it amplifies your energy, both positive and negative. That's why it is very important to love what you do; everything is possible in this city. I love hotels; they are magical places. And I love museums. My grandfather always told me when I was growing up that when I traveled it was very important to go to the local museums. For me, going to museums or art galleries is a form of meditation. It always calms me down. We are so lucky to live in this amazing city with wonderful cultural institutions.

I have been very blessed to be surrounded with wonderful family and friends that I admire and respect. I learn a lot of them. Most of them are in different industries and they are all passionate about what they do. I think that's the key. Do what you love.

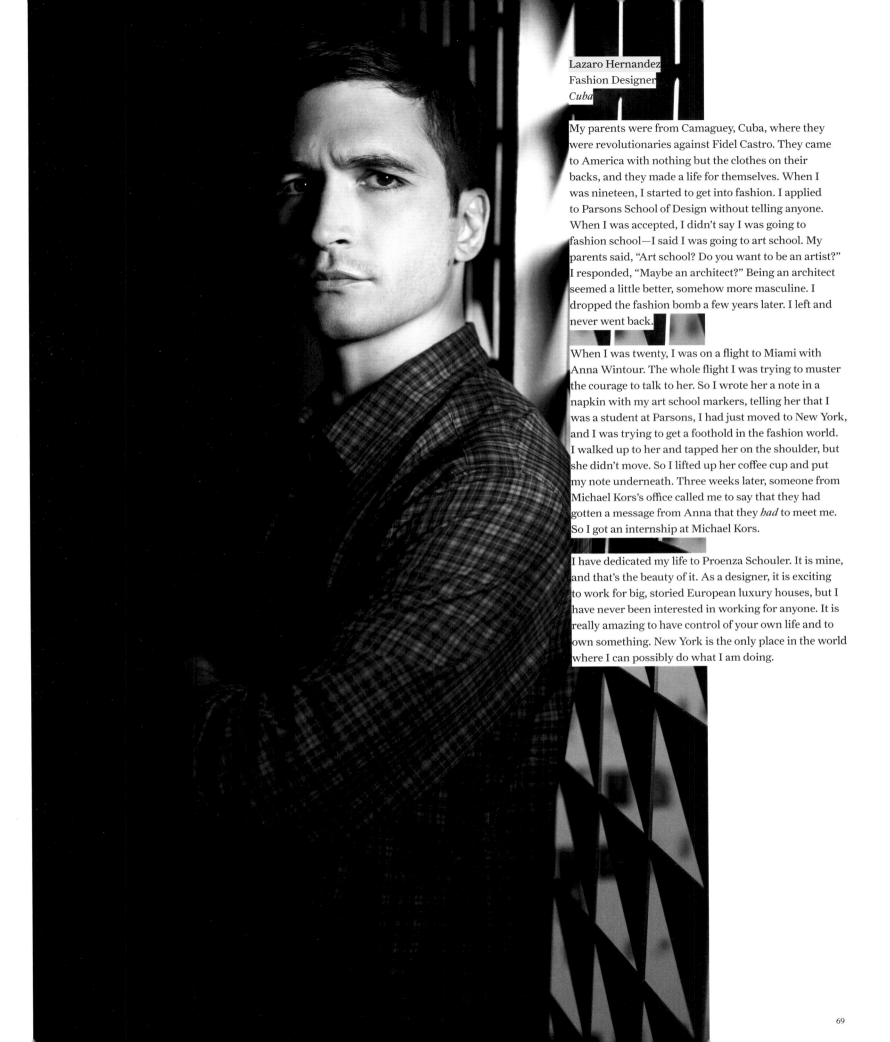

Lazaro Hernandez
Fashion Designer
Cuba

My parents were from Camaguey, Cuba, where they were revolutionaries against Fidel Castro. They came to America with nothing but the clothes on their backs, and they made a life for themselves. When I was nineteen, I started to get into fashion. I applied to Parsons School of Design without telling anyone. When I was accepted, I didn't say I was going to fashion school—I said I was going to art school. My parents said, "Art school? Do you want to be an artist?" I responded, "Maybe an architect?" Being an architect seemed a little better, somehow more masculine. I dropped the fashion bomb a few years later. I left and never went back.

When I was twenty, I was on a flight to Miami with Anna Wintour. The whole flight I was trying to muster the courage to talk to her. So I wrote her a note in a napkin with my art school markers, telling her that I was a student at Parsons, I had just moved to New York, and I was trying to get a foothold in the fashion world. I walked up to her and tapped her on the shoulder, but she didn't move. So I lifted up her coffee cup and put my note underneath. Three weeks later, someone from Michael Kors's office called me to say that they had gotten a message from Anna that they *had* to meet me. So I got an internship at Michael Kors.

I have dedicated my life to Proenza Schouler. It is mine, and that's the beauty of it. As a designer, it is exciting to work for big, storied European luxury houses, but I have never been interested in working for anyone. It is really amazing to have control of your own life and to own something. New York is the only place in the world where I can possibly do what I am doing.

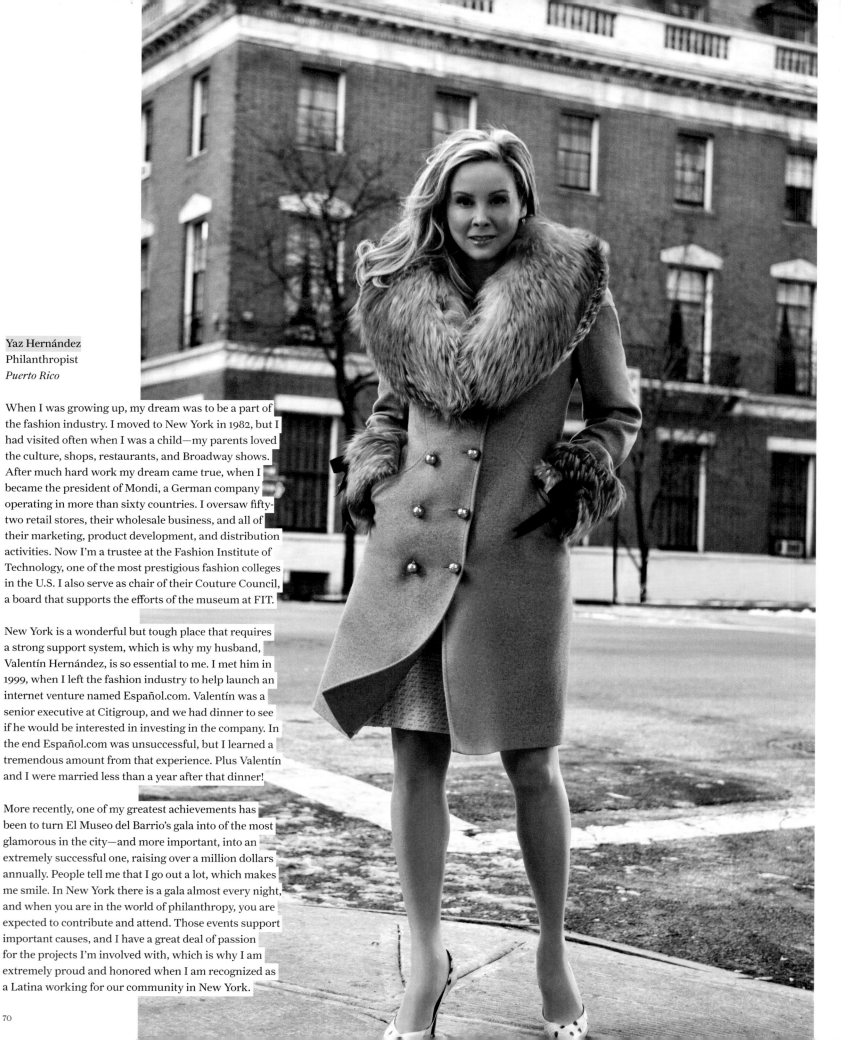

Yaz Hernández
Philanthropist
Puerto Rico

When I was growing up, my dream was to be a part of the fashion industry. I moved to New York in 1982, but I had visited often when I was a child—my parents loved the culture, shops, restaurants, and Broadway shows. After much hard work my dream came true, when I became the president of Mondi, a German company operating in more than sixty countries. I oversaw fifty-two retail stores, their wholesale business, and all of their marketing, product development, and distribution activities. Now I'm a trustee at the Fashion Institute of Technology, one of the most prestigious fashion colleges in the U.S. I also serve as chair of their Couture Council, a board that supports the efforts of the museum at FIT.

New York is a wonderful but tough place that requires a strong support system, which is why my husband, Valentín Hernández, is so essential to me. I met him in 1999, when I left the fashion industry to help launch an internet venture named Español.com. Valentín was a senior executive at Citigroup, and we had dinner to see if he would be interested in investing in the company. In the end Español.com was unsuccessful, but I learned a tremendous amount from that experience. Plus Valentín and I were married less than a year after that dinner!

More recently, one of my greatest achievements has been to turn El Museo del Barrio's gala into of the most glamorous in the city—and more important, into an extremely successful one, raising over a million dollars annually. People tell me that I go out a lot, which makes me smile. In New York there is a gala almost every night, and when you are in the world of philanthropy, you are expected to contribute and attend. Those events support important causes, and I have a great deal of passion for the projects I'm involved with, which is why I am extremely proud and honored when I am recognized as a Latina working for our community in New York.

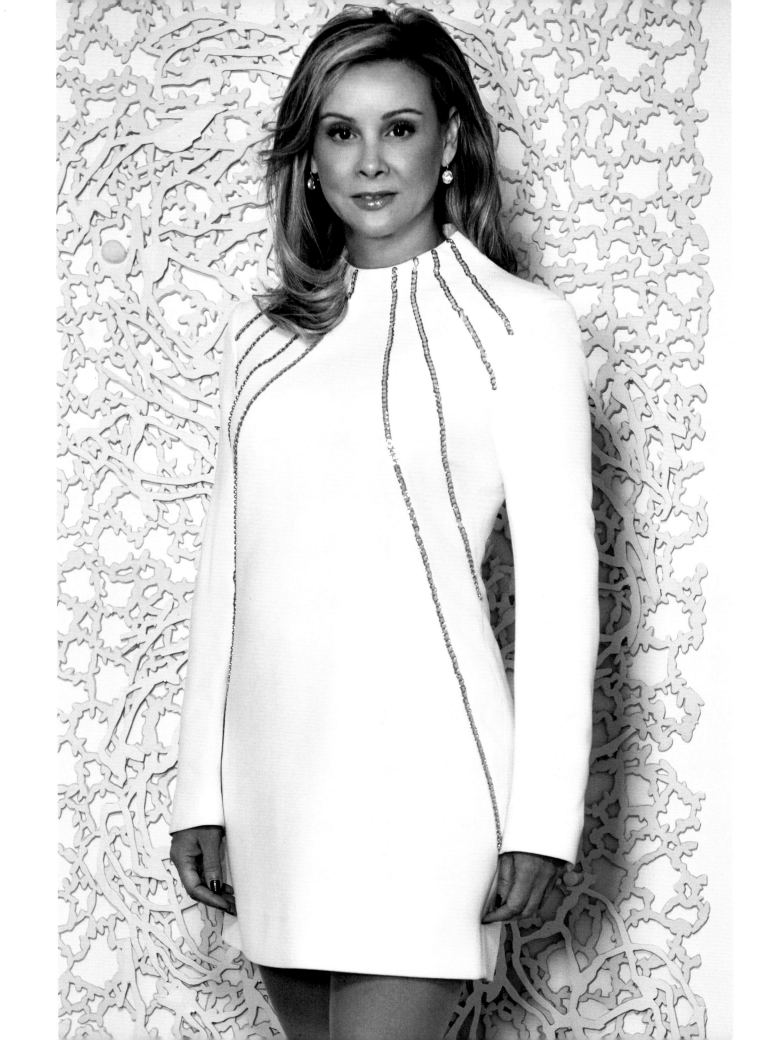

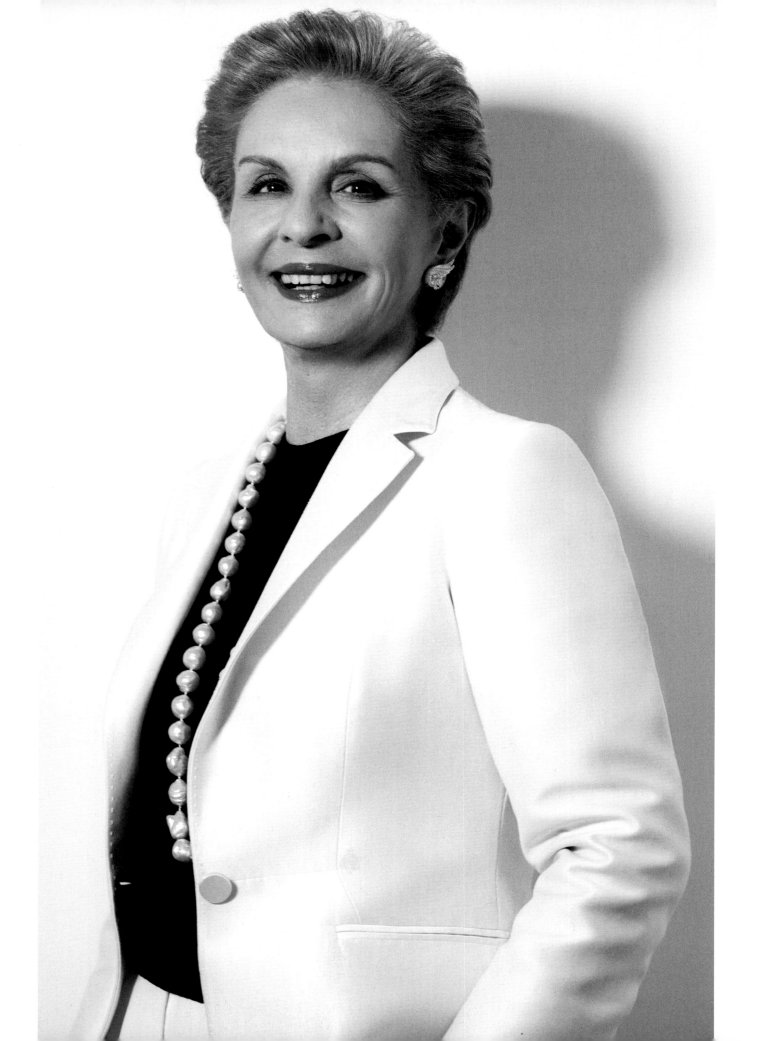

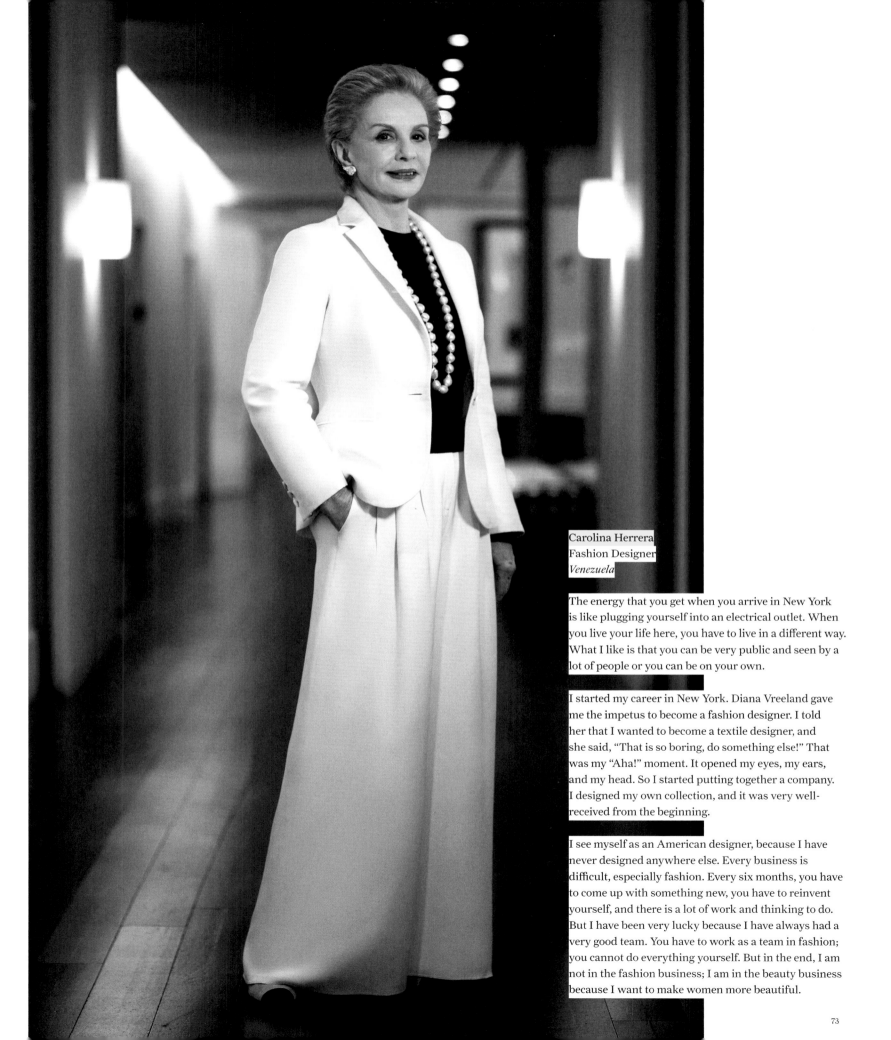

Carolina Herrera
Fashion Designer
Venezuela

The energy that you get when you arrive in New York is like plugging yourself into an electrical outlet. When you live your life here, you have to live in a different way. What I like is that you can be very public and seen by a lot of people or you can be on your own.

I started my career in New York. Diana Vreeland gave me the impetus to become a fashion designer. I told her that I wanted to become a textile designer, and she said, "That is so boring, do something else!" That was my "Aha!" moment. It opened my eyes, my ears, and my head. So I started putting together a company. I designed my own collection, and it was very well-received from the beginning.

I see myself as an American designer, because I have never designed anywhere else. Every business is difficult, especially fashion. Every six months, you have to come up with something new, you have to reinvent yourself, and there is a lot of work and thinking to do. But I have been very lucky because I have always had a very good team. You have to work as a team in fashion; you cannot do everything yourself. But in the end, I am not in the fashion business; I am in the beauty business because I want to make women more beautiful.

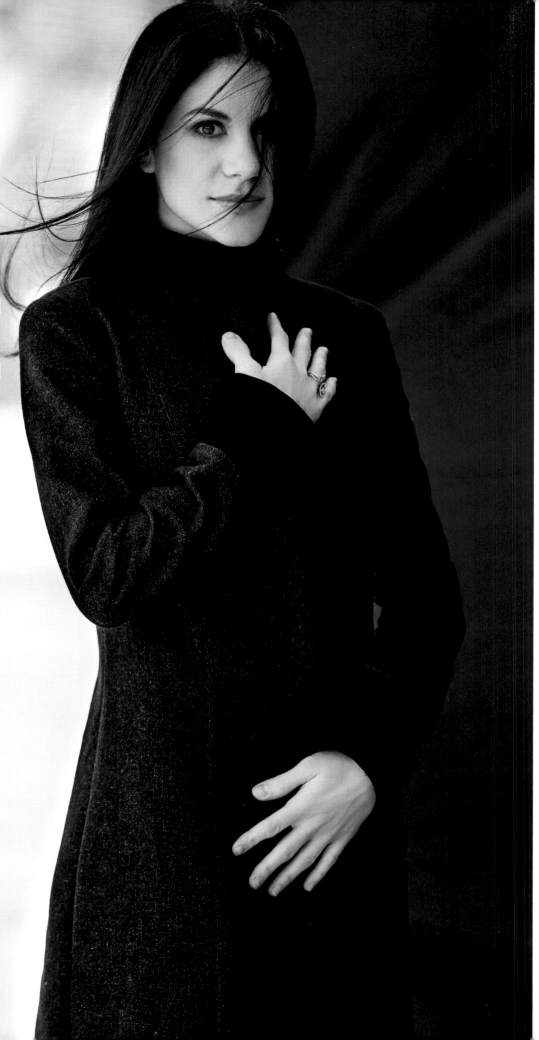

Paloma Herrera
Ballet Dancer
Argentina

I started taking ballet when I was seven. I told my mom that I wanted to dance, and first she took me to improvisation class. I said, "Mom I love this! But I want pointe shoes." My parents loved classical music and all the arts, but they didn't have much interest in ballet. But they took me to a very good teacher. I loved ballet from the very first day that I took a class. People asked me what I wanted to be when I grew up, and I would always say, "A dancer!" There was no question in my mind. I couldn't imagine doing anything else.

I was fifteen when I first came to New York, and I didn't speak any English at all. But I was lucky because in the dance world you don't have to speak any language; you express yourself with the body. I auditioned for the American Ballet Theater and I got chosen. That was one of those moments in your life when everything changes.

I always live day by day. I am here today; I have no idea what will happen tomorrow. So I always live one hundred percent, like it is my last day. New York is so fulfilling with all the art forms that are here. The city has filled my soul and given me everything. But at the same time, I have my family, and I love Argentina and my friends, so I am split in half.

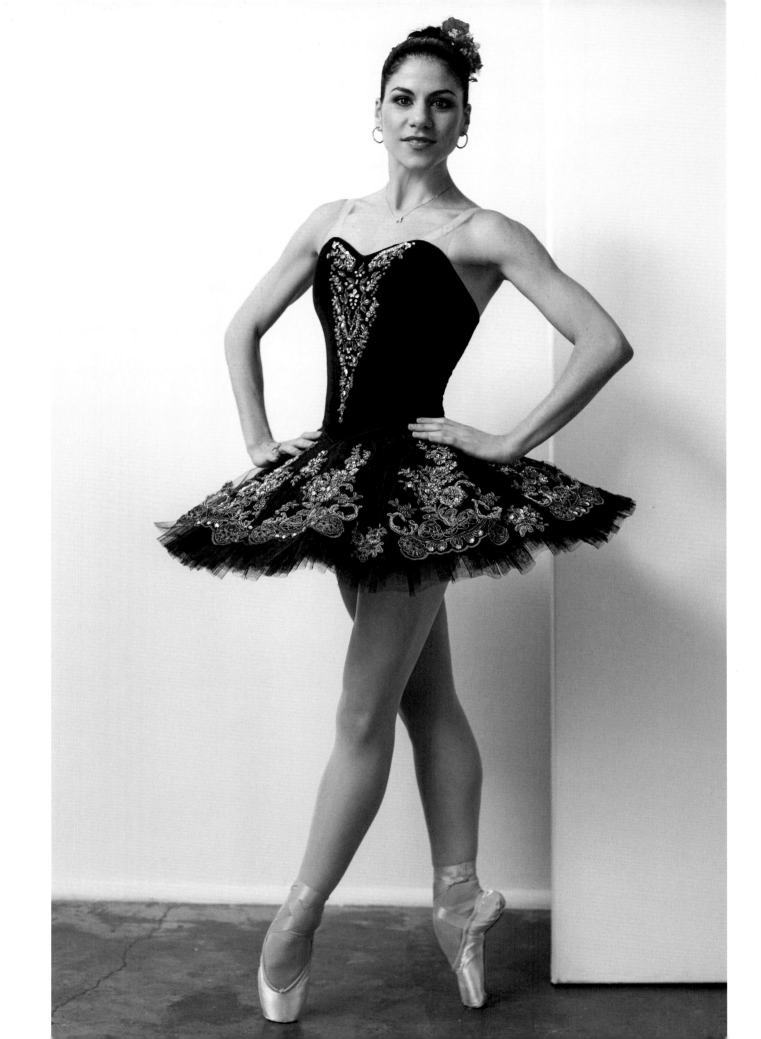

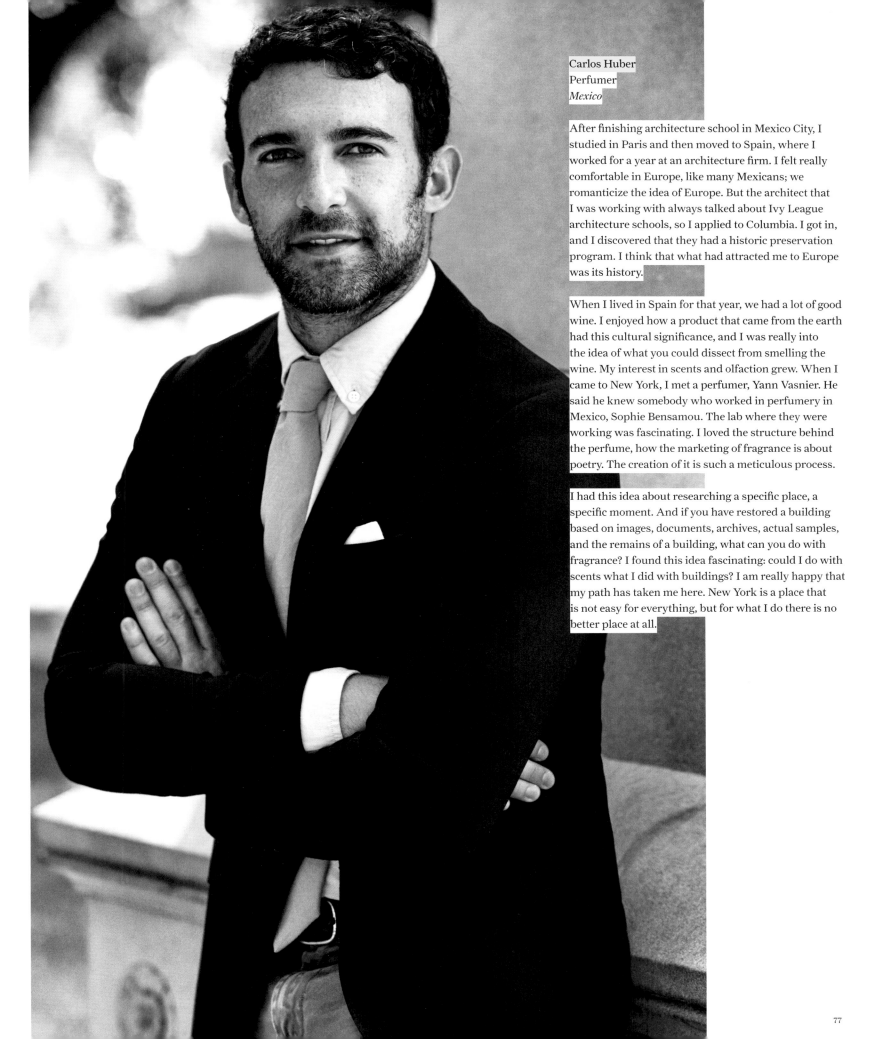

Carlos Huber
Perfumer
Mexico

After finishing architecture school in Mexico City, I studied in Paris and then moved to Spain, where I worked for a year at an architecture firm. I felt really comfortable in Europe, like many Mexicans; we romanticize the idea of Europe. But the architect that I was working with always talked about Ivy League architecture schools, so I applied to Columbia. I got in, and I discovered that they had a historic preservation program. I think that what had attracted me to Europe was its history.

When I lived in Spain for that year, we had a lot of good wine. I enjoyed how a product that came from the earth had this cultural significance, and I was really into the idea of what you could dissect from smelling the wine. My interest in scents and olfaction grew. When I came to New York, I met a perfumer, Yann Vasnier. He said he knew somebody who worked in perfumery in Mexico, Sophie Bensamou. The lab where they were working was fascinating. I loved the structure behind the perfume, how the marketing of fragrance is about poetry. The creation of it is such a meticulous process.

I had this idea about researching a specific place, a specific moment. And if you have restored a building based on images, documents, archives, actual samples, and the remains of a building, what can you do with fragrance? I found this idea fascinating: could I do with scents what I did with buildings? I am really happy that my path has taken me here. New York is a place that is not easy for everything, but for what I do there is no better place at all.

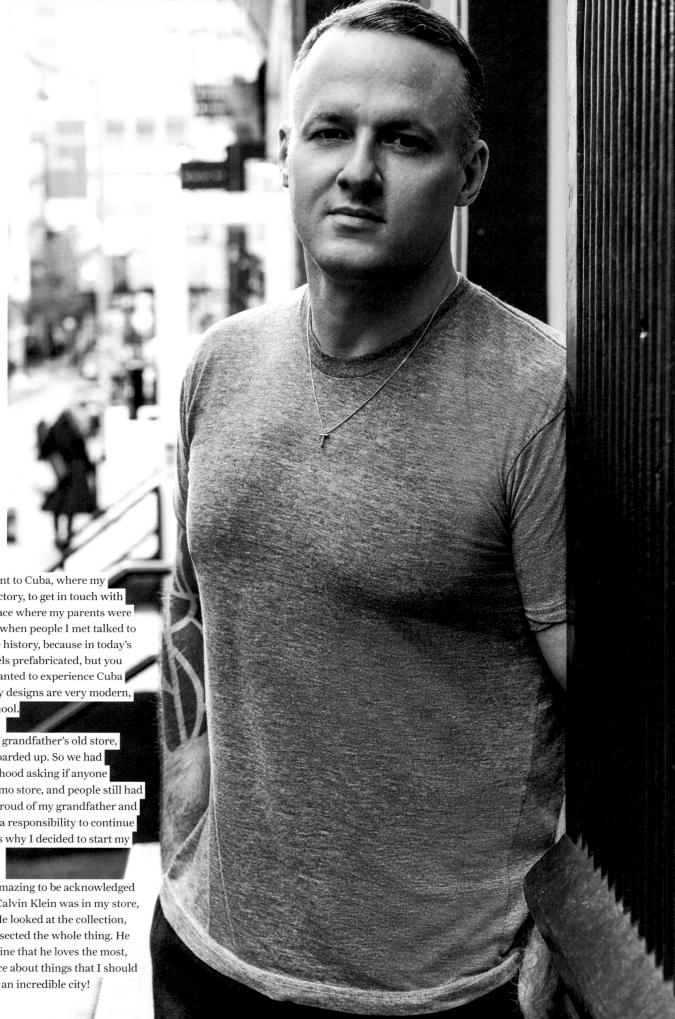

Alejandro Ingelmo
Shoe Designer
Cuba

A couple of years ago I went to Cuba, where my
grandfather had a shoe factory, to get in touch with
my roots and to see the place where my parents were
from. It was very magical when people I met talked to
me about my family. I love history, because in today's
world everything often feels prefabricated, but you
can't make up history. I wanted to experience Cuba
firsthand. Even though my designs are very modern,
my values are very old school.

We were trying to find my grandfather's old store,
but the building was all boarded up. So we had
to go around the neighborhood asking if anyone
remembered the old Ingelmo store, and people still had
stories about it. I'm very proud of my grandfather and
have always felt like I had a responsibility to continue
the family business. That's why I decided to start my
own shoe label.

I love what I do, and it is amazing to be acknowledged
in the business. One day, Calvin Klein was in my store,
and I introduced myself. He looked at the collection,
and in five minutes, he dissected the whole thing. He
talked about the shoe of mine that he loves the most,
and he gave me great advice about things that I should
be looking at. New York is an incredible city!

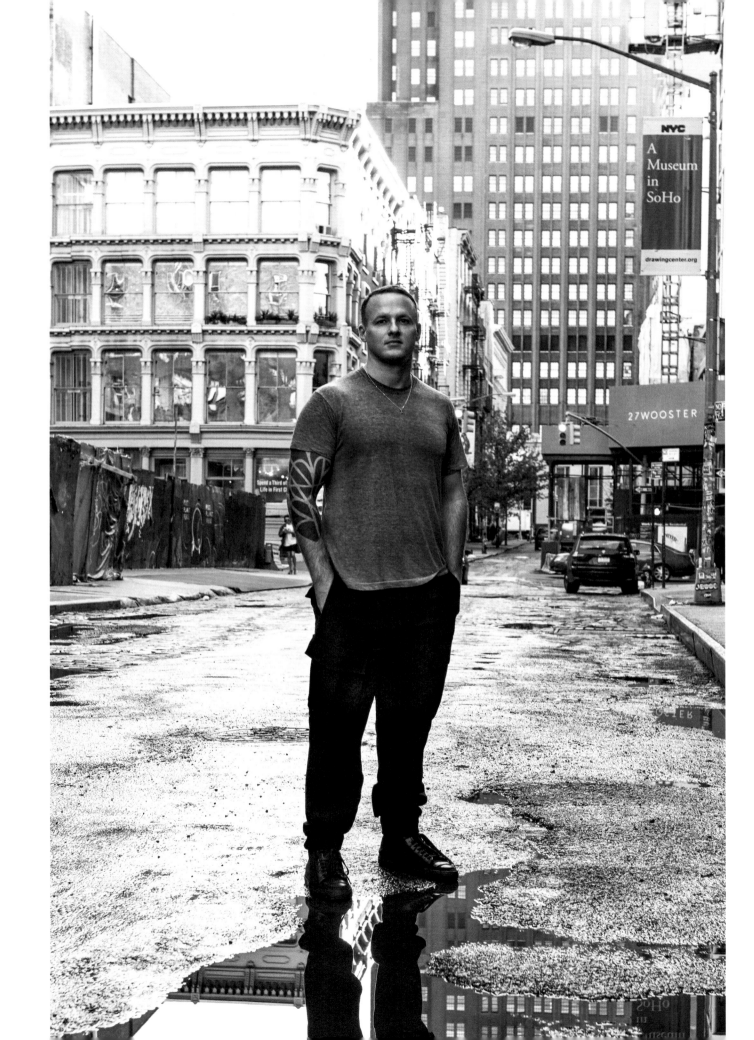

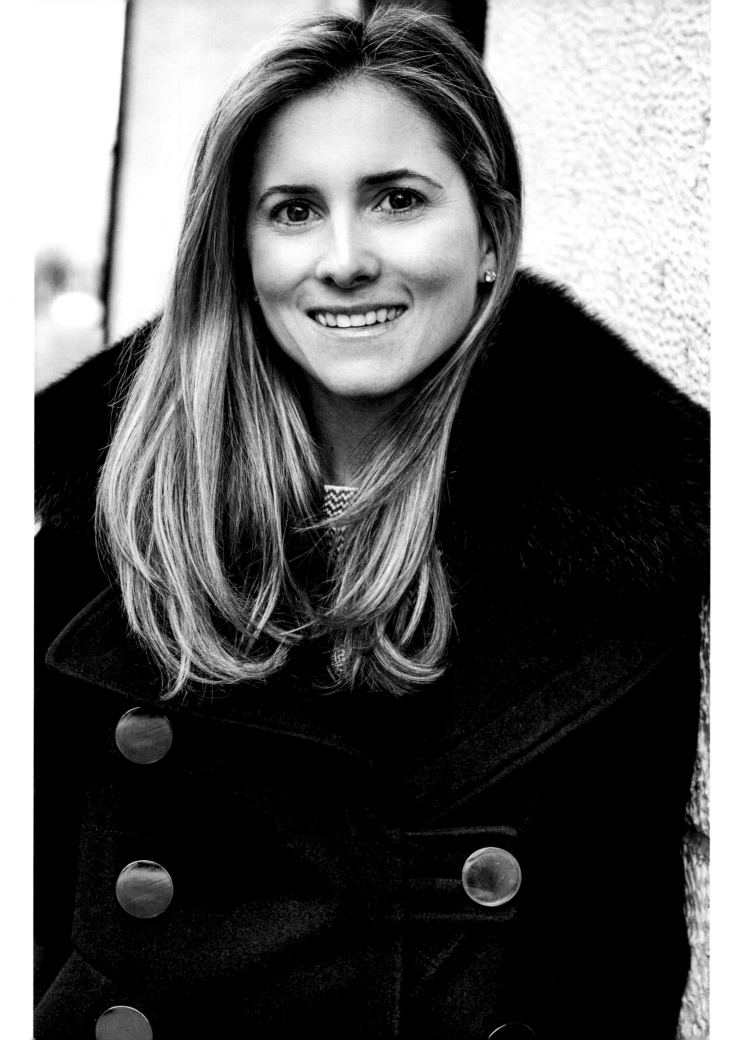

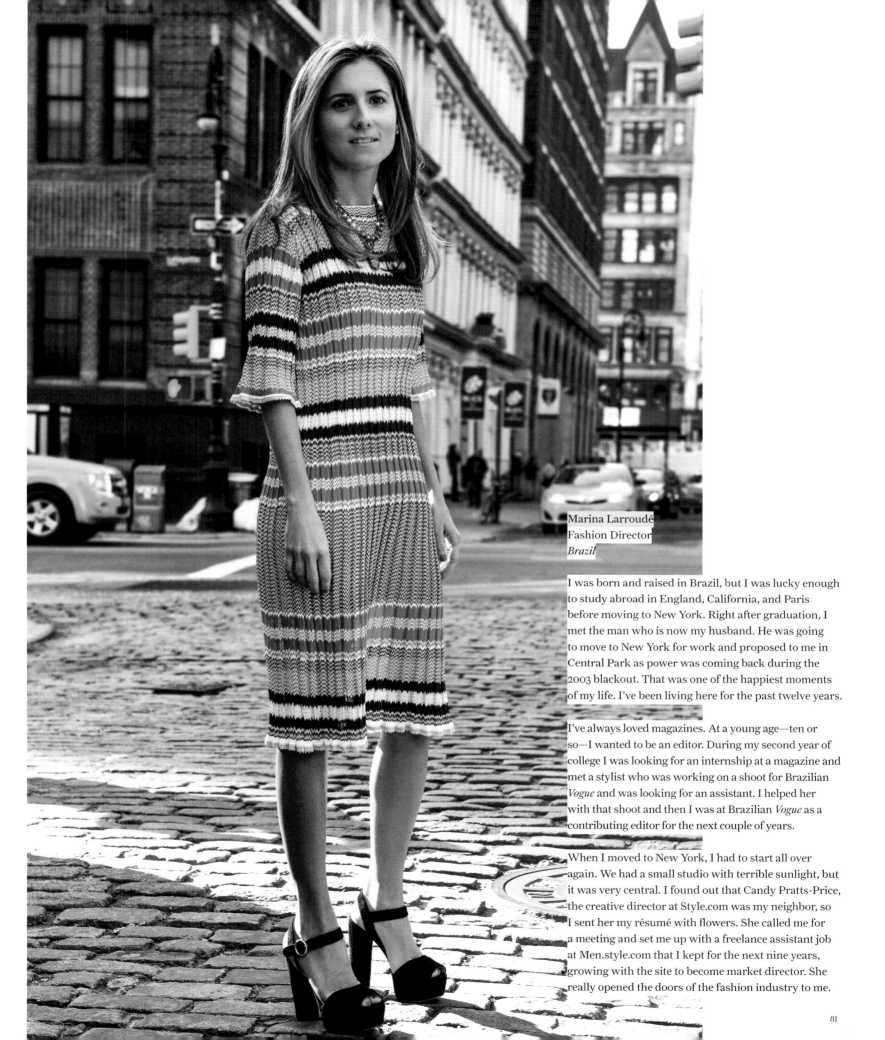

Marina Larroudé
Fashion Director
Brazil

I was born and raised in Brazil, but I was lucky enough to study abroad in England, California, and Paris before moving to New York. Right after graduation, I met the man who is now my husband. He was going to move to New York for work and proposed to me in Central Park as power was coming back during the 2003 blackout. That was one of the happiest moments of my life. I've been living here for the past twelve years.

I've always loved magazines. At a young age—ten or so—I wanted to be an editor. During my second year of college I was looking for an internship at a magazine and met a stylist who was working on a shoot for Brazilian *Vogue* and was looking for an assistant. I helped her with that shoot and then I was at Brazilian *Vogue* as a contributing editor for the next couple of years.

When I moved to New York, I had to start all over again. We had a small studio with terrible sunlight, but it was very central. I found out that Candy Pratts-Price, the creative director at Style.com was my neighbor, so I sent her my résumé with flowers. She called me for a meeting and set me up with a freelance assistant job at Men.style.com that I kept for the next nine years, growing with the site to become market director. She really opened the doors of the fashion industry to me.

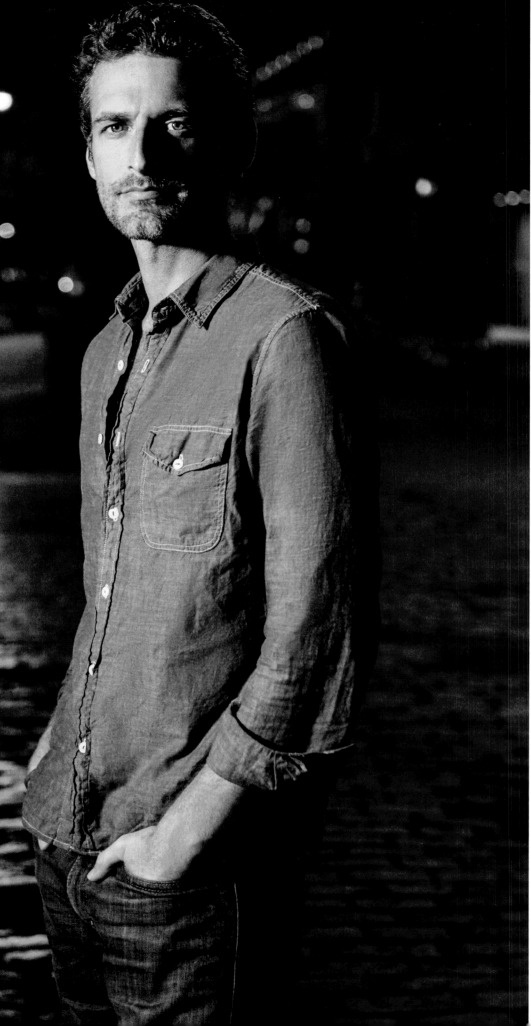

Alexi Lubomirski
Fashion Photographer
Peru

I took a year off between high school and college to discover my roots. My father is Polish-French, and my mother is Peruvian-English. I spent three or four months in Peru. It was a bizarre experience; I was brought up in Botswana, so I felt completely out of place in Peru. During my first week there, I started meeting all my relatives and started to piece together different elements of my personality. I have the English sense of humor, the French romance, the Latin passion, and the Polish fiery patriotism.

After university, I worked as an assistant for Mario Testino for four years. A month after my thirtieth birthday I moved to New York. My first place was on Mott Street. It was tiny, and I was sharing it with a friend. We didn't have a penny to our names, and we were there every night eating Chinese food, trying to figure out our next move. But soon enough my career turned into a gallop. You get one chance to prove yourself because there are a thousand people behind you. But once you do that, you get work day and night. I'm addicted to the creative energy here.

I'm the luckiest guy on the planet. Every day I wake up excited. I get to play and solve creative puzzles. Growing up, I looked at my mother's fashion magazines, and I escaped into the magical storylines in incredible places. I was always drawn to the travel stories where they shot a model at the pyramids or Macchu Picchu, creating a fantasy with pictures. The best part of fashion photography is creating narratives. It's like playing dress-up. You get your best friends and some cool clothes and you make a story.

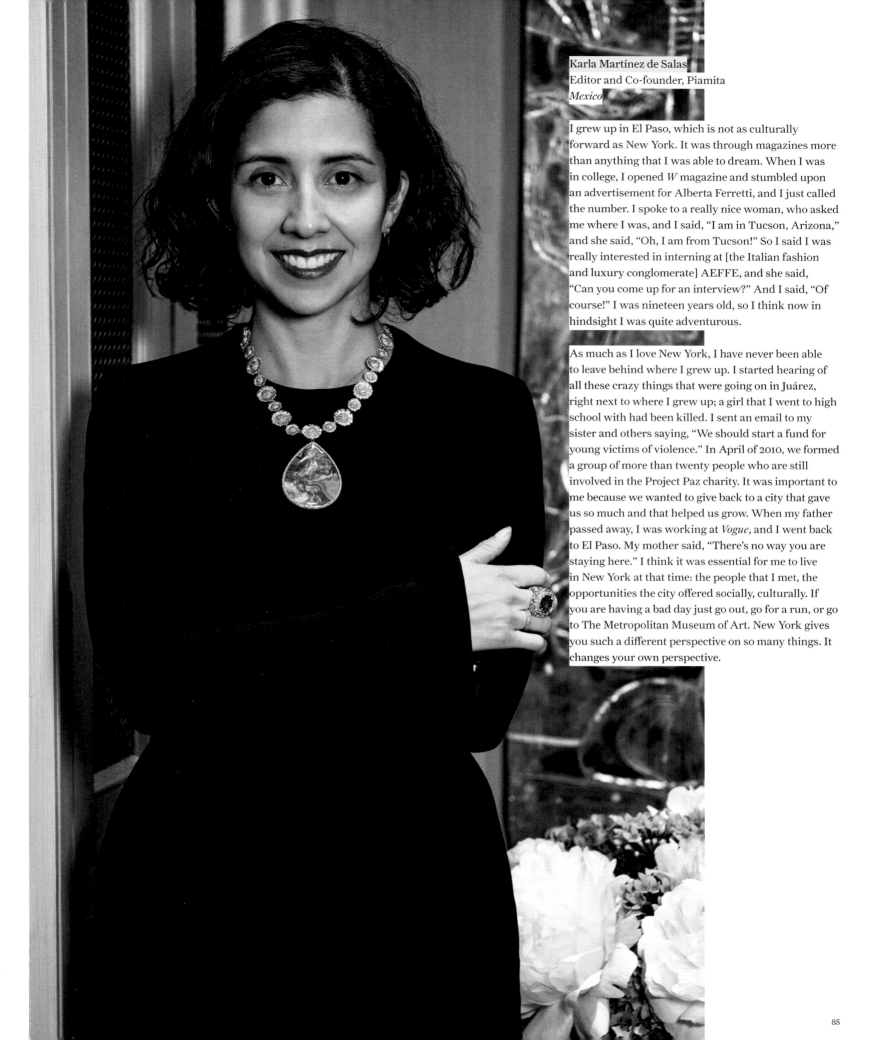

Karla Martínez de Salas
Editor and Co-founder, Piamita
Mexico

I grew up in El Paso, which is not as culturally forward as New York. It was through magazines more than anything that I was able to dream. When I was in college, I opened *W* magazine and stumbled upon an advertisement for Alberta Ferretti, and I just called the number. I spoke to a really nice woman, who asked me where I was, and I said, "I am in Tucson, Arizona," and she said, "Oh, I am from Tucson!" So I said I was really interested in interning at [the Italian fashion and luxury conglomerate] AEFFE, and she said, "Can you come up for an interview?" And I said, "Of course!" I was nineteen years old, so I think now in hindsight I was quite adventurous.

As much as I love New York, I have never been able to leave behind where I grew up. I started hearing of all these crazy things that were going on in Juárez, right next to where I grew up; a girl that I went to high school with had been killed. I sent an email to my sister and others saying, "We should start a fund for young victims of violence." In April of 2010, we formed a group of more than twenty people who are still involved in the Project Paz charity. It was important to me because we wanted to give back to a city that gave us so much and that helped us grow. When my father passed away, I was working at *Vogue*, and I went back to El Paso. My mother said, "There's no way you are staying here." I think it was essential for me to live in New York at that time: the people that I met, the opportunities the city offered socially, culturally. If you are having a bad day just go out, go for a run, or go to The Metropolitan Museum of Art. New York gives you such a different perspective on so many things. It changes your own perspective.

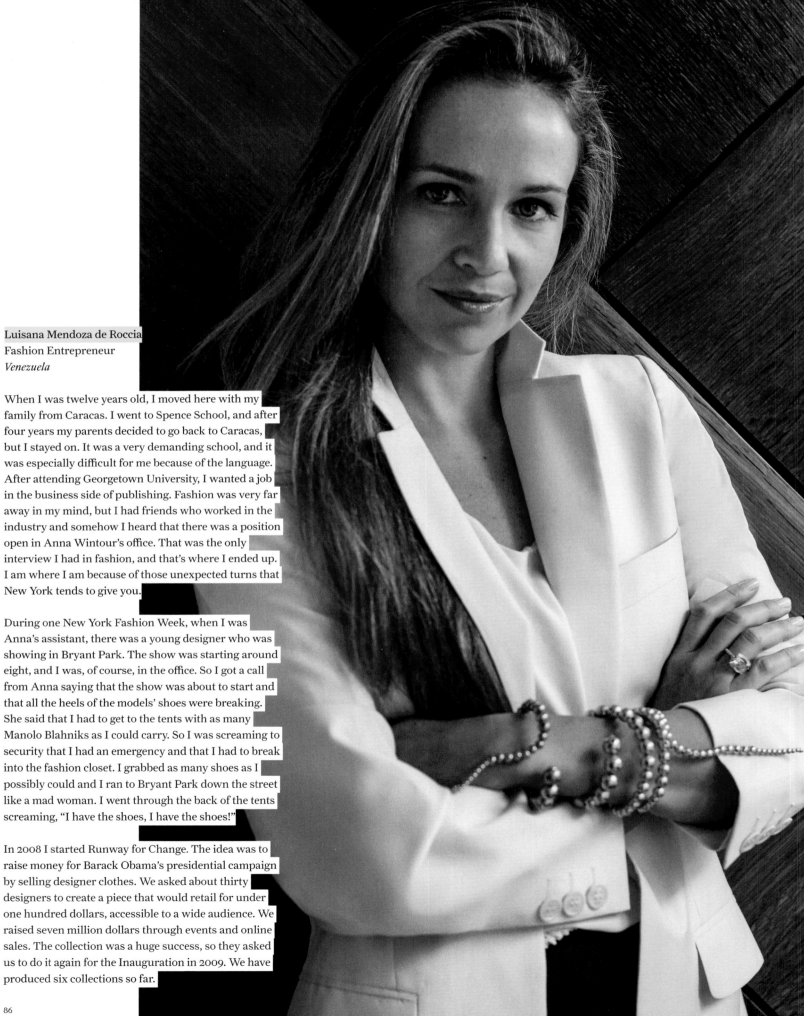

Luisana Mendoza de Roccia
Fashion Entrepreneur
Venezuela

When I was twelve years old, I moved here with my
family from Caracas. I went to Spence School, and after
four years my parents decided to go back to Caracas,
but I stayed on. It was a very demanding school, and it
was especially difficult for me because of the language.
After attending Georgetown University, I wanted a job
in the business side of publishing. Fashion was very far
away in my mind, but I had friends who worked in the
industry and somehow I heard that there was a position
open in Anna Wintour's office. That was the only
interview I had in fashion, and that's where I ended up.
I am where I am because of those unexpected turns that
New York tends to give you.

During one New York Fashion Week, when I was
Anna's assistant, there was a young designer who was
showing in Bryant Park. The show was starting around
eight, and I was, of course, in the office. So I got a call
from Anna saying that the show was about to start and
that all the heels of the models' shoes were breaking.
She said that I had to get to the tents with as many
Manolo Blahniks as I could carry. So I was screaming to
security that I had an emergency and that I had to break
into the fashion closet. I grabbed as many shoes as I
possibly could and I ran to Bryant Park down the street
like a mad woman. I went through the back of the tents
screaming, "I have the shoes, I have the shoes!"

In 2008 I started Runway for Change. The idea was to
raise money for Barack Obama's presidential campaign
by selling designer clothes. We asked about thirty
designers to create a piece that would retail for under
one hundred dollars, accessible to a wide audience. We
raised seven million dollars through events and online
sales. The collection was a huge success, so they asked
us to do it again for the Inauguration in 2009. We have
produced six collections so far.

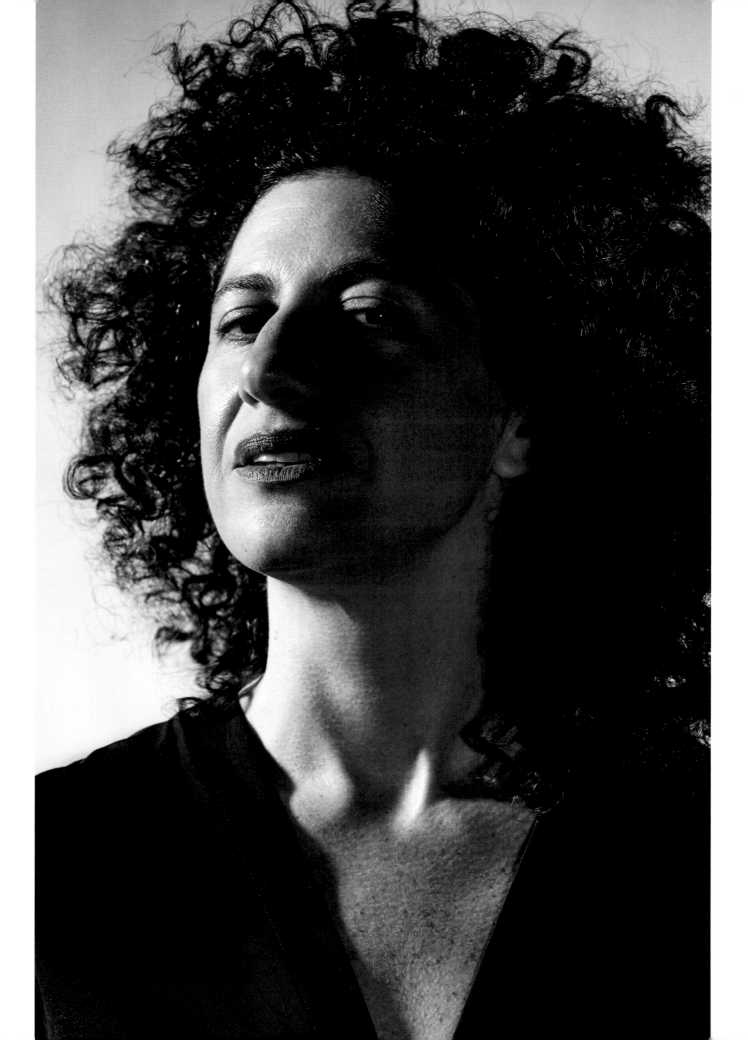

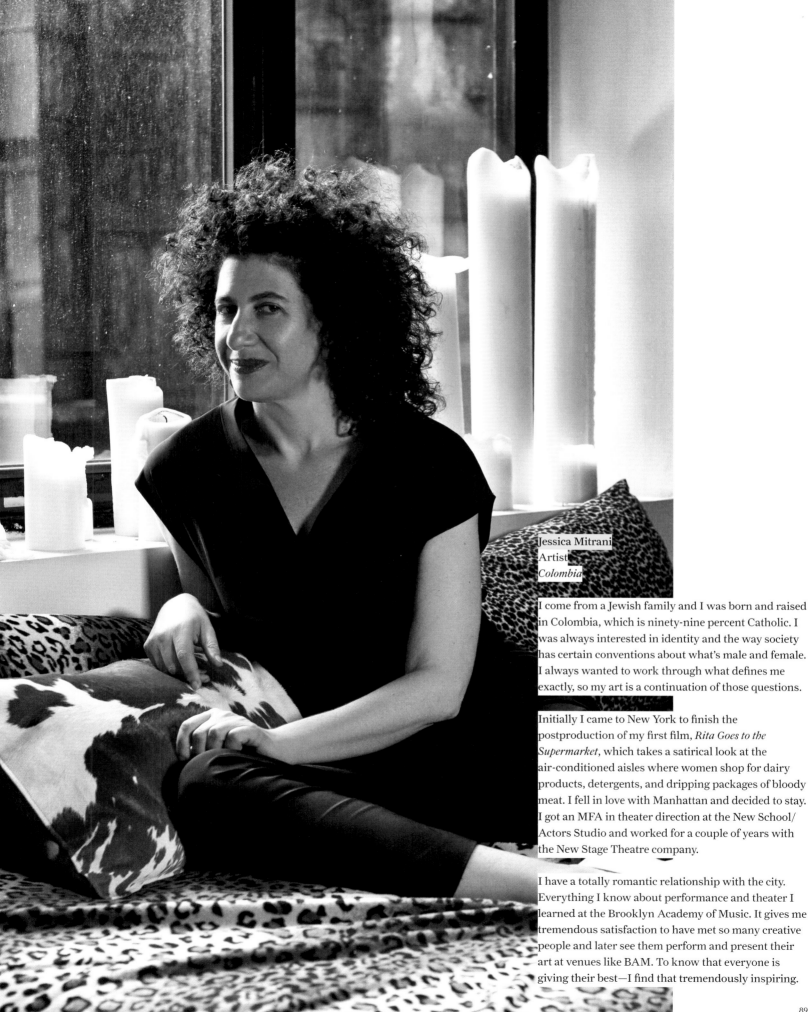

Jessica Mitrani
Artist
Colombia

I come from a Jewish family and I was born and raised in Colombia, which is ninety-nine percent Catholic. I was always interested in identity and the way society has certain conventions about what's male and female. I always wanted to work through what defines me exactly, so my art is a continuation of those questions.

Initially I came to New York to finish the postproduction of my first film, *Rita Goes to the Supermarket*, which takes a satirical look at the air-conditioned aisles where women shop for dairy products, detergents, and dripping packages of bloody meat. I fell in love with Manhattan and decided to stay. I got an MFA in theater direction at the New School/Actors Studio and worked for a couple of years with the New Stage Theatre company.

I have a totally romantic relationship with the city. Everything I know about performance and theater I learned at the Brooklyn Academy of Music. It gives me tremendous satisfaction to have met so many creative people and later see them perform and present their art at venues like BAM. To know that everyone is giving their best—I find that tremendously inspiring.

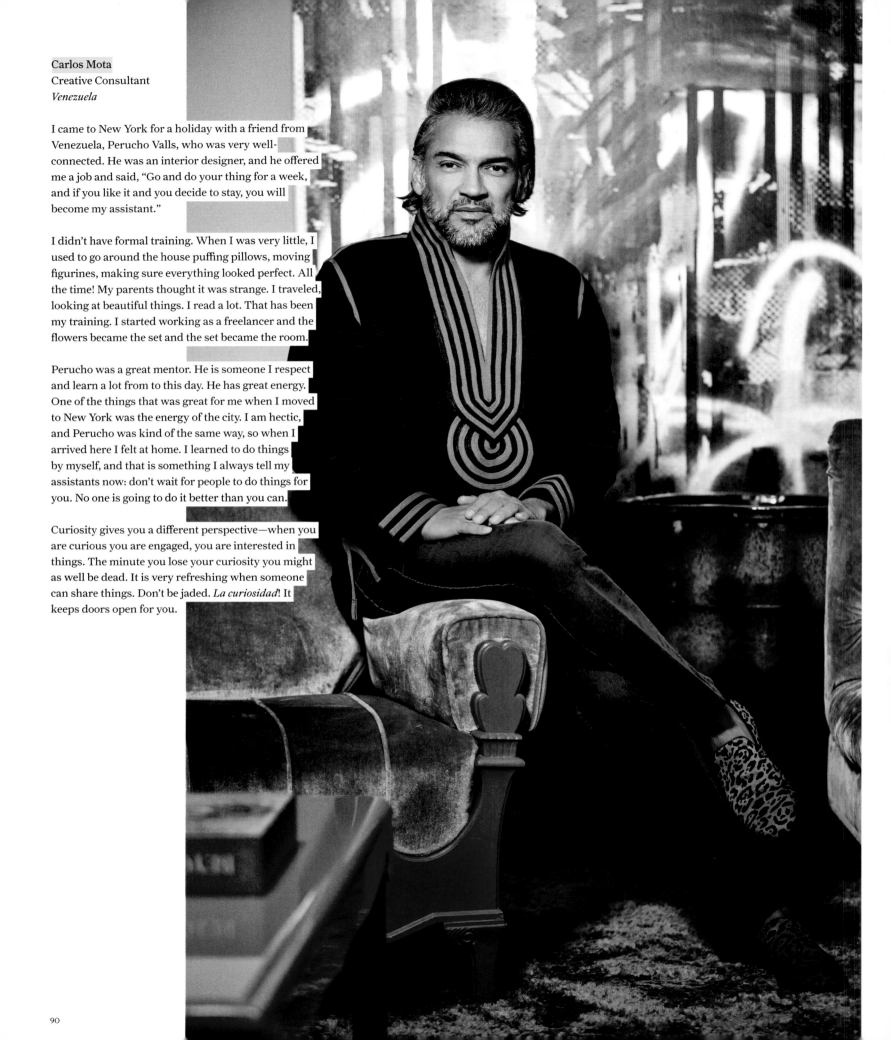

Carlos Mota
Creative Consultant
Venezuela

I came to New York for a holiday with a friend from Venezuela, Perucho Valls, who was very well-connected. He was an interior designer, and he offered me a job and said, "Go and do your thing for a week, and if you like it and you decide to stay, you will become my assistant."

I didn't have formal training. When I was very little, I used to go around the house puffing pillows, moving figurines, making sure everything looked perfect. All the time! My parents thought it was strange. I traveled, looking at beautiful things. I read a lot. That has been my training. I started working as a freelancer and the flowers became the set and the set became the room.

Perucho was a great mentor. He is someone I respect and learn a lot from to this day. He has great energy. One of the things that was great for me when I moved to New York was the energy of the city. I am hectic, and Perucho was kind of the same way, so when I arrived here I felt at home. I learned to do things by myself, and that is something I always tell my assistants now: don't wait for people to do things for you. No one is going to do it better than you can.

Curiosity gives you a different perspective—when you are curious you are engaged, you are interested in things. The minute you lose your curiosity you might as well be dead. It is very refreshing when someone can share things. Don't be jaded. *La curiosidad*! It keeps doors open for you.

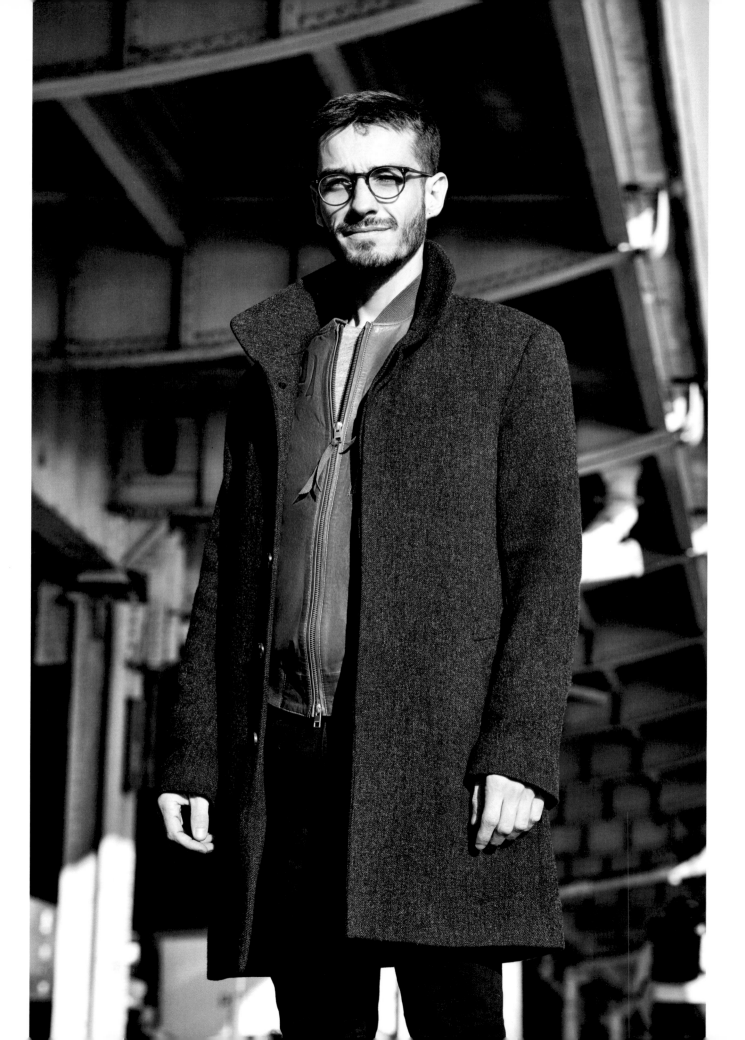

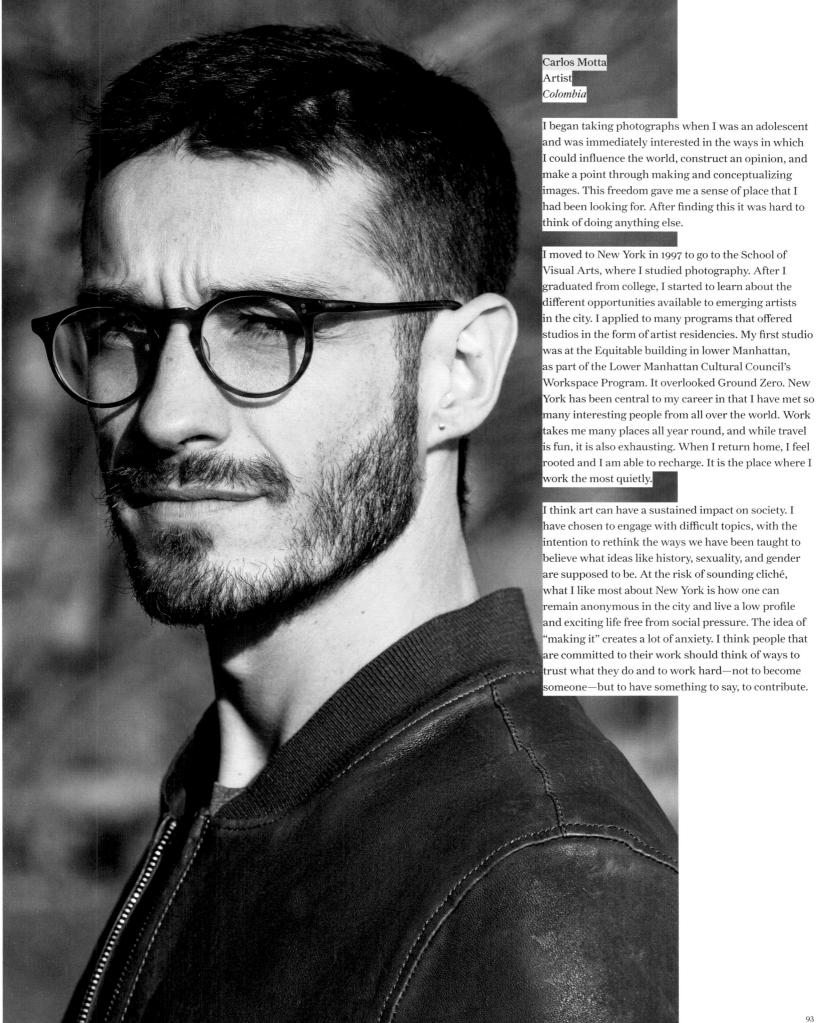

Carlos Motta
Artist
Colombia

I began taking photographs when I was an adolescent and was immediately interested in the ways in which I could influence the world, construct an opinion, and make a point through making and conceptualizing images. This freedom gave me a sense of place that I had been looking for. After finding this it was hard to think of doing anything else.

I moved to New York in 1997 to go to the School of Visual Arts, where I studied photography. After I graduated from college, I started to learn about the different opportunities available to emerging artists in the city. I applied to many programs that offered studios in the form of artist residencies. My first studio was at the Equitable building in lower Manhattan, as part of the Lower Manhattan Cultural Council's Workspace Program. It overlooked Ground Zero. New York has been central to my career in that I have met so many interesting people from all over the world. Work takes me many places all year round, and while travel is fun, it is also exhausting. When I return home, I feel rooted and I am able to recharge. It is the place where I work the most quietly.

I think art can have a sustained impact on society. I have chosen to engage with difficult topics, with the intention to rethink the ways we have been taught to believe what ideas like history, sexuality, and gender are supposed to be. At the risk of sounding cliché, what I like most about New York is how one can remain anonymous in the city and live a low profile and exciting life free from social pressure. The idea of "making it" creates a lot of anxiety. I think people that are committed to their work should think of ways to trust what they do and to work hard—not to become someone—but to have something to say, to contribute.

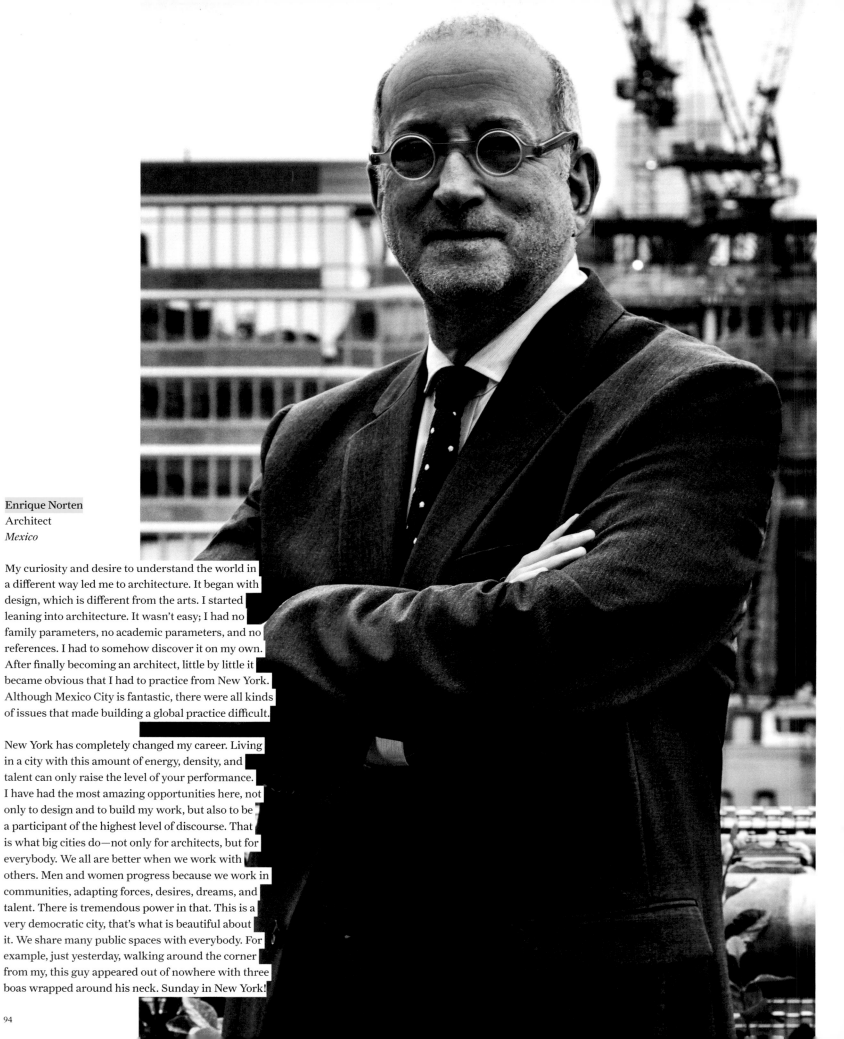

Enrique Norten
Architect
Mexico

My curiosity and desire to understand the world in a different way led me to architecture. It began with design, which is different from the arts. I started leaning into architecture. It wasn't easy; I had no family parameters, no academic parameters, and no references. I had to somehow discover it on my own. After finally becoming an architect, little by little it became obvious that I had to practice from New York. Although Mexico City is fantastic, there were all kinds of issues that made building a global practice difficult.

New York has completely changed my career. Living in a city with this amount of energy, density, and talent can only raise the level of your performance. I have had the most amazing opportunities here, not only to design and to build my work, but also to be a participant of the highest level of discourse. That is what big cities do—not only for architects, but for everybody. We all are better when we work with others. Men and women progress because we work in communities, adapting forces, desires, dreams, and talent. There is tremendous power in that. This is a very democratic city, that's what is beautiful about it. We share many public spaces with everybody. For example, just yesterday, walking around the corner from my, this guy appeared out of nowhere with three boas wrapped around his neck. Sunday in New York!

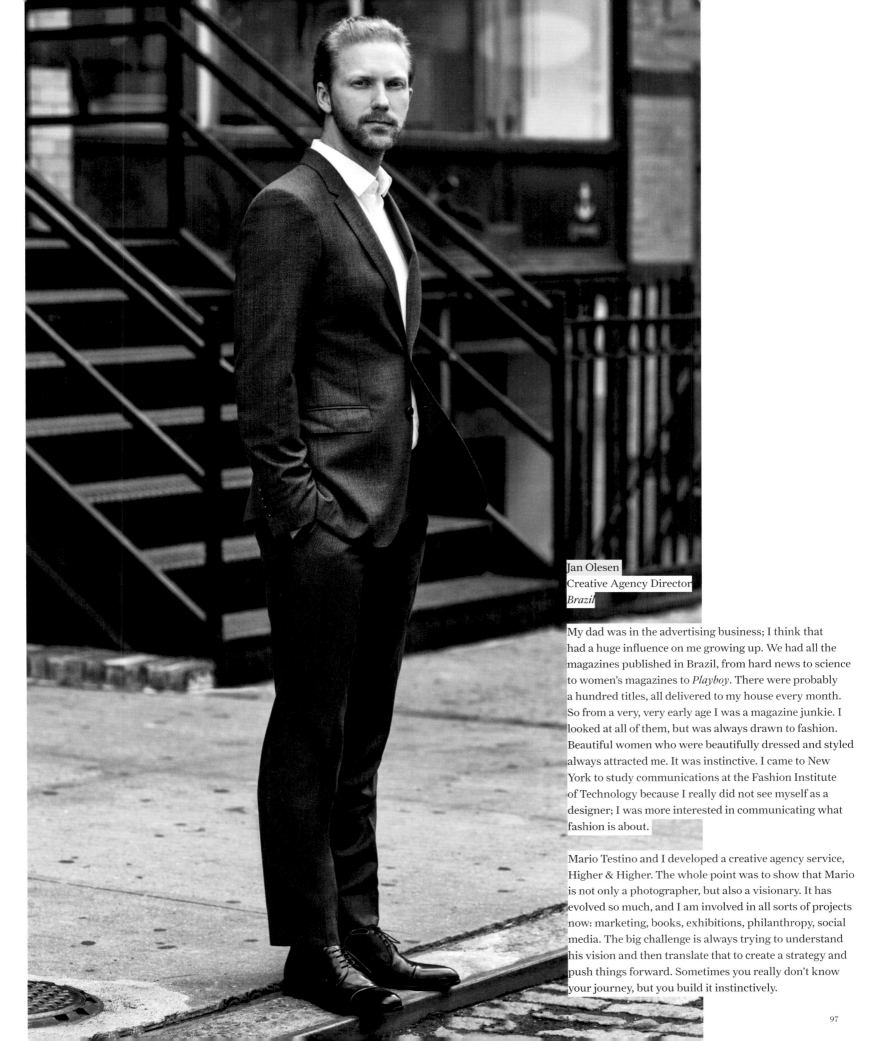

Jan Olesen
Creative Agency Director
Brazil

My dad was in the advertising business; I think that had a huge influence on me growing up. We had all the magazines published in Brazil, from hard news to science to women's magazines to *Playboy*. There were probably a hundred titles, all delivered to my house every month. So from a very, very early age I was a magazine junkie. I looked at all of them, but was always drawn to fashion. Beautiful women who were beautifully dressed and styled always attracted me. It was instinctive. I came to New York to study communications at the Fashion Institute of Technology because I really did not see myself as a designer; I was more interested in communicating what fashion is about.

Mario Testino and I developed a creative agency service, Higher & Higher. The whole point was to show that Mario is not only a photographer, but also a visionary. It has evolved so much, and I am involved in all sorts of projects now: marketing, books, exhibitions, philanthropy, social media. The big challenge is always trying to understand his vision and then translate that to create a strategy and push things forward. Sometimes you really don't know your journey, but you build it instinctively.

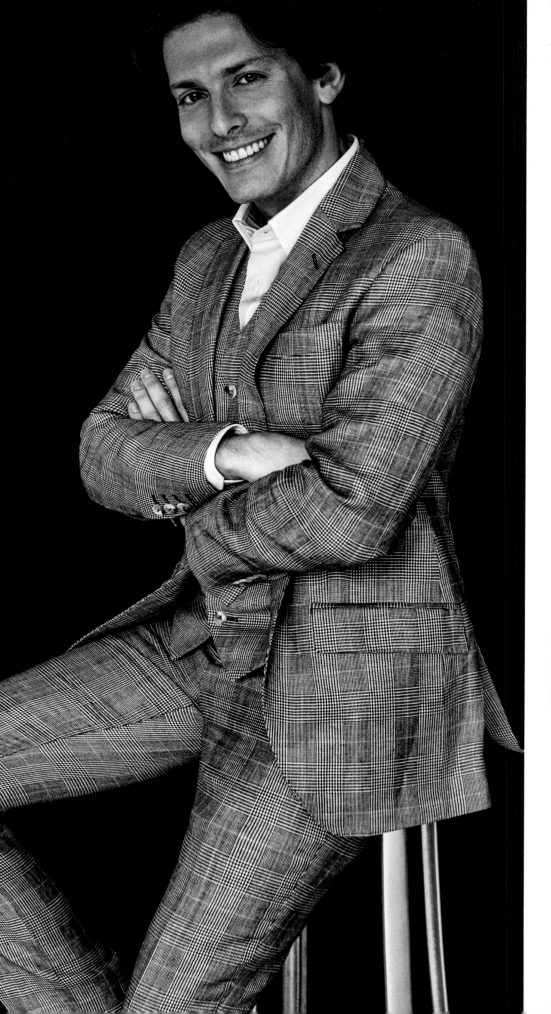

Edgardo Osorio
Shoe Designer
Colombia

My mom is an interior designer; she studied it, but she never practiced it professionally. I was always interested in beauty, fashion, design, and being creative. I was that little boy that, instead of being outside playing soccer, would stay inside with the girls reading *Vogue*. My mother had four sisters, and they did a lot of shopping. Women always surrounded me, and that has never really changed. It is a cultural thing: Latin women like to look sexy, dress up, and enjoy their femininity. They are like, "Bring on the color, bring on the fun!"

When I was nineteen, I dropped out of the University of London. I decided to move to Italy, where I got a job at Salvatore Ferragamo, and my career took off. I worked for six or seven years in Florence for Ferragamo and Roberto Cavalli. But then I moved to New York. I had grown up in the U.S., and I love the city. I thought that the kind of shoes that I wanted to make were perfect for American women.

In a department store in New York, I was looking at everything in the shoe department, and there was nothing that I liked. I realized that it was the right time for something new and exciting. So I started my own label, Aquazzura, here. I make really sexy but comfortable shoes. New York was the first place where I showed my collection and had my very first clients. It is still my favorite city in the world. When I am away too long I feel like I am missing something.

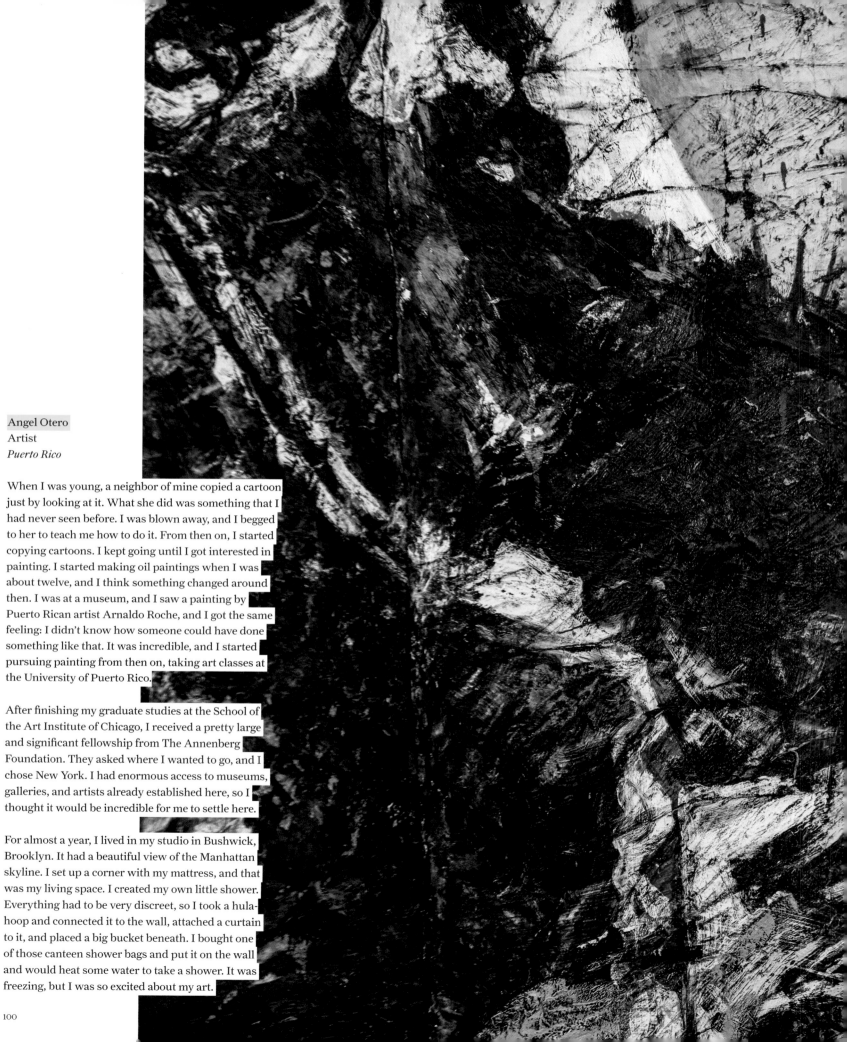

Angel Otero
Artist
Puerto Rico

When I was young, a neighbor of mine copied a cartoon just by looking at it. What she did was something that I had never seen before. I was blown away, and I begged to her to teach me how to do it. From then on, I started copying cartoons. I kept going until I got interested in painting. I started making oil paintings when I was about twelve, and I think something changed around then. I was at a museum, and I saw a painting by Puerto Rican artist Arnaldo Roche, and I got the same feeling: I didn't know how someone could have done something like that. It was incredible, and I started pursuing painting from then on, taking art classes at the University of Puerto Rico.

After finishing my graduate studies at the School of the Art Institute of Chicago, I received a pretty large and significant fellowship from The Annenberg Foundation. They asked where I wanted to go, and I chose New York. I had enormous access to museums, galleries, and artists already established here, so I thought it would be incredible for me to settle here.

For almost a year, I lived in my studio in Bushwick, Brooklyn. It had a beautiful view of the Manhattan skyline. I set up a corner with my mattress, and that was my living space. I created my own little shower. Everything had to be very discreet, so I took a hula-hoop and connected it to the wall, attached a curtain to it, and placed a big bucket beneath. I bought one of those canteen shower bags and put it on the wall and would heat some water to take a shower. It was freezing, but I was so excited about my art.

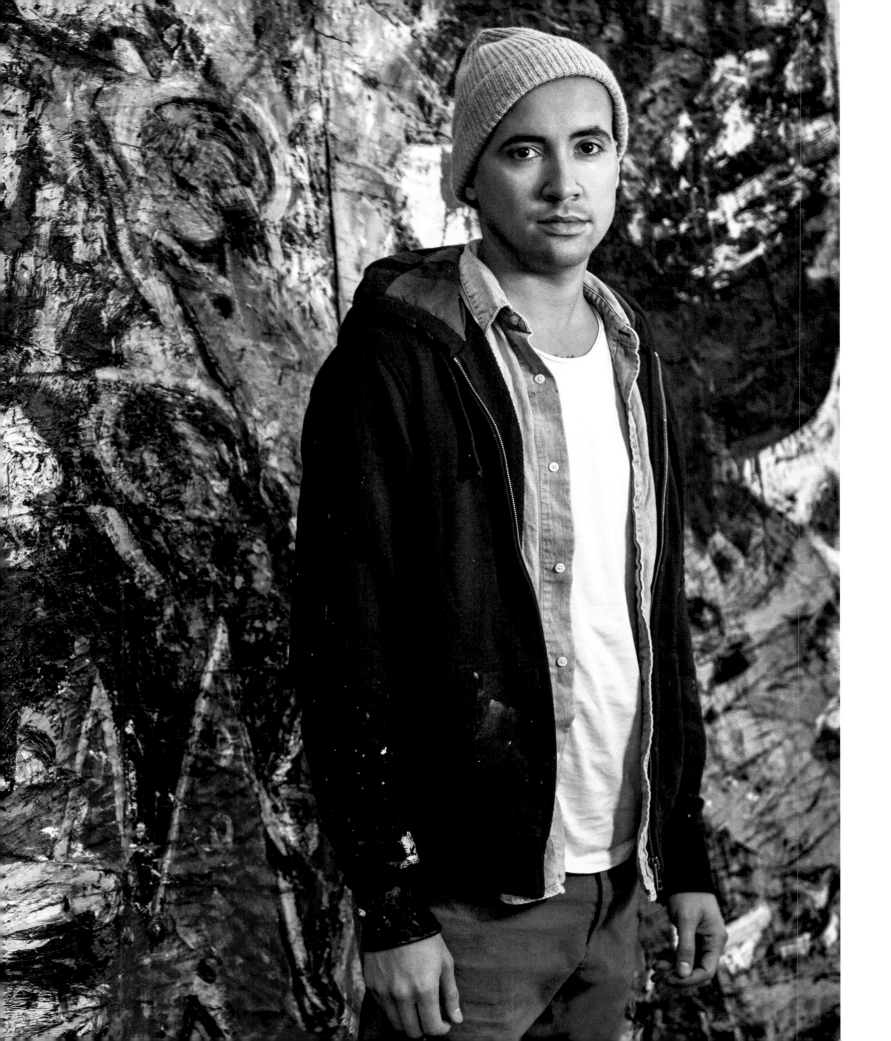

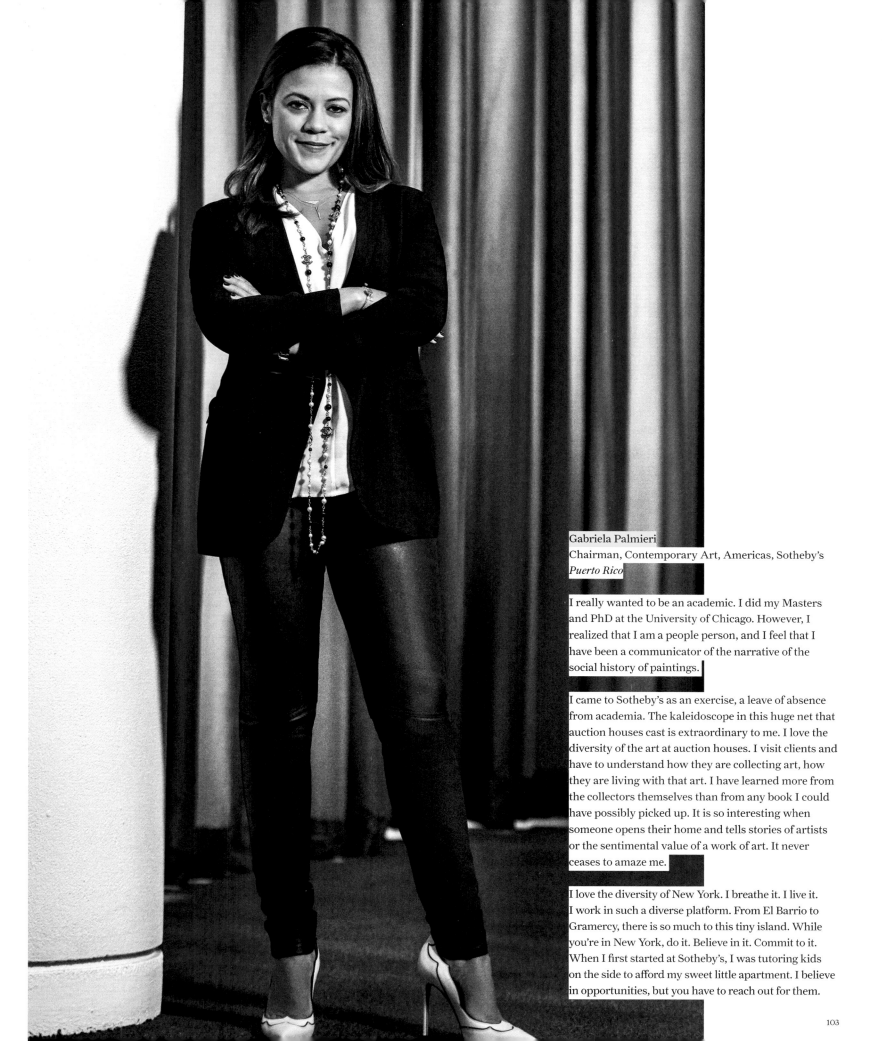

Gabriela Palmieri
Chairman, Contemporary Art, Americas, Sotheby's
Puerto Rico

I really wanted to be an academic. I did my Masters and PhD at the University of Chicago. However, I realized that I am a people person, and I feel that I have been a communicator of the narrative of the social history of paintings.

I came to Sotheby's as an exercise, a leave of absence from academia. The kaleidoscope in this huge net that auction houses cast is extraordinary to me. I love the diversity of the art at auction houses. I visit clients and have to understand how they are collecting art, how they are living with that art. I have learned more from the collectors themselves than from any book I could have possibly picked up. It is so interesting when someone opens their home and tells stories of artists or the sentimental value of a work of art. It never ceases to amaze me.

I love the diversity of New York. I breathe it. I live it. I work in such a diverse platform. From El Barrio to Gramercy, there is so much to this tiny island. While you're in New York, do it. Believe in it. Commit to it. When I first started at Sotheby's, I was tutoring kids on the side to afford my sweet little apartment. I believe in opportunities, but you have to reach out for them.

José Parlá
Artist
Cuba

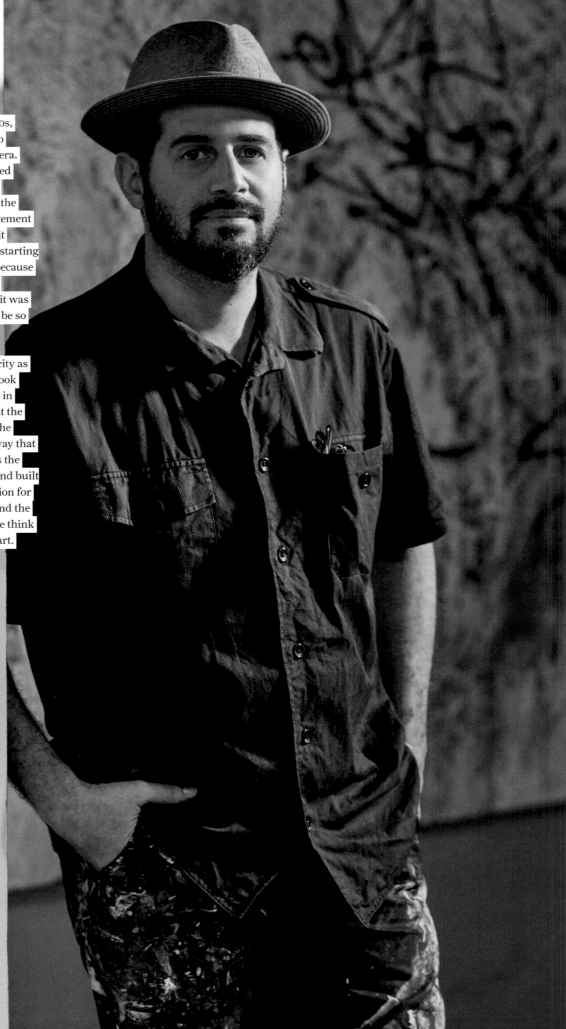

My family and I moved to Florida in the early 1980s, after living in Cuba, where I was born, and Puerto Rico. Those were the golden years of the hip-hop era. Breakdancing was big, hip-hop, and what we called at that time writing. Everybody was writing their name and making art on walls, in school, around the neighborhood, and pretty much all over. The movement came from New York City and Philadelphia, and it spread out to the world, but back then it was just starting to catch on. It was an art form unique in history because it was an adolescent movement. The fact that you could create art was a very positive thing. I think it was quite remarkable and spectacular that kids could be so organized to create art.

When I moved to New York, I thought about the city as being made up of layers. You cross a bridge, you look down at it, and you see all the layers; when you're in the subway going through the tunnels, you look at the diversity in all of those layers. To me it is always the stories of people that make up those layers. The way that this city was built over many hundreds of years is the story of migration, of the people who came here and built and rebuilt the city. It's a major source of inspiration for my work. I look at the floors, the constructions, and the buildings as a reflection on humanity. It makes me think of our origins—cave paintings and the history of art. That's New York.

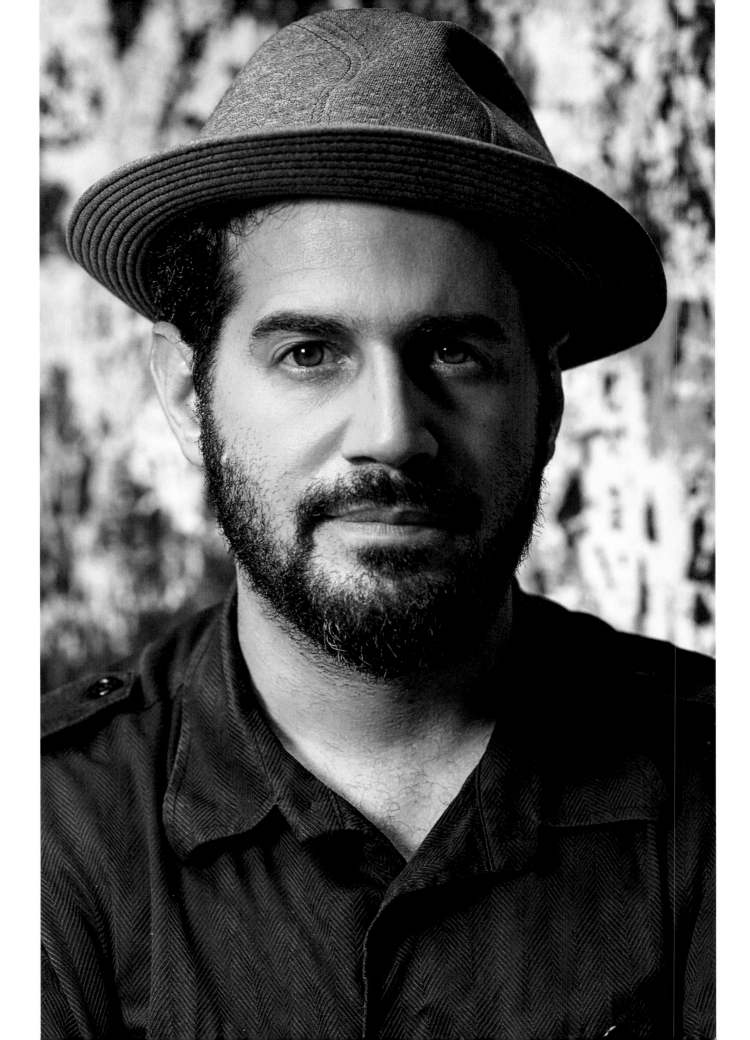

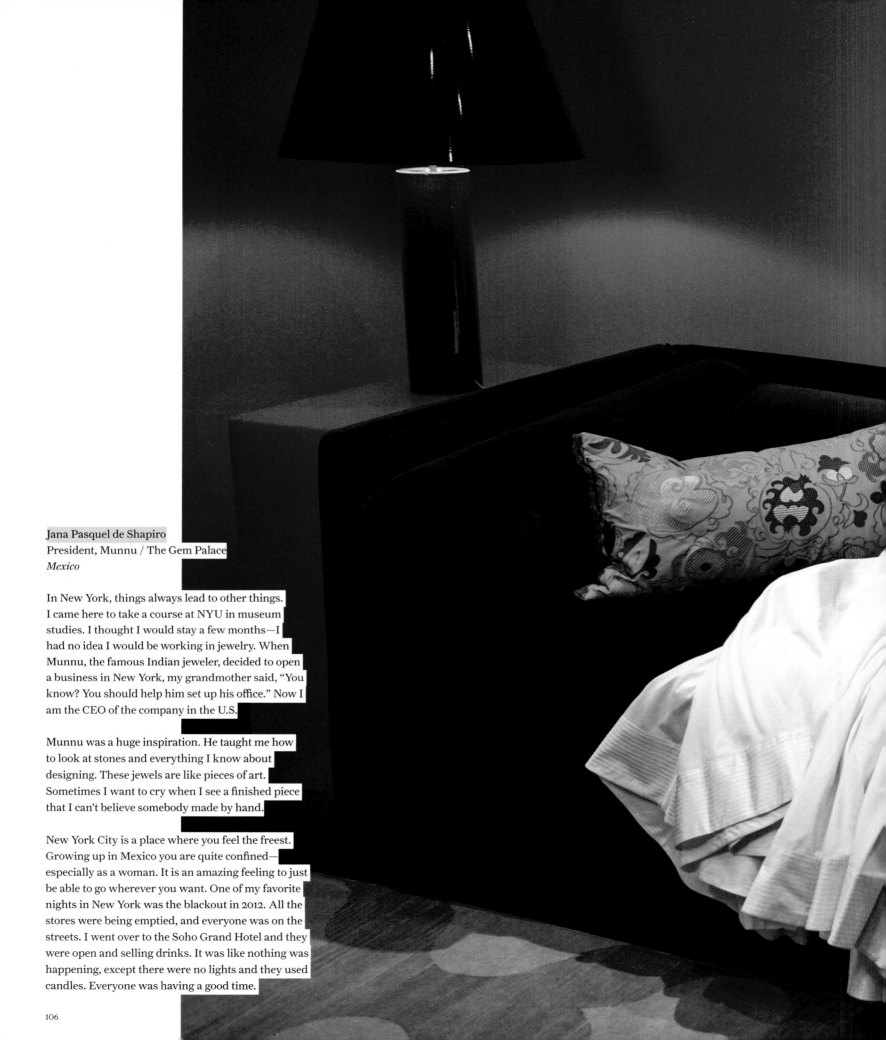

Jana Pasquel de Shapiro
President, Munnu / The Gem Palace
Mexico

In New York, things always lead to other things.
I came here to take a course at NYU in museum
studies. I thought I would stay a few months—I
had no idea I would be working in jewelry. When
Munnu, the famous Indian jeweler, decided to open
a business in New York, my grandmother said, "You
know? You should help him set up his office." Now I
am the CEO of the company in the U.S.

Munnu was a huge inspiration. He taught me how
to look at stones and everything I know about
designing. These jewels are like pieces of art.
Sometimes I want to cry when I see a finished piece
that I can't believe somebody made by hand.

New York City is a place where you feel the freest.
Growing up in Mexico you are quite confined—
especially as a woman. It is an amazing feeling to just
be able to go wherever you want. One of my favorite
nights in New York was the blackout in 2012. All the
stores were being emptied, and everyone was on the
streets. I went over to the Soho Grand Hotel and they
were open and selling drinks. It was like nothing was
happening, except there were no lights and they used
candles. Everyone was having a good time.

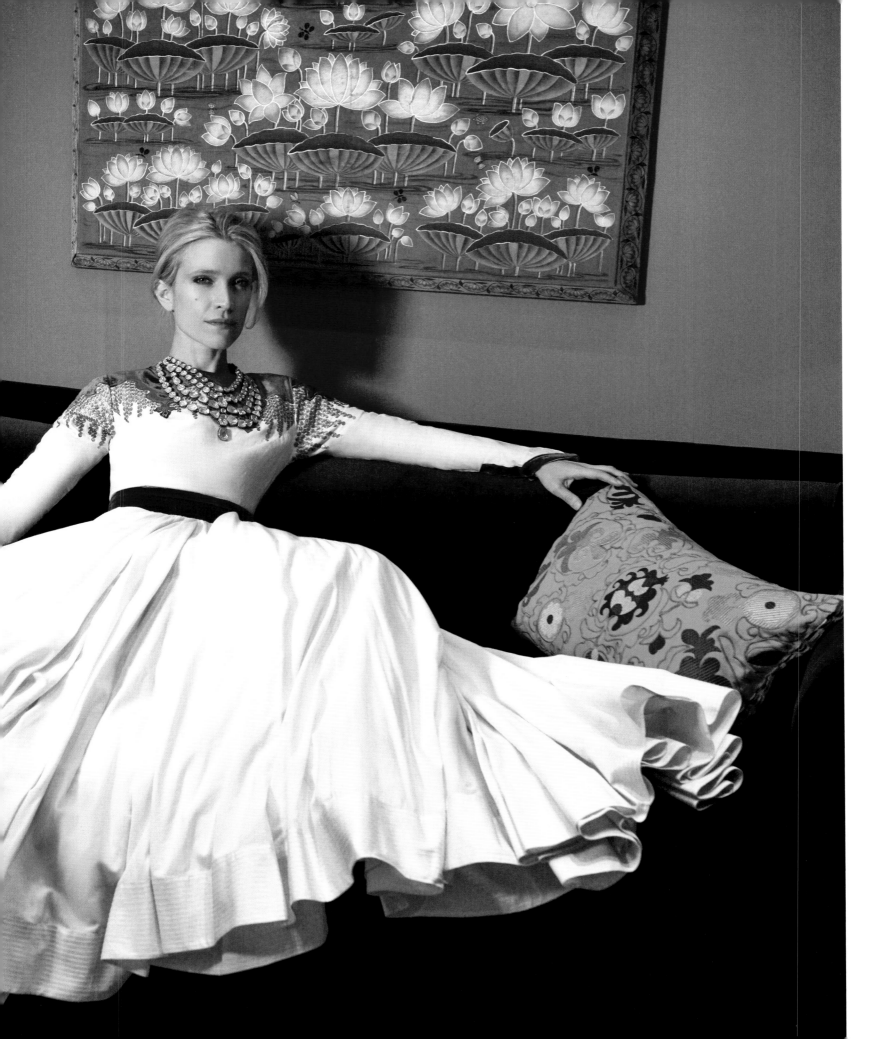

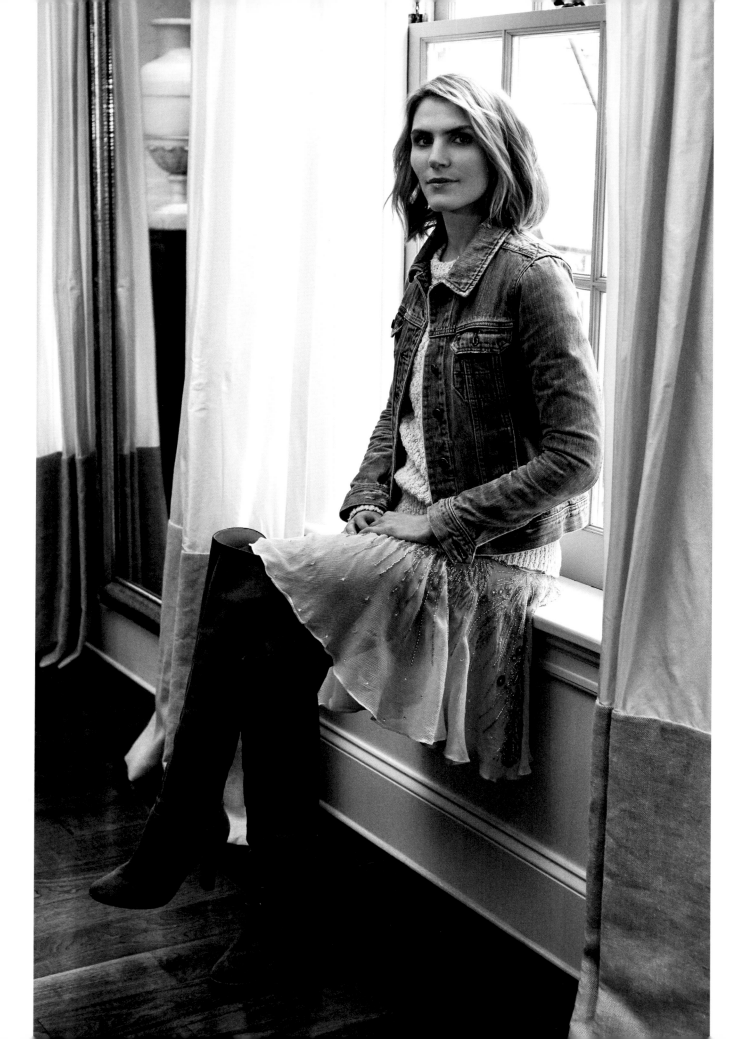

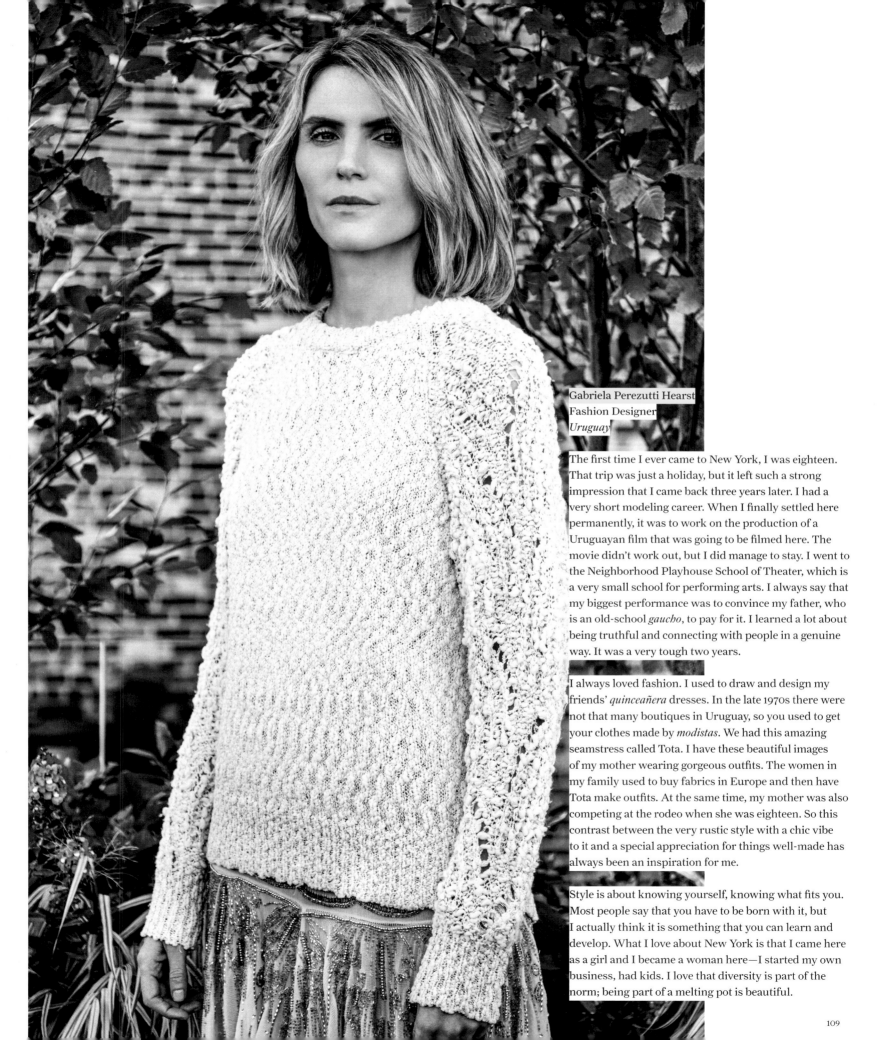

Gabriela Perezutti Hearst
Fashion Designer
Uruguay

The first time I ever came to New York, I was eighteen. That trip was just a holiday, but it left such a strong impression that I came back three years later. I had a very short modeling career. When I finally settled here permanently, it was to work on the production of a Uruguayan film that was going to be filmed here. The movie didn't work out, but I did manage to stay. I went to the Neighborhood Playhouse School of Theater, which is a very small school for performing arts. I always say that my biggest performance was to convince my father, who is an old-school *gaucho*, to pay for it. I learned a lot about being truthful and connecting with people in a genuine way. It was a very tough two years.

I always loved fashion. I used to draw and design my friends' *quinceañera* dresses. In the late 1970s there were not that many boutiques in Uruguay, so you used to get your clothes made by *modistas*. We had this amazing seamstress called Tota. I have these beautiful images of my mother wearing gorgeous outfits. The women in my family used to buy fabrics in Europe and then have Tota make outfits. At the same time, my mother was also competing at the rodeo when she was eighteen. So this contrast between the very rustic style with a chic vibe to it and a special appreciation for things well-made has always been an inspiration for me.

Style is about knowing yourself, knowing what fits you. Most people say that you have to be born with it, but I actually think it is something that you can learn and develop. What I love about New York is that I came here as a girl and I became a woman here—I started my own business, had kids. I love that diversity is part of the norm; being part of a melting pot is beautiful.

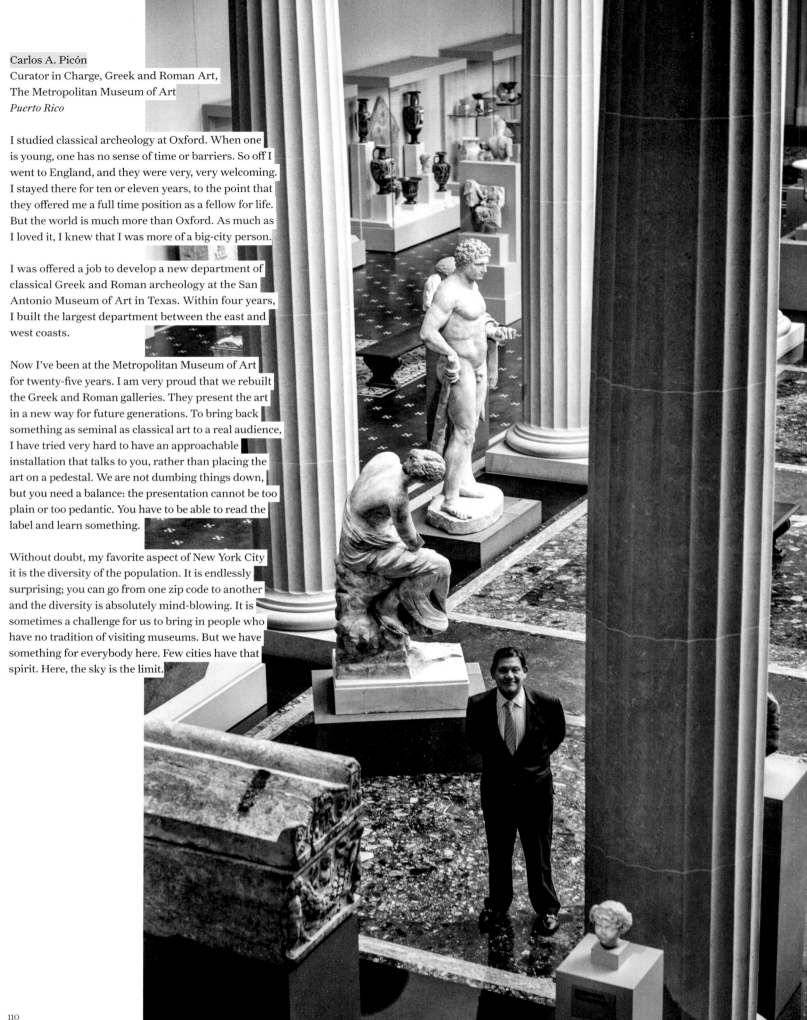

Carlos A. Picón
Curator in Charge, Greek and Roman Art,
The Metropolitan Museum of Art
Puerto Rico

I studied classical archeology at Oxford. When one is young, one has no sense of time or barriers. So off I went to England, and they were very, very welcoming. I stayed there for ten or eleven years, to the point that they offered me a full time position as a fellow for life. But the world is much more than Oxford. As much as I loved it, I knew that I was more of a big-city person.

I was offered a job to develop a new department of classical Greek and Roman archeology at the San Antonio Museum of Art in Texas. Within four years, I built the largest department between the east and west coasts.

Now I've been at the Metropolitan Museum of Art for twenty-five years. I am very proud that we rebuilt the Greek and Roman galleries. They present the art in a new way for future generations. To bring back something as seminal as classical art to a real audience, I have tried very hard to have an approachable installation that talks to you, rather than placing the art on a pedestal. We are not dumbing things down, but you need a balance: the presentation cannot be too plain or too pedantic. You have to be able to read the label and learn something.

Without doubt, my favorite aspect of New York City it is the diversity of the population. It is endlessly surprising; you can go from one zip code to another and the diversity is absolutely mind-blowing. It is sometimes a challenge for us to bring in people who have no tradition of visiting museums. But we have something for everybody here. Few cities have that spirit. Here, the sky is the limit.

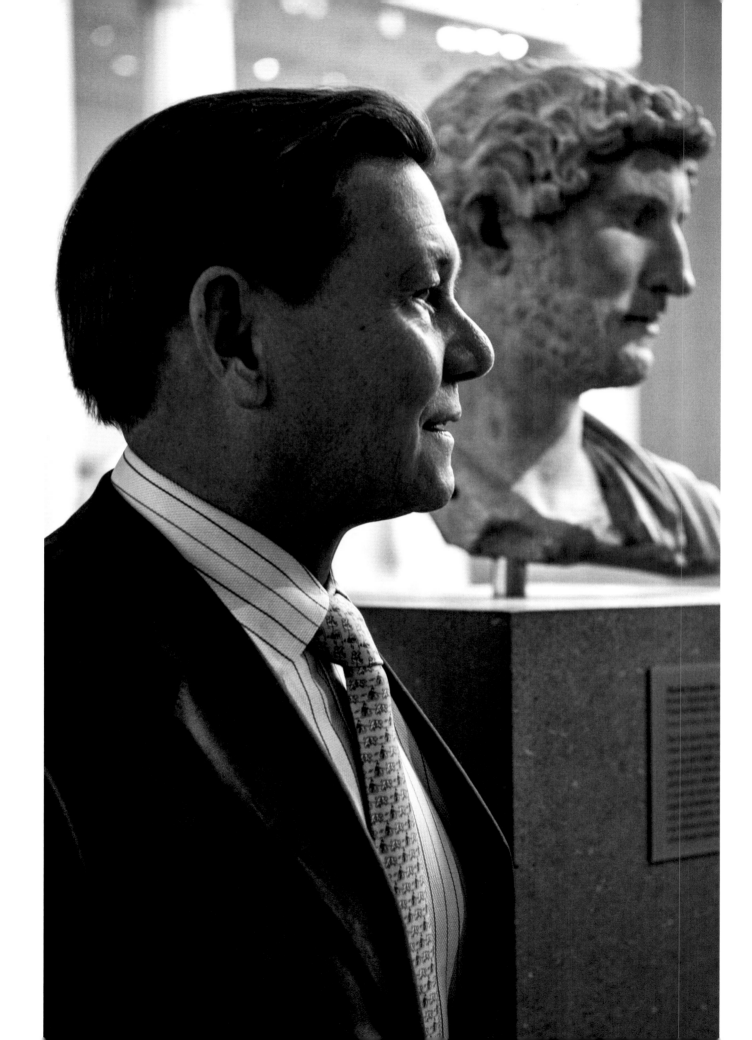

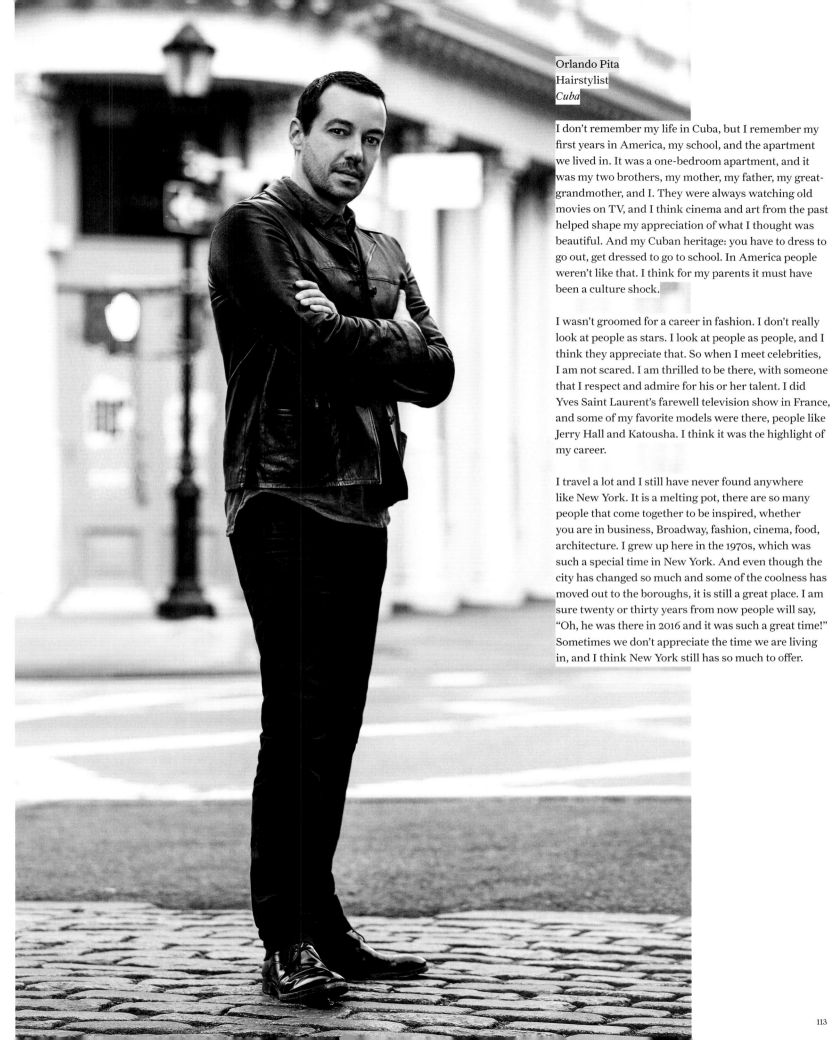

Orlando Pita
Hairstylist
Cuba

I don't remember my life in Cuba, but I remember my first years in America, my school, and the apartment we lived in. It was a one-bedroom apartment, and it was my two brothers, my mother, my father, my great-grandmother, and I. They were always watching old movies on TV, and I think cinema and art from the past helped shape my appreciation of what I thought was beautiful. And my Cuban heritage: you have to dress to go out, get dressed to go to school. In America people weren't like that. I think for my parents it must have been a culture shock.

I wasn't groomed for a career in fashion. I don't really look at people as stars. I look at people as people, and I think they appreciate that. So when I meet celebrities, I am not scared. I am thrilled to be there, with someone that I respect and admire for his or her talent. I did Yves Saint Laurent's farewell television show in France, and some of my favorite models were there, people like Jerry Hall and Katousha. I think it was the highlight of my career.

I travel a lot and I still have never found anywhere like New York. It is a melting pot, there are so many people that come together to be inspired, whether you are in business, Broadway, fashion, cinema, food, architecture. I grew up here in the 1970s, which was such a special time in New York. And even though the city has changed so much and some of the coolness has moved out to the boroughs, it is still a great place. I am sure twenty or thirty years from now people will say, "Oh, he was there in 2016 and it was such a great time!" Sometimes we don't appreciate the time we are living in, and I think New York still has so much to offer.

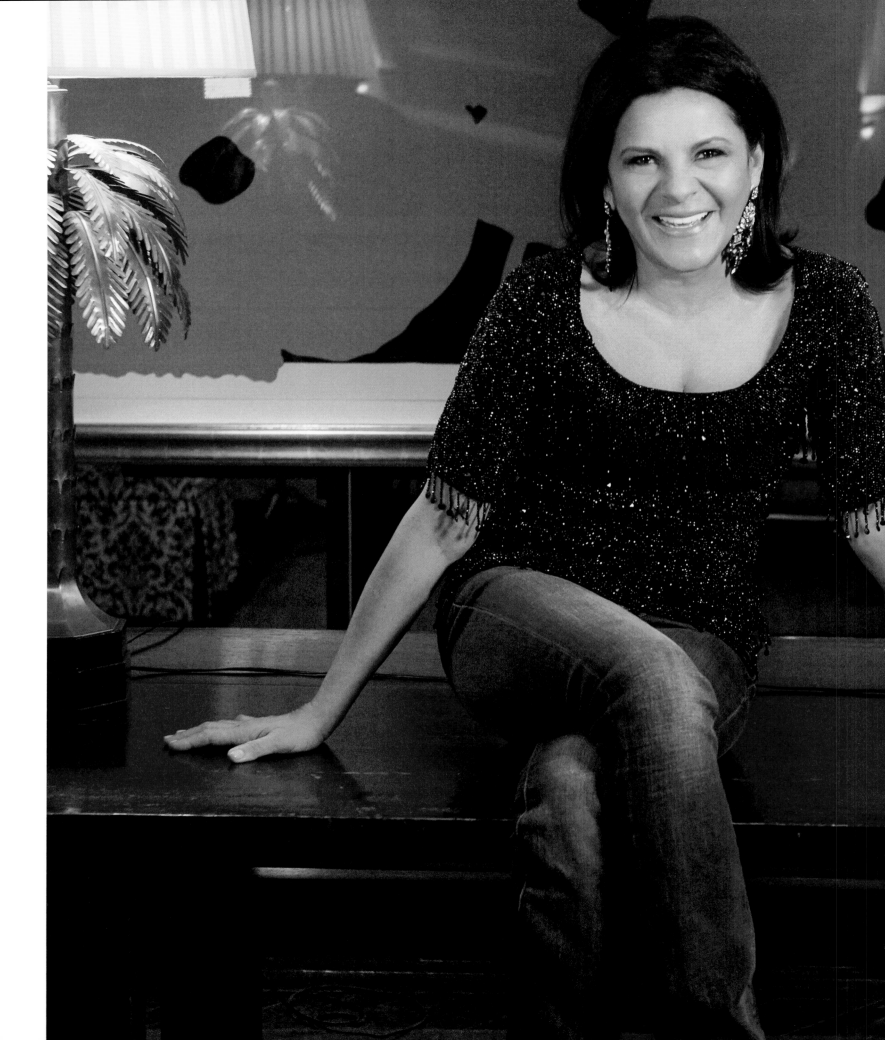

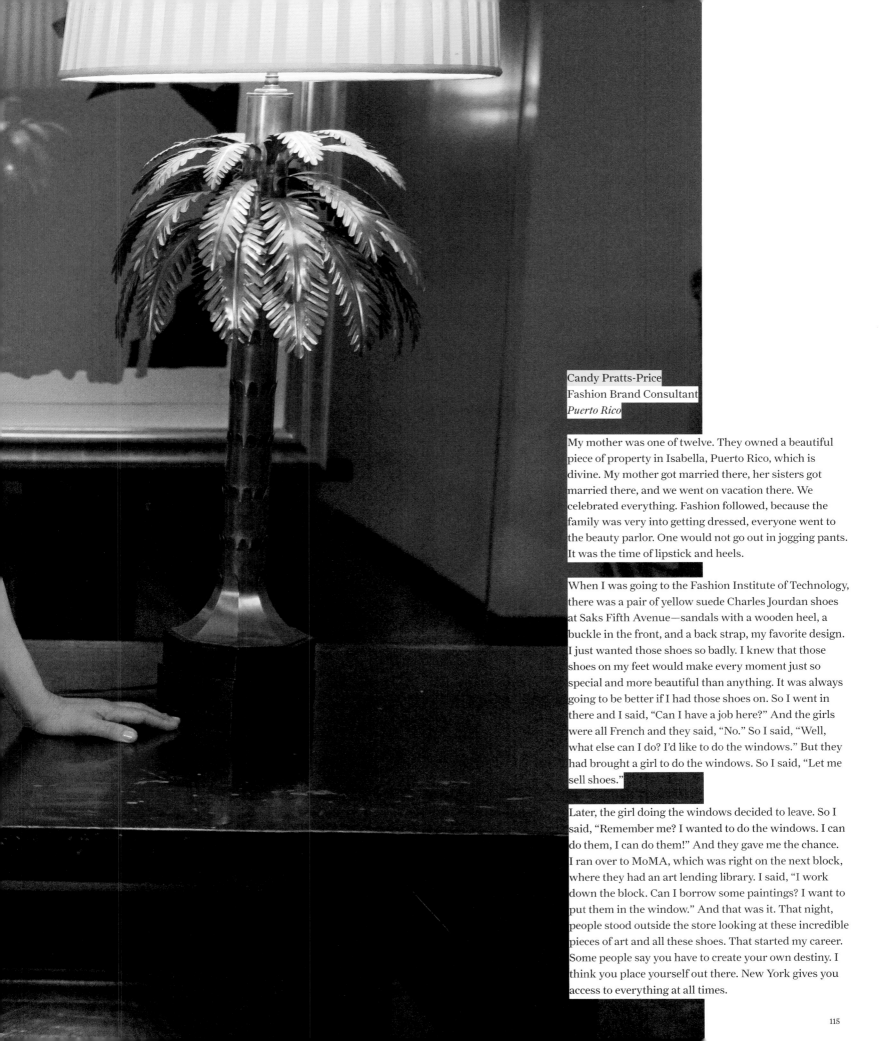

Candy Pratts-Price
Fashion Brand Consultant
Puerto Rico

My mother was one of twelve. They owned a beautiful piece of property in Isabella, Puerto Rico, which is divine. My mother got married there, her sisters got married there, and we went on vacation there. We celebrated everything. Fashion followed, because the family was very into getting dressed, everyone went to the beauty parlor. One would not go out in jogging pants. It was the time of lipstick and heels.

When I was going to the Fashion Institute of Technology, there was a pair of yellow suede Charles Jourdan shoes at Saks Fifth Avenue—sandals with a wooden heel, a buckle in the front, and a back strap, my favorite design. I just wanted those shoes so badly. I knew that those shoes on my feet would make every moment just so special and more beautiful than anything. It was always going to be better if I had those shoes on. So I went in there and I said, "Can I have a job here?" And the girls were all French and they said, "No." So I said, "Well, what else can I do? I'd like to do the windows." But they had brought a girl to do the windows. So I said, "Let me sell shoes."

Later, the girl doing the windows decided to leave. So I said, "Remember me? I wanted to do the windows. I can do them, I can do them!" And they gave me the chance. I ran over to MoMA, which was right on the next block, where they had an art lending library. I said, "I work down the block. Can I borrow some paintings? I want to put them in the window." And that was it. That night, people stood outside the store looking at these incredible pieces of art and all these shoes. That started my career. Some people say you have to create your own destiny. I think you place yourself out there. New York gives you access to everything at all times.

115

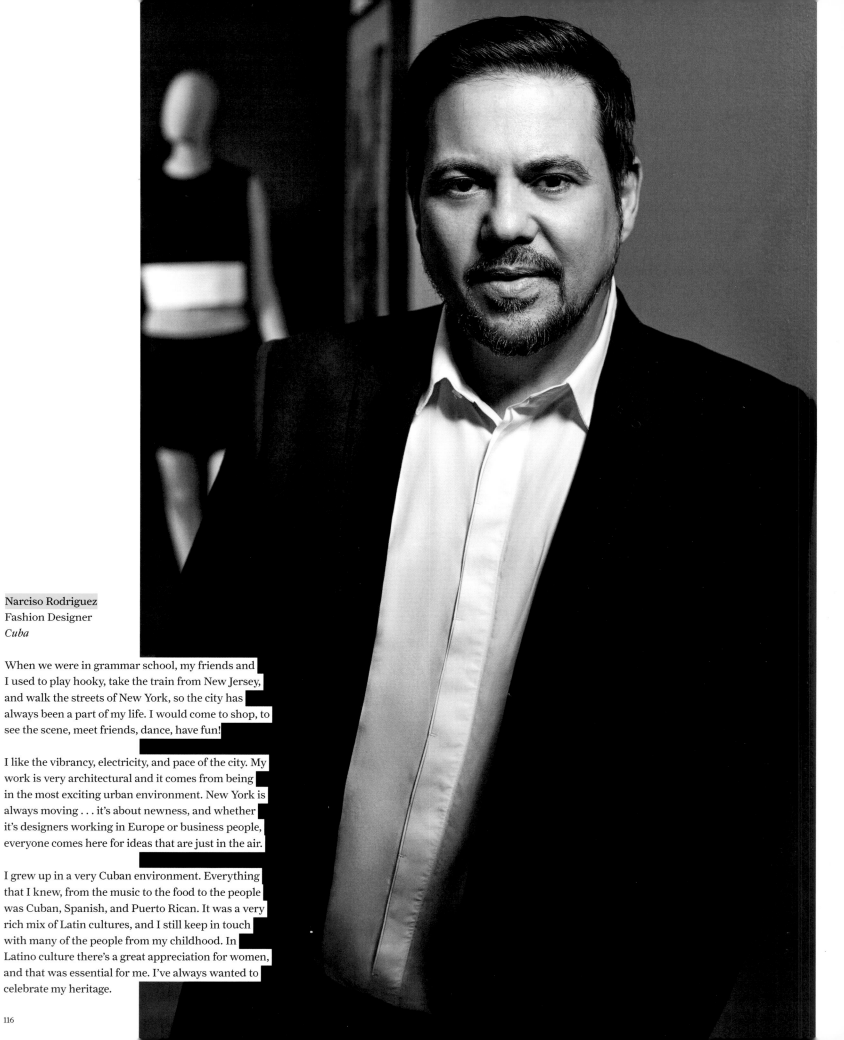

Narciso Rodriguez
Fashion Designer
Cuba

When we were in grammar school, my friends and I used to play hooky, take the train from New Jersey, and walk the streets of New York, so the city has always been a part of my life. I would come to shop, to see the scene, meet friends, dance, have fun!

I like the vibrancy, electricity, and pace of the city. My work is very architectural and it comes from being in the most exciting urban environment. New York is always moving . . . it's about newness, and whether it's designers working in Europe or business people, everyone comes here for ideas that are just in the air.

I grew up in a very Cuban environment. Everything that I knew, from the music to the food to the people was Cuban, Spanish, and Puerto Rican. It was a very rich mix of Latin cultures, and I still keep in touch with many of the people from my childhood. In Latino culture there's a great appreciation for women, and that was essential for me. I've always wanted to celebrate my heritage.

Ben Rodriguez-Cubeñas
Art Philanthropist
Cuba

My parents were not happy with the political situation after the Cuban Revolution in 1959, so they moved, first to Florida and then to New York. We would go on vacation to Puerto Rico just about every summer. On one trip, we visited the Museo de Arte de Ponce in Puerto Rico. There was a rotunda there, and I remember sitting in that lobby looking at all the artwork with my mother and my grandmother. I must have been around five. I thought, "Wow! I really like this place!" That was what sparked my interest in the arts.

Art makes you think. It makes you happy, makes you sad, gives you an escape, and makes you feel good. Art has transformed my life because I love meeting, being with, and learning from artists. I meet and work with hundreds of them. It has just made my life much more fulfilling and interesting to know these people and get to know a little bit of their creative process and how the arts impact people's lives.

Art is much more democratic than it was in the past. In Cuba, where I'm from, artists are bypassing the whole gallery system; they create galleries and studios in their own spaces. Here there's social media and new technologies: you can share work through your website, you can get the word out about your latest project through Facebook or Instagram. So there are a lot of new opportunities now for artists.

There have been tremendous gains by the Latino community in the United States and in New York in the last ten years or so. We are part of the power structure of the United States, and our influence will continue to grow. The Latino community is more connected and influential now and we need to continue paving the way for many others to advance and reach their potential.

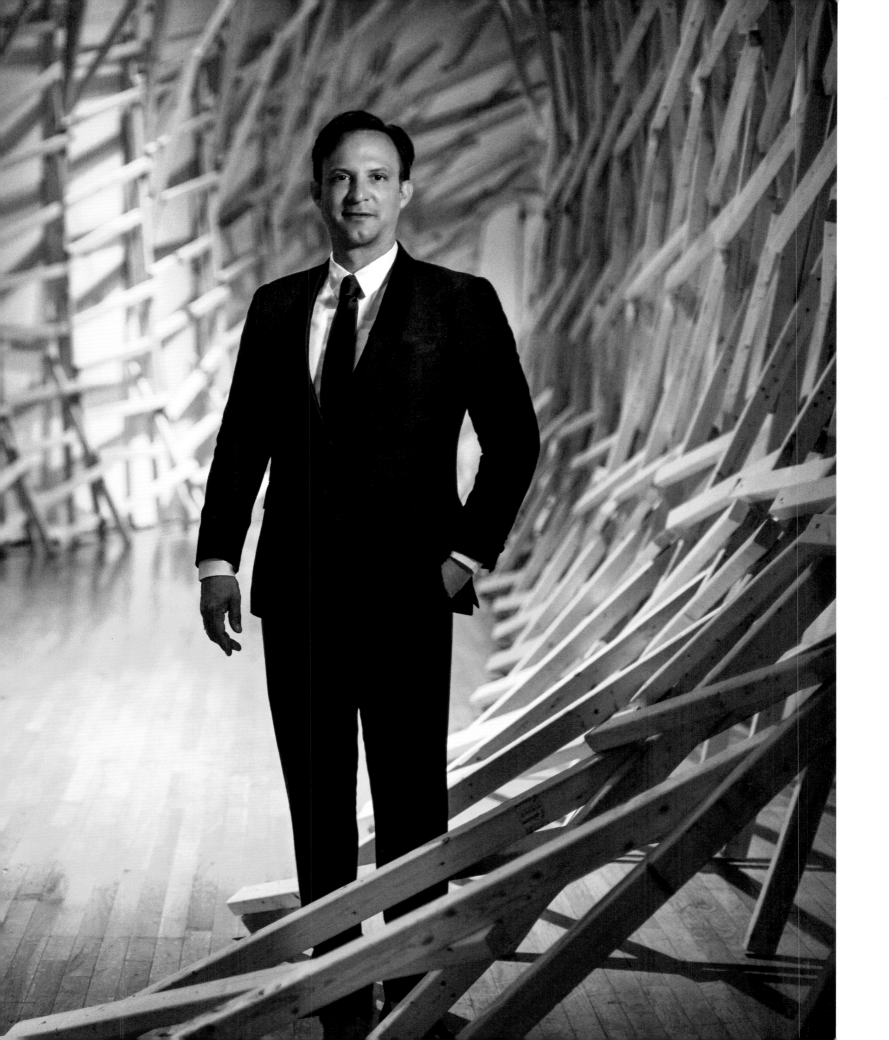

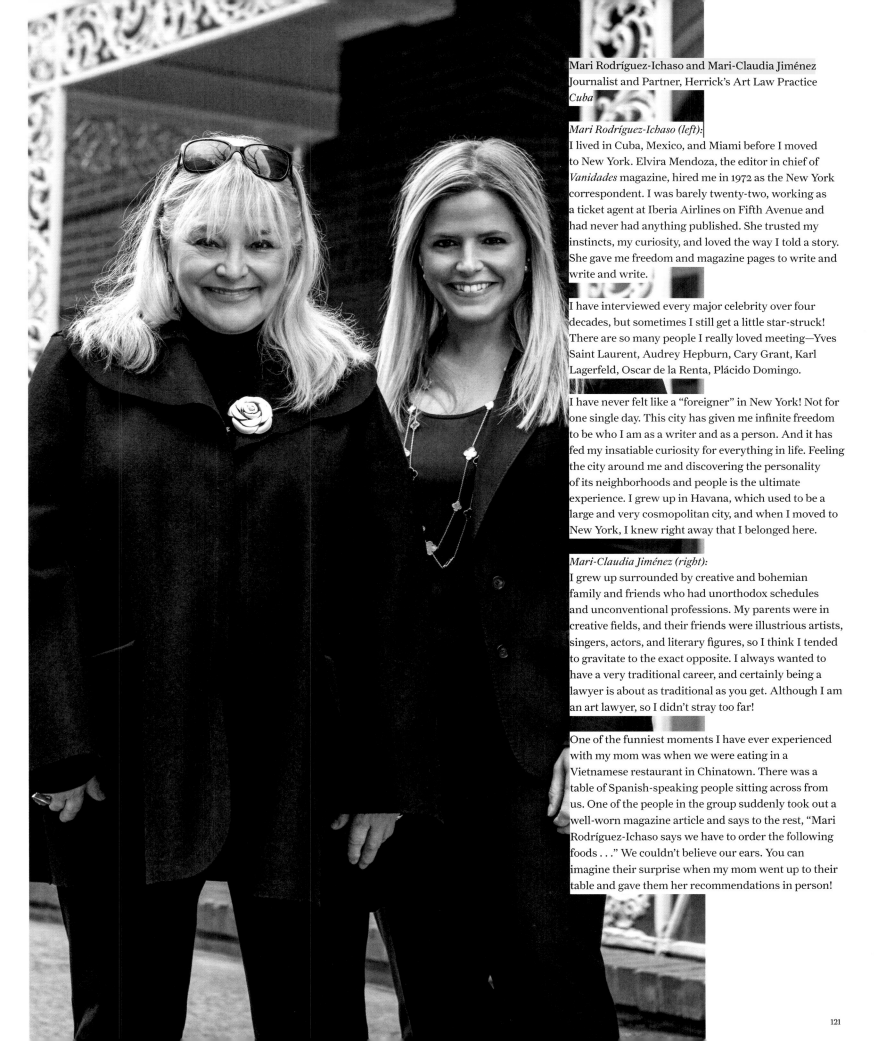

Mari Rodríguez-Ichaso and Mari-Claudia Jiménez
Journalist and Partner, Herrick's Art Law Practice
Cuba

Mari Rodríguez-Ichaso (left):
I lived in Cuba, Mexico, and Miami before I moved
to New York. Elvira Mendoza, the editor in chief of
Vanidades magazine, hired me in 1972 as the New York
correspondent. I was barely twenty-two, working as
a ticket agent at Iberia Airlines on Fifth Avenue and
had never had anything published. She trusted my
instincts, my curiosity, and loved the way I told a story.
She gave me freedom and magazine pages to write and
write and write.

I have interviewed every major celebrity over four
decades, but sometimes I still get a little star-struck!
There are so many people I really loved meeting—Yves
Saint Laurent, Audrey Hepburn, Cary Grant, Karl
Lagerfeld, Oscar de la Renta, Plácido Domingo.

I have never felt like a "foreigner" in New York! Not for
one single day. This city has given me infinite freedom
to be who I am as a writer and as a person. And it has
fed my insatiable curiosity for everything in life. Feeling
the city around me and discovering the personality
of its neighborhoods and people is the ultimate
experience. I grew up in Havana, which used to be a
large and very cosmopolitan city, and when I moved to
New York, I knew right away that I belonged here.

Mari-Claudia Jiménez (right):
I grew up surrounded by creative and bohemian
family and friends who had unorthodox schedules
and unconventional professions. My parents were in
creative fields, and their friends were illustrious artists,
singers, actors, and literary figures, so I think I tended
to gravitate to the exact opposite. I always wanted to
have a very traditional career, and certainly being a
lawyer is about as traditional as you get. Although I am
an art lawyer, so I didn't stray too far!

One of the funniest moments I have ever experienced
with my mom was when we were eating in a
Vietnamese restaurant in Chinatown. There was a
table of Spanish-speaking people sitting across from
us. One of the people in the group suddenly took out a
well-worn magazine article and says to the rest, "Mari
Rodríguez-Ichaso says we have to order the following
foods . . ." We couldn't believe our ears. You can
imagine their surprise when my mom went up to their
table and gave them her recommendations in person!

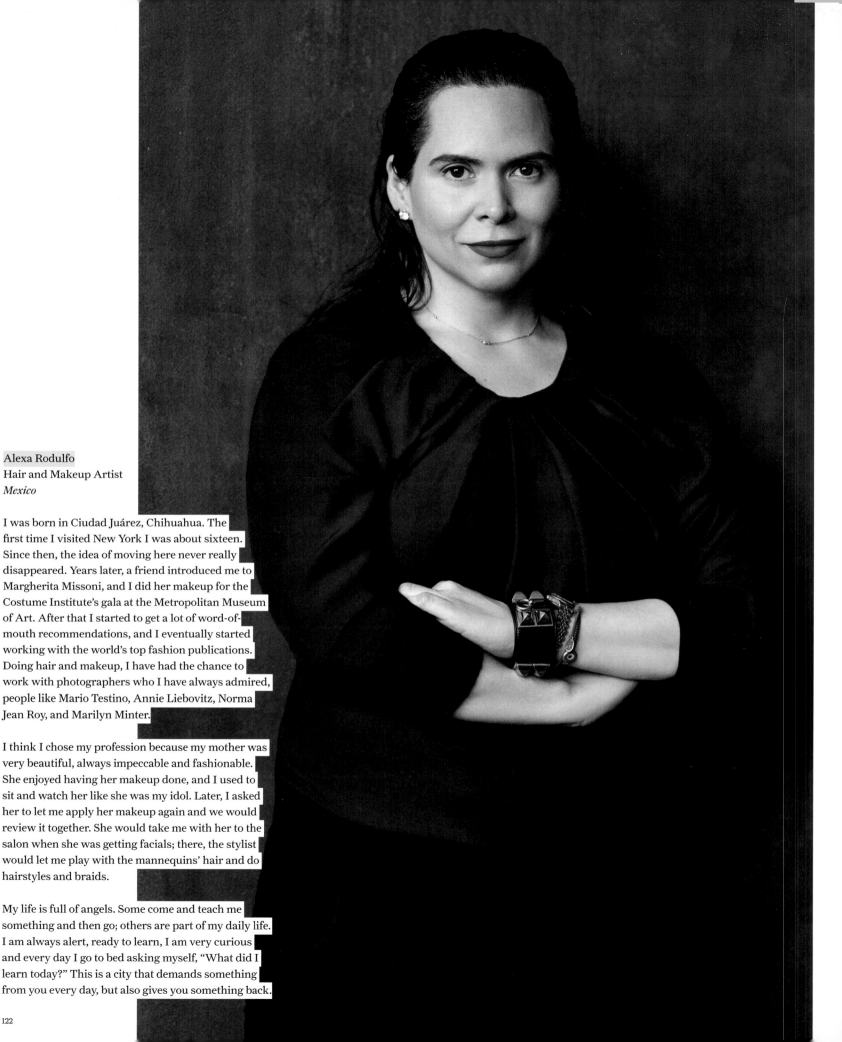

Alexa Rodulfo
Hair and Makeup Artist
Mexico

I was born in Ciudad Juárez, Chihuahua. The first time I visited New York I was about sixteen. Since then, the idea of moving here never really disappeared. Years later, a friend introduced me to Margherita Missoni, and I did her makeup for the Costume Institute's gala at the Metropolitan Museum of Art. After that I started to get a lot of word-of-mouth recommendations, and I eventually started working with the world's top fashion publications. Doing hair and makeup, I have had the chance to work with photographers who I have always admired, people like Mario Testino, Annie Liebovitz, Norma Jean Roy, and Marilyn Minter.

I think I chose my profession because my mother was very beautiful, always impeccable and fashionable. She enjoyed having her makeup done, and I used to sit and watch her like she was my idol. Later, I asked her to let me apply her makeup again and we would review it together. She would take me with her to the salon when she was getting facials; there, the stylist would let me play with the mannequins' hair and do hairstyles and braids.

My life is full of angels. Some come and teach me something and then go; others are part of my daily life. I am always alert, ready to learn, I am very curious and every day I go to bed asking myself, "What did I learn today?" This is a city that demands something from you every day, but also gives you something back.

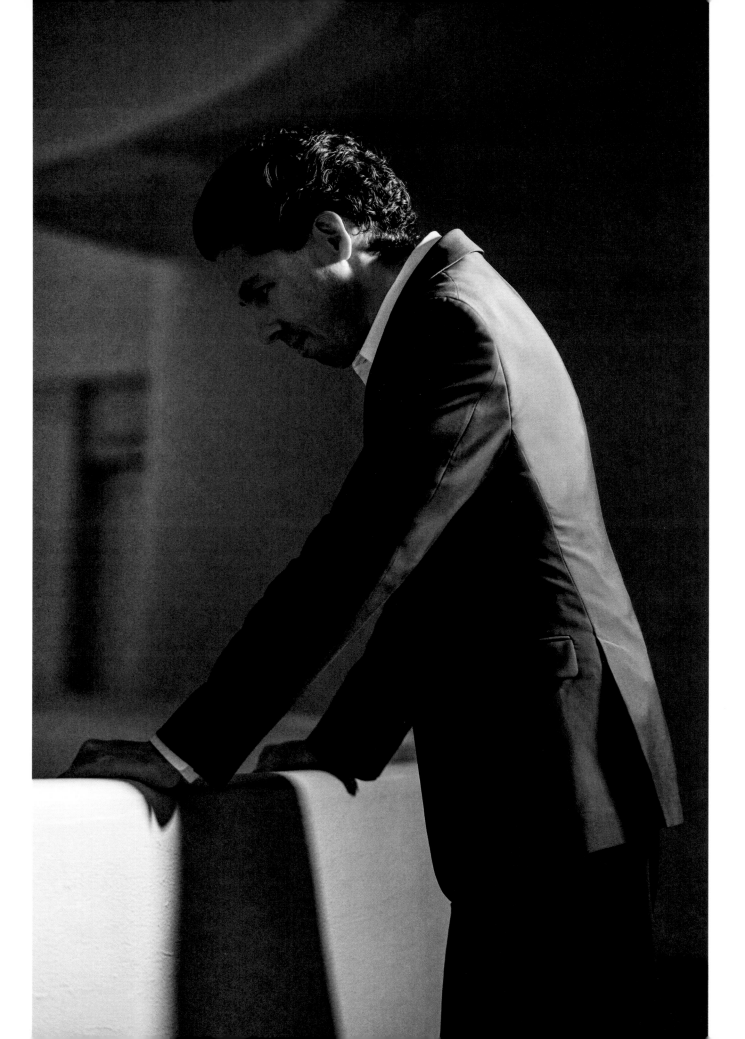

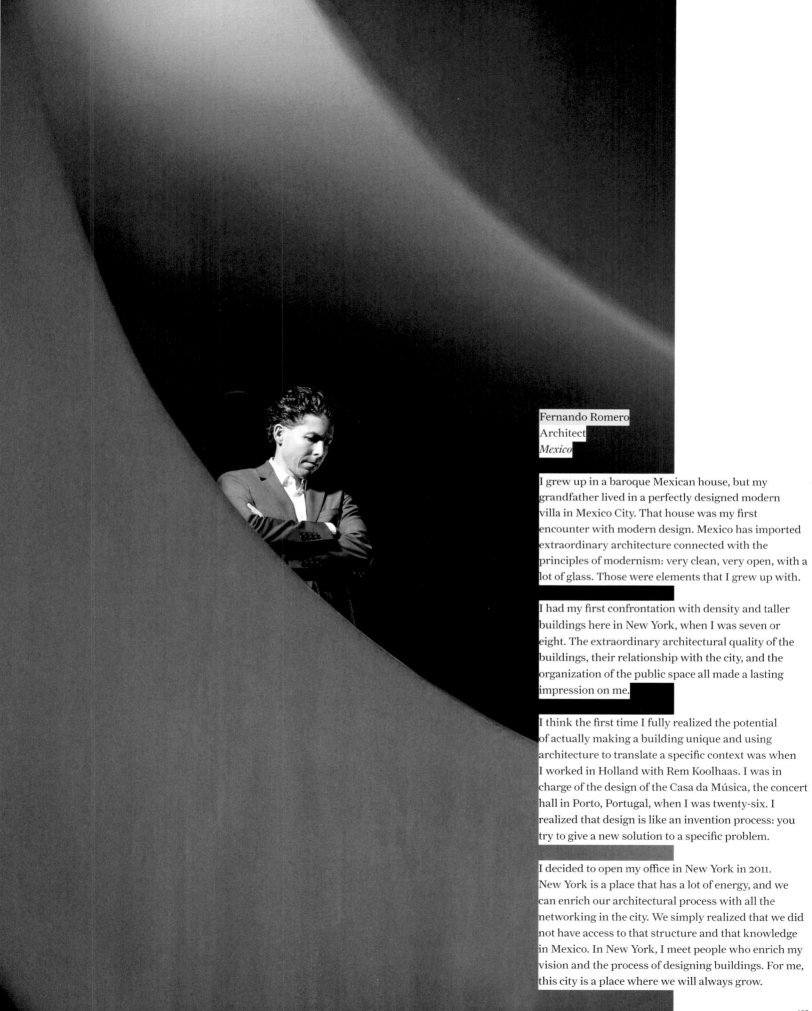

Fernando Romero
Architect
Mexico

I grew up in a baroque Mexican house, but my grandfather lived in a perfectly designed modern villa in Mexico City. That house was my first encounter with modern design. Mexico has imported extraordinary architecture connected with the principles of modernism: very clean, very open, with a lot of glass. Those were elements that I grew up with.

I had my first confrontation with density and taller buildings here in New York, when I was seven or eight. The extraordinary architectural quality of the buildings, their relationship with the city, and the organization of the public space all made a lasting impression on me.

I think the first time I fully realized the potential of actually making a building unique and using architecture to translate a specific context was when I worked in Holland with Rem Koolhaas. I was in charge of the design of the Casa da Música, the concert hall in Porto, Portugal, when I was twenty-six. I realized that design is like an invention process: you try to give a new solution to a specific problem.

I decided to open my office in New York in 2011. New York is a place that has a lot of energy, and we can enrich our architectural process with all the networking in the city. We simply realized that we did not have access to that structure and that knowledge in Mexico. In New York, I meet people who enrich my vision and the process of designing buildings. For me, this city is a place where we will always grow.

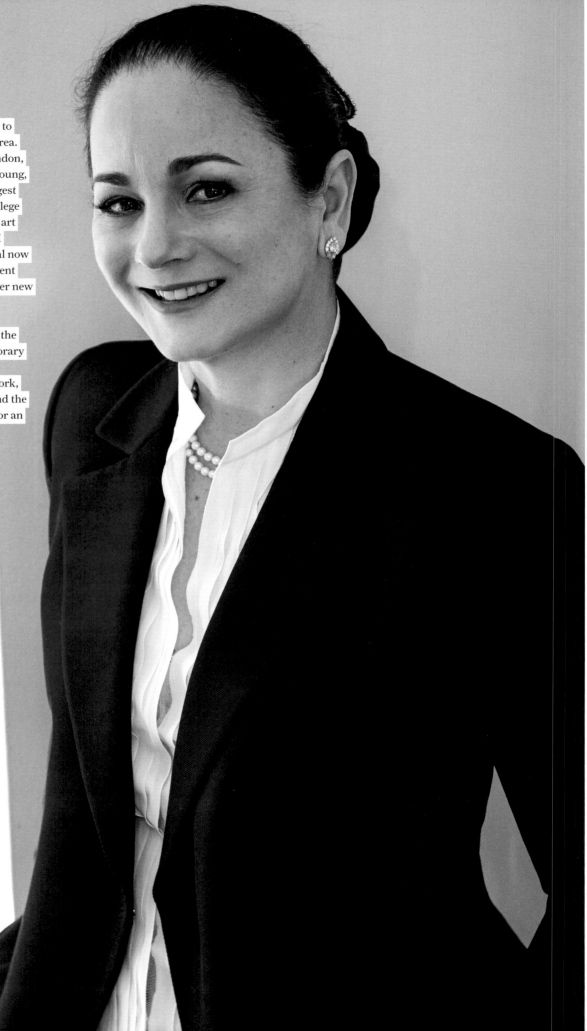

Patricia Ruiz-Healy
Art Historian and Gallerist
Mexico

I was Miss Mexico in 1980, and then I went on to compete for Miss Universe in Seoul, South Korea. After that, I won a scholarship to study in London, and that is where I discovered art. I married young, and I didn't finish college. But when my youngest daughter started first grade, I went back to college and graduated with two majors: business and art history. Then I did my Masters in art history. I developed the idea of a business in art. My goal now is to promote and establish the artists I represent internationally, and at the same time to discover new talent. But it all takes time.

I have always been interested in searching for the new, and New York, as the capital of contemporary art, is a place where you can find this on an international scale. I love the energy of New York, the dynamism, the wealth of opportunities, and the amount of exposure to art that you get here. For an art dealer, New York is heaven.

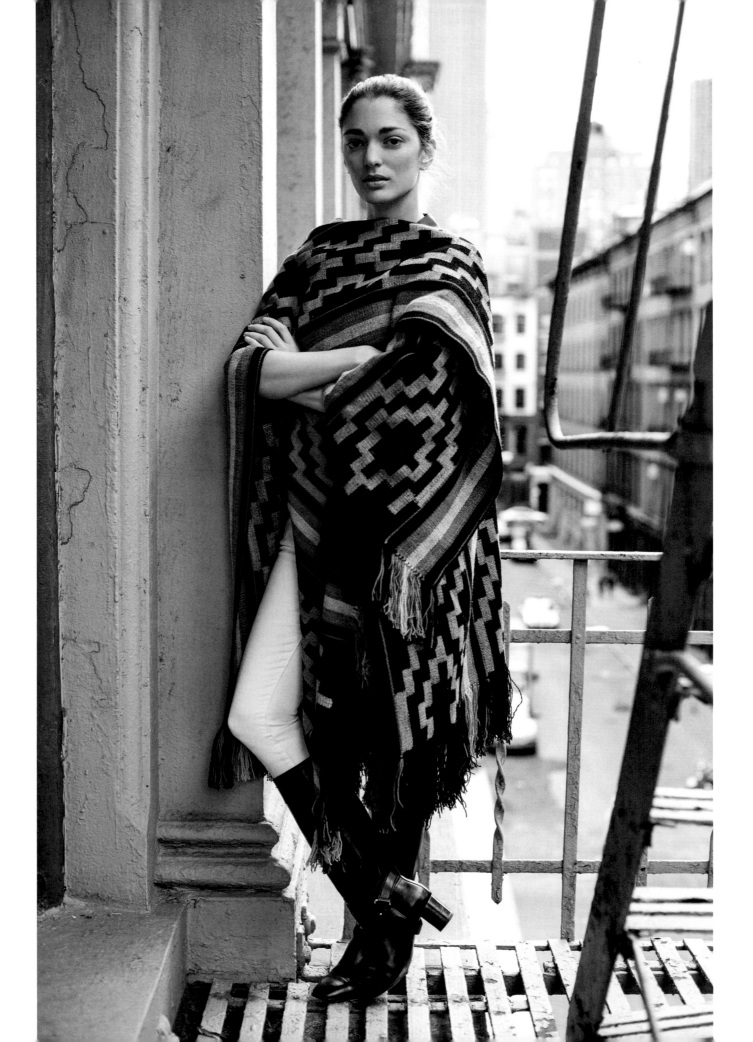

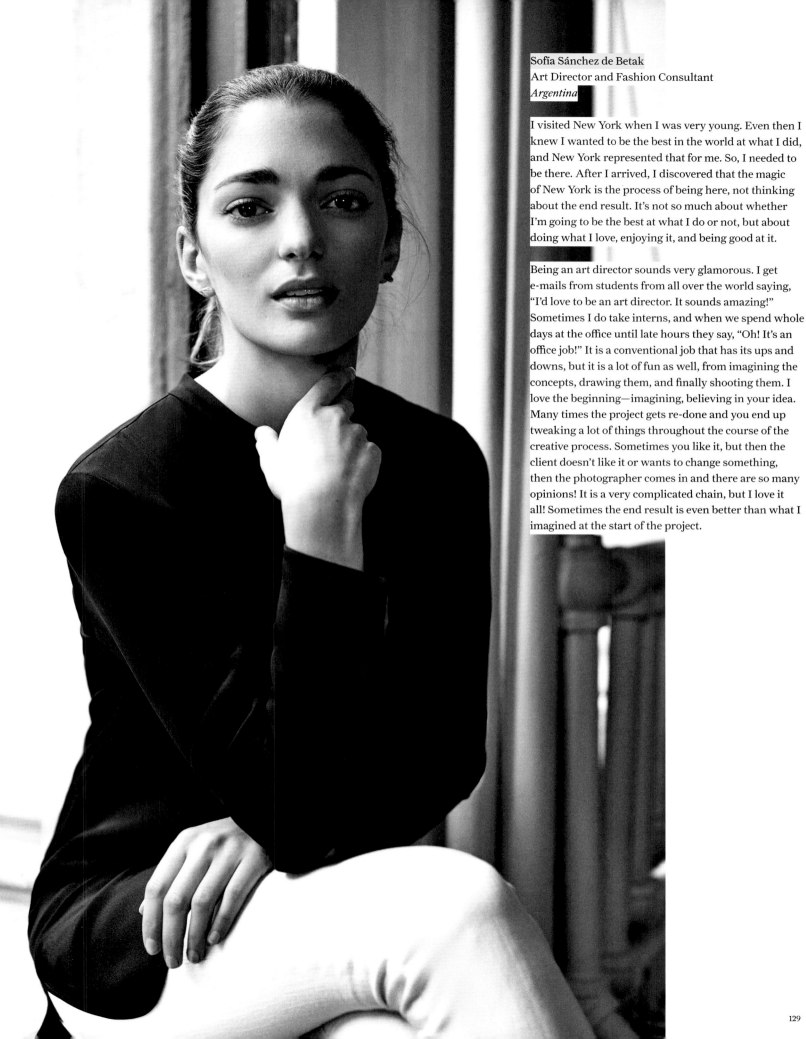

Sofía Sánchez de Betak
Art Director and Fashion Consultant
Argentina

I visited New York when I was very young. Even then I knew I wanted to be the best in the world at what I did, and New York represented that for me. So, I needed to be there. After I arrived, I discovered that the magic of New York is the process of being here, not thinking about the end result. It's not so much about whether I'm going to be the best at what I do or not, but about doing what I love, enjoying it, and being good at it.

Being an art director sounds very glamorous. I get e-mails from students from all over the world saying, "I'd love to be an art director. It sounds amazing!" Sometimes I do take interns, and when we spend whole days at the office until late hours they say, "Oh! It's an office job!" It is a conventional job that has its ups and downs, but it is a lot of fun as well, from imagining the concepts, drawing them, and finally shooting them. I love the beginning—imagining, believing in your idea. Many times the project gets re-done and you end up tweaking a lot of things throughout the course of the creative process. Sometimes you like it, but then the client doesn't like it or wants to change something, then the photographer comes in and there are so many opinions! It is a very complicated chain, but I love it all! Sometimes the end result is even better than what I imagined at the start of the project.

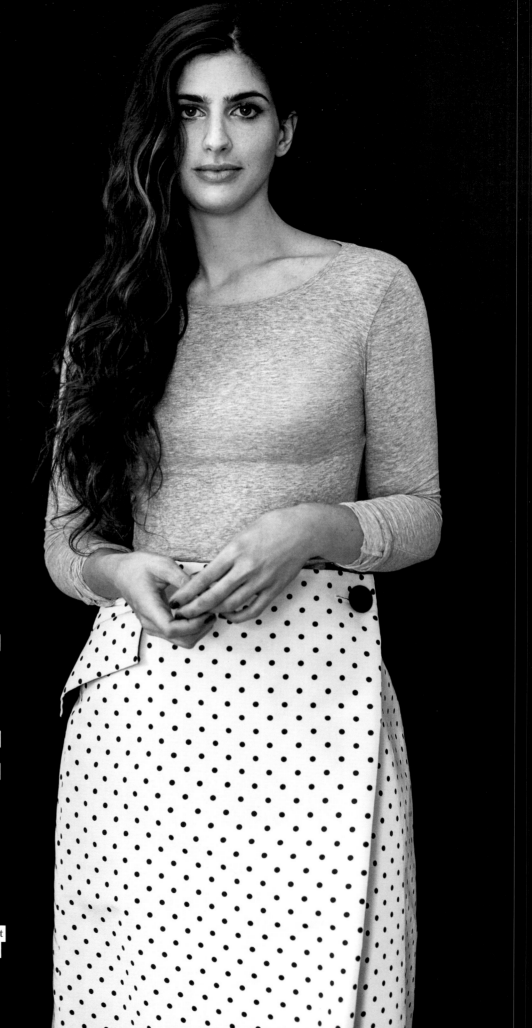

Bettina Santo Domingo
Media Manager
Colombia

I came to New York when I was asked to do a project during fashion week for the online luxury fashion retailer Moda Operandi. I arrived with one suitcase thinking I would stay for a week, but I never left. The only constant in New York is change. The weather changes, the people change, the places change. This is what attracts me to it—I am a person who needs change and excitement.

I took an interest in documentary filmmaking when I was in high school. Filmmaking allowed me to learn so much about myself—from that moment on, I knew it was something I could do. I think that is the most important thing in your career—find something that you like and stick to it.

At the moment I am working on a project that traces the roots of the runway. I'm excited about it because I get to combine my passion for documentary film with my current work at Moda Operandi. Everyone has experienced that feeling of confidence they get from wearing the right dress or putting the right outfit together. It immediately gives you a boost by showing people your personality and individuality. Like film, fashion is a tool for self-expression.

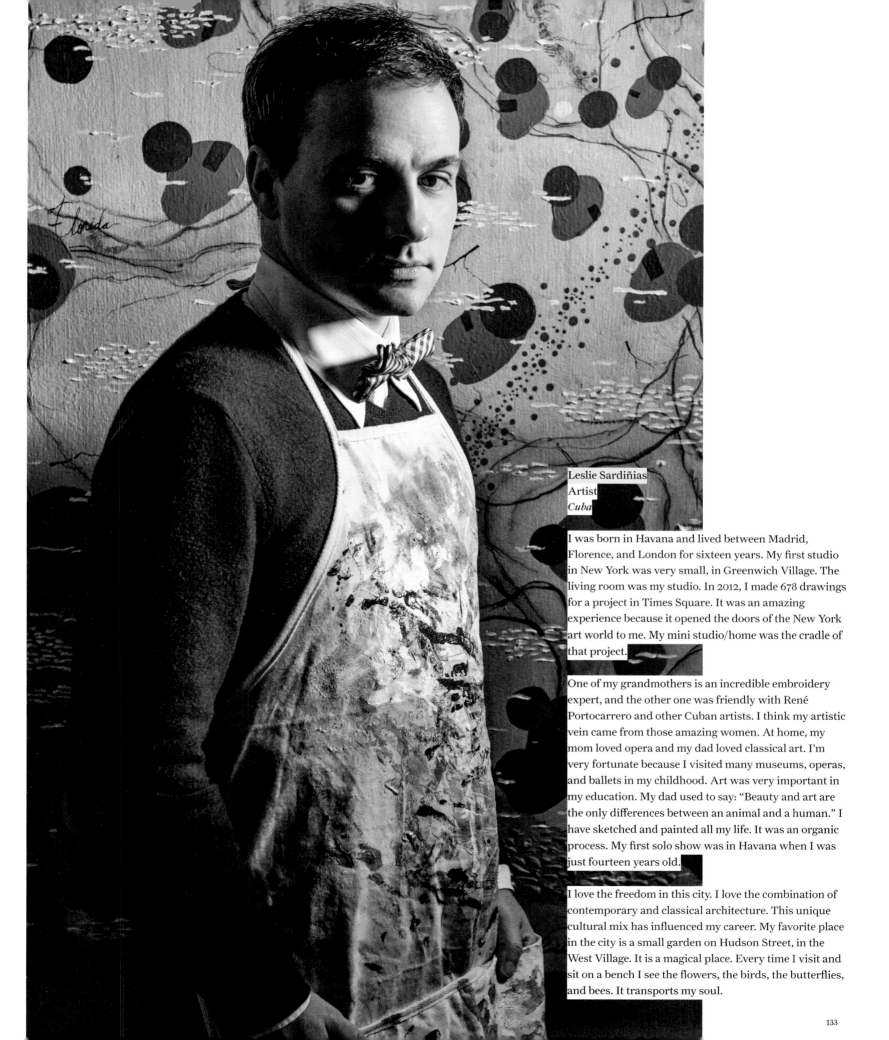

Leslie Sardiñias
Artist
Cuba

I was born in Havana and lived between Madrid, Florence, and London for sixteen years. My first studio in New York was very small, in Greenwich Village. The living room was my studio. In 2012, I made 678 drawings for a project in Times Square. It was an amazing experience because it opened the doors of the New York art world to me. My mini studio/home was the cradle of that project.

One of my grandmothers is an incredible embroidery expert, and the other one was friendly with René Portocarrero and other Cuban artists. I think my artistic vein came from those amazing women. At home, my mom loved opera and my dad loved classical art. I'm very fortunate because I visited many museums, operas, and ballets in my childhood. Art was very important in my education. My dad used to say: "Beauty and art are the only differences between an animal and a human." I have sketched and painted all my life. It was an organic process. My first solo show was in Havana when I was just fourteen years old.

I love the freedom in this city. I love the combination of contemporary and classical architecture. This unique cultural mix has influenced my career. My favorite place in the city is a small garden on Hudson Street, in the West Village. It is a magical place. Every time I visit and sit on a bench I see the flowers, the birds, the butterflies, and bees. It transports my soul.

Andrés Serrano
Artist
Honduras and Cuba

Growing up, I was not rooted to one culture and one identity. I went to school with Italians, so I am multicultural in that sense, and I was influenced by many different places, not only home.

Piss Christ shocked a lot of people, but one of the things that spooked me is that I was an unknown artist, and all of a sudden I was put in this arena where people were scrutinizing me. I thought that *Piss Christ* was only a photograph. It is only a part of me, and I don't feel there's anything shocking, provocative, or controversial about me; it's just the way I am. I am always surprised when some people feel like you've done something where you crossed the line, because I don't see that line as an artist.

New York changes like someone changes who you want to stay the same. After September 11, I read about all kinds of celebrities who left town immediately. I was talking to a friend of mine and we said, "Well, where are we going to go? We are going stay here, we've got nowhere else to go." Even then, when New York was full of dust, people like me said, "Who's going to man the city? We have to stay and man the city!" That's how you feel: you feel like this is your home and you have to defend it.

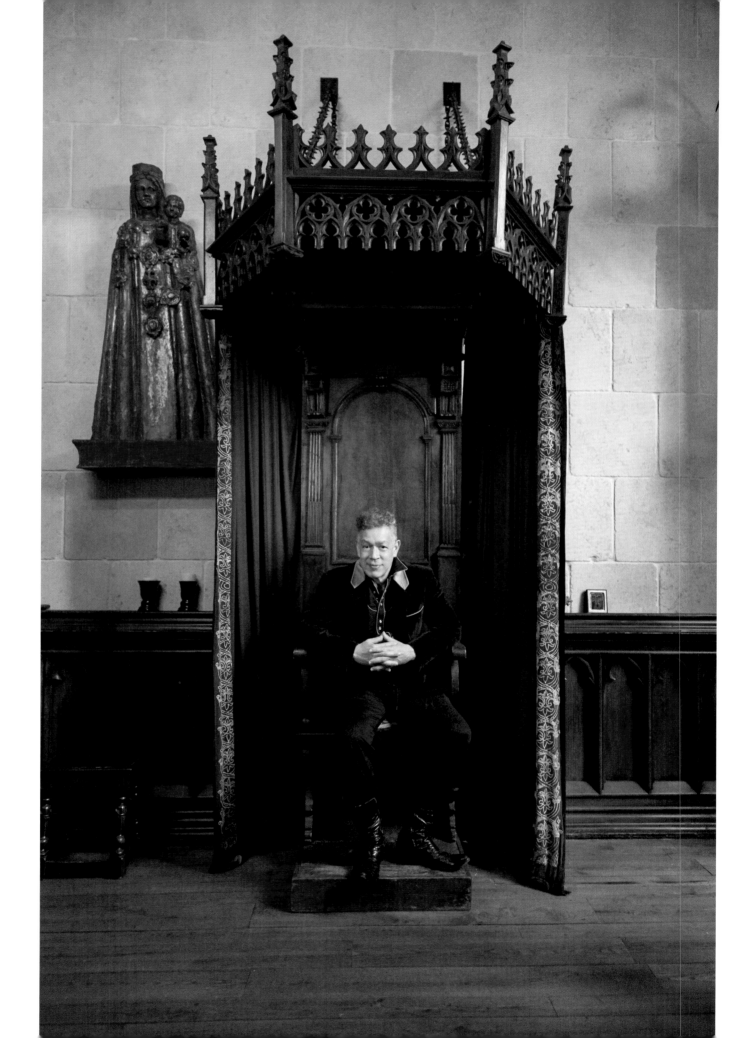

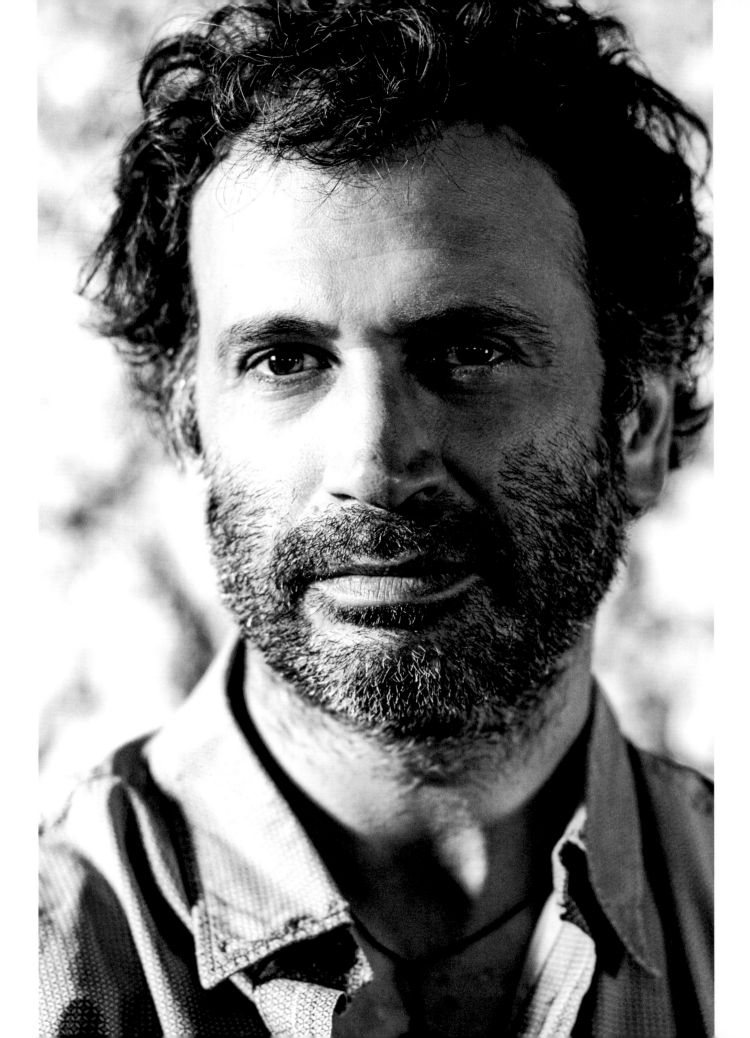

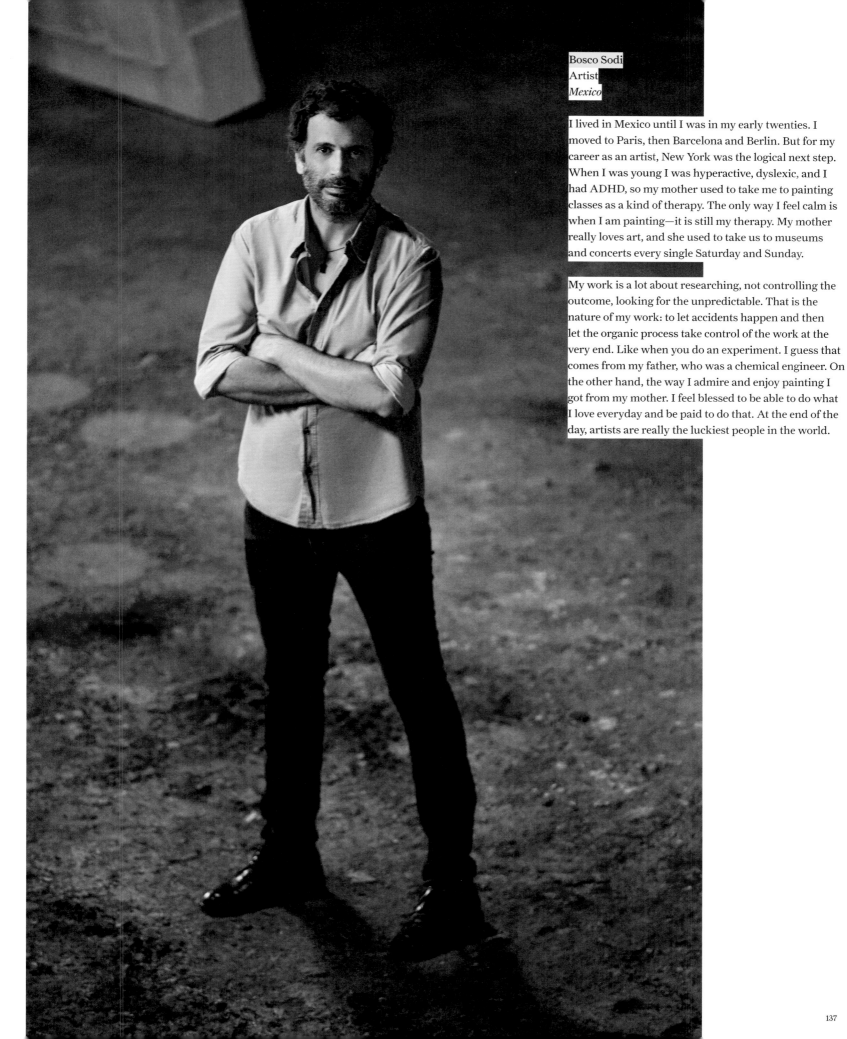

Bosco Sodi
Artist
Mexico

I lived in Mexico until I was in my early twenties. I moved to Paris, then Barcelona and Berlin. But for my career as an artist, New York was the logical next step. When I was young I was hyperactive, dyslexic, and I had ADHD, so my mother used to take me to painting classes as a kind of therapy. The only way I feel calm is when I am painting—it is still my therapy. My mother really loves art, and she used to take us to museums and concerts every single Saturday and Sunday.

My work is a lot about researching, not controlling the outcome, looking for the unpredictable. That is the nature of my work: to let accidents happen and then let the organic process take control of the work at the very end. Like when you do an experiment. I guess that comes from my father, who was a chemical engineer. On the other hand, the way I admire and enjoy painting I got from my mother. I feel blessed to be able to do what I love everyday and be paid to do that. At the end of the day, artists are really the luckiest people in the world.

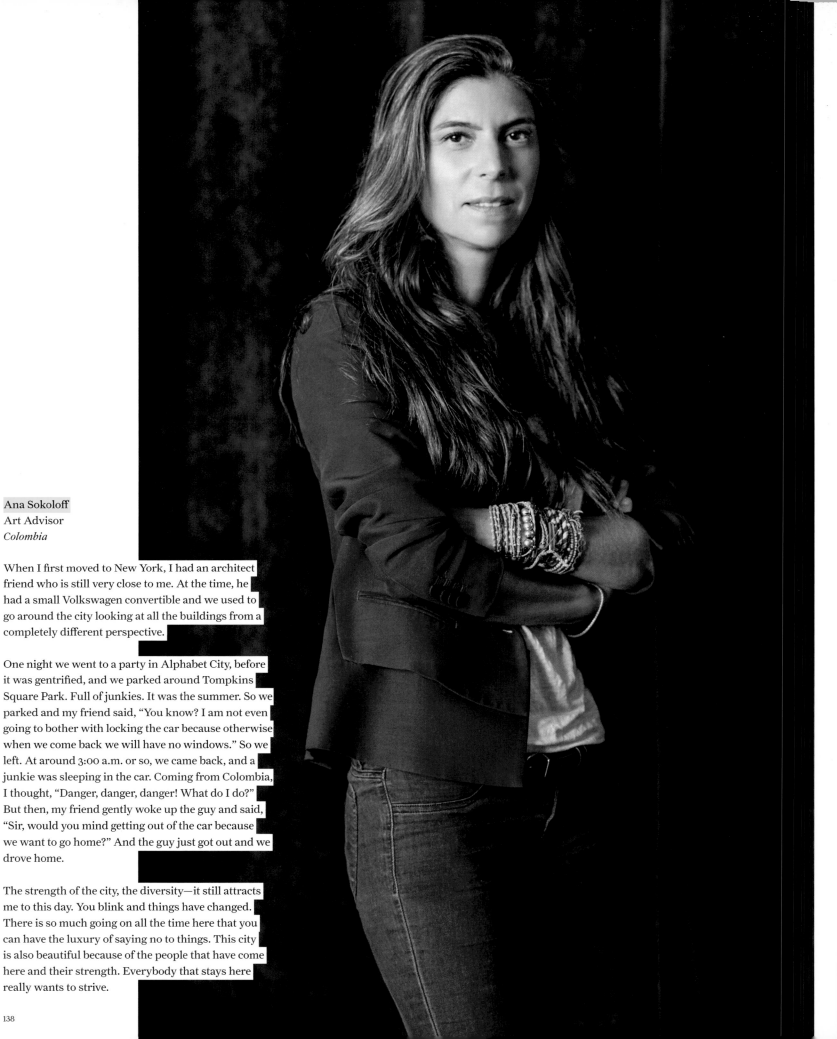

Ana Sokoloff
Art Advisor
Colombia

When I first moved to New York, I had an architect friend who is still very close to me. At the time, he had a small Volkswagen convertible and we used to go around the city looking at all the buildings from a completely different perspective.

One night we went to a party in Alphabet City, before it was gentrified, and we parked around Tompkins Square Park. Full of junkies. It was the summer. So we parked and my friend said, "You know? I am not even going to bother with locking the car because otherwise when we come back we will have no windows." So we left. At around 3:00 a.m. or so, we came back, and a junkie was sleeping in the car. Coming from Colombia, I thought, "Danger, danger, danger! What do I do?" But then, my friend gently woke up the guy and said, "Sir, would you mind getting out of the car because we want to go home?" And the guy just got out and we drove home.

The strength of the city, the diversity—it still attracts me to this day. You blink and things have changed. There is so much going on all the time here that you can have the luxury of saying no to things. This city is also beautiful because of the people that have come here and their strength. Everybody that stays here really wants to strive.

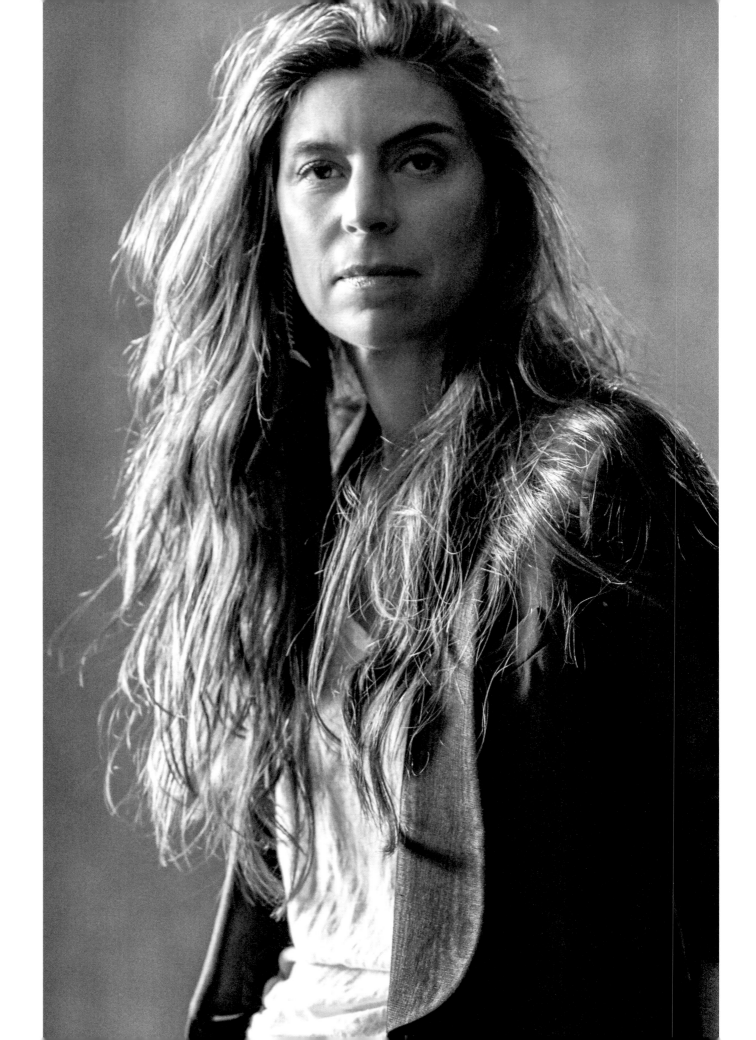

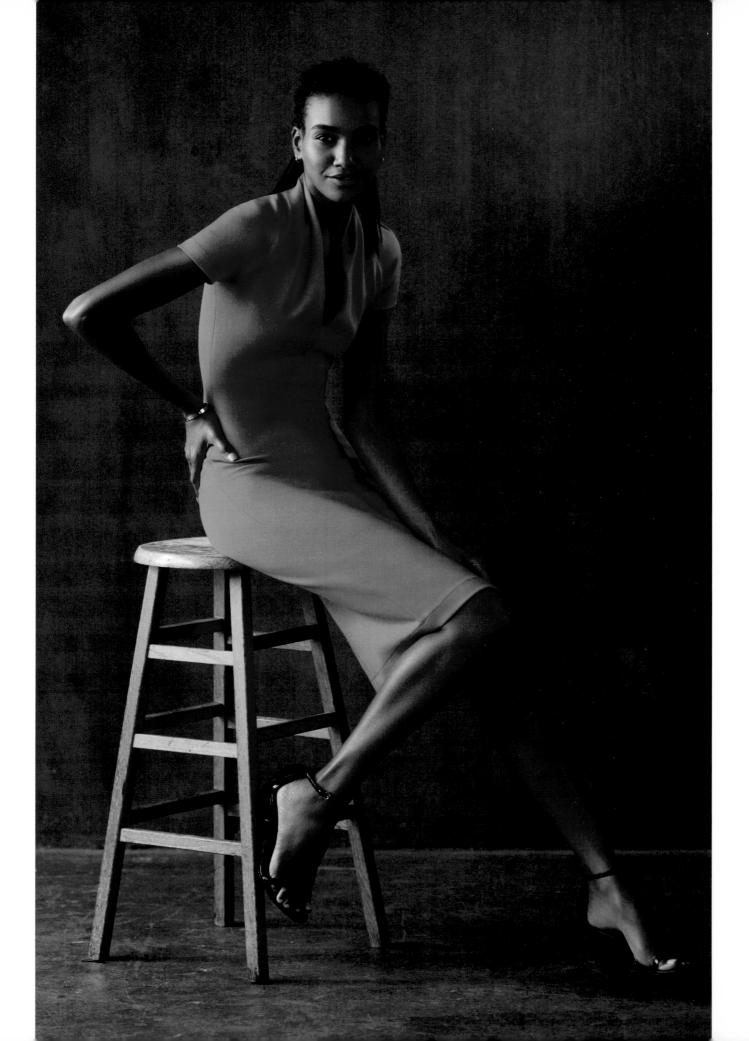

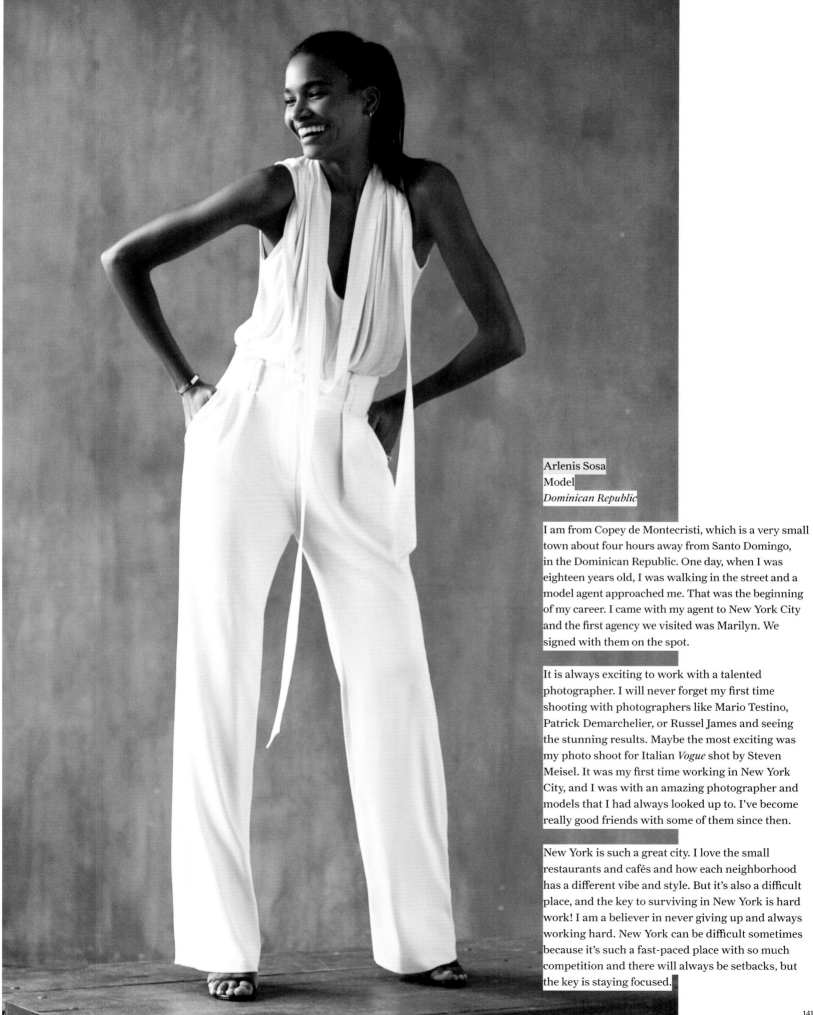

Arlenis Sosa
Model
Dominican Republic

I am from Copey de Montecristi, which is a very small town about four hours away from Santo Domingo, in the Dominican Republic. One day, when I was eighteen years old, I was walking in the street and a model agent approached me. That was the beginning of my career. I came with my agent to New York City and the first agency we visited was Marilyn. We signed with them on the spot.

It is always exciting to work with a talented photographer. I will never forget my first time shooting with photographers like Mario Testino, Patrick Demarchelier, or Russel James and seeing the stunning results. Maybe the most exciting was my photo shoot for Italian *Vogue* shot by Steven Meisel. It was my first time working in New York City, and I was with an amazing photographer and models that I had always looked up to. I've become really good friends with some of them since then.

New York is such a great city. I love the small restaurants and cafés and how each neighborhood has a different vibe and style. But it's also a difficult place, and the key to surviving in New York is hard work! I am a believer in never giving up and always working hard. New York can be difficult sometimes because it's such a fast-paced place with so much competition and there will always be setbacks, but the key is staying focused.

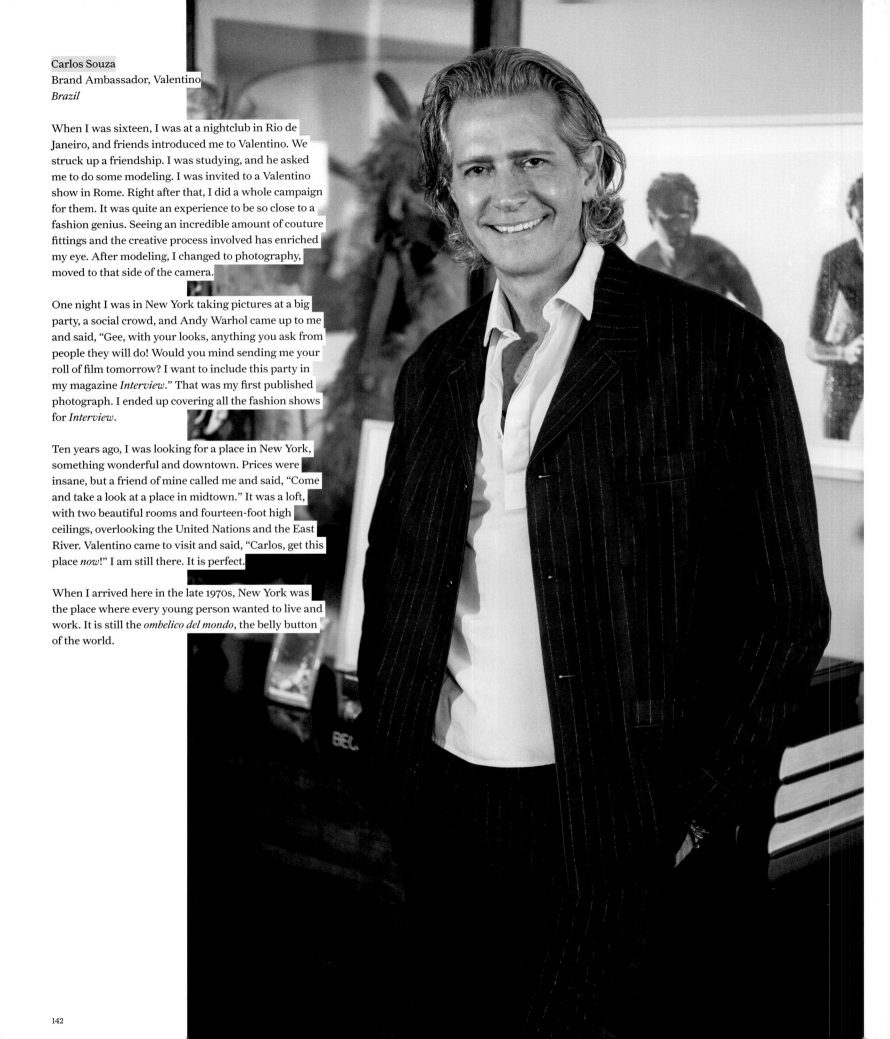

Carlos Souza
Brand Ambassador, Valentino
Brazil

When I was sixteen, I was at a nightclub in Rio de Janeiro, and friends introduced me to Valentino. We struck up a friendship. I was studying, and he asked me to do some modeling. I was invited to a Valentino show in Rome. Right after that, I did a whole campaign for them. It was quite an experience to be so close to a fashion genius. Seeing an incredible amount of couture fittings and the creative process involved has enriched my eye. After modeling, I changed to photography, moved to that side of the camera.

One night I was in New York taking pictures at a big party, a social crowd, and Andy Warhol came up to me and said, "Gee, with your looks, anything you ask from people they will do! Would you mind sending me your roll of film tomorrow? I want to include this party in my magazine *Interview*." That was my first published photograph. I ended up covering all the fashion shows for *Interview*.

Ten years ago, I was looking for a place in New York, something wonderful and downtown. Prices were insane, but a friend of mine called me and said, "Come and take a look at a place in midtown." It was a loft, with two beautiful rooms and fourteen-foot high ceilings, overlooking the United Nations and the East River. Valentino came to visit and said, "Carlos, get this place *now*!" I am still there. It is perfect.

When I arrived here in the late 1970s, New York was the place where every young person wanted to live and work. It is still the *ombelico del mondo*, the belly button of the world.

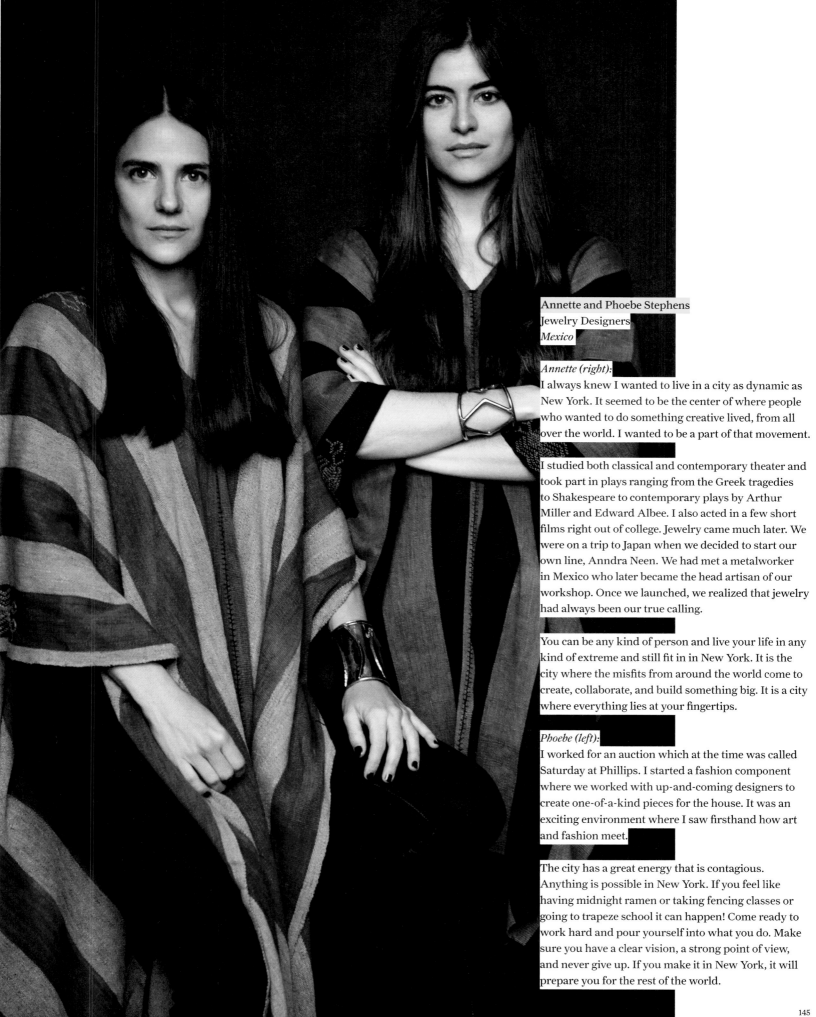

Annette and Phoebe Stephens
Jewelry Designers
Mexico

Annette (right):
I always knew I wanted to live in a city as dynamic as New York. It seemed to be the center of where people who wanted to do something creative lived, from all over the world. I wanted to be a part of that movement.

I studied both classical and contemporary theater and took part in plays ranging from the Greek tragedies to Shakespeare to contemporary plays by Arthur Miller and Edward Albee. I also acted in a few short films right out of college. Jewelry came much later. We were on a trip to Japan when we decided to start our own line, Anndra Neen. We had met a metalworker in Mexico who later became the head artisan of our workshop. Once we launched, we realized that jewelry had always been our true calling.

You can be any kind of person and live your life in any kind of extreme and still fit in in New York. It is the city where the misfits from around the world come to create, collaborate, and build something big. It is a city where everything lies at your fingertips.

Phoebe (left):
I worked for an auction which at the time was called Saturday at Phillips. I started a fashion component where we worked with up-and-coming designers to create one-of-a-kind pieces for the house. It was an exciting environment where I saw firsthand how art and fashion meet.

The city has a great energy that is contagious. Anything is possible in New York. If you feel like having midnight ramen or taking fencing classes or going to trapeze school it can happen! Come ready to work hard and pour yourself into what you do. Make sure you have a clear vision, a strong point of view, and never give up. If you make it in New York, it will prepare you for the rest of the world.

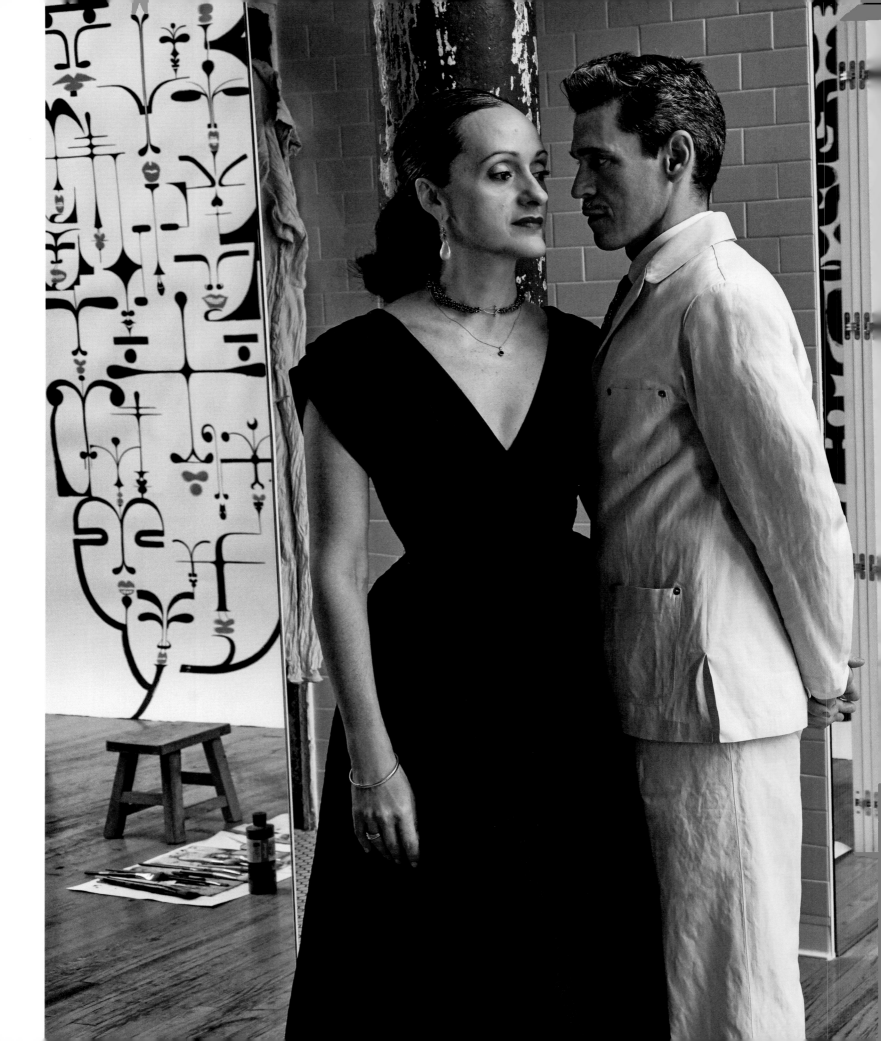

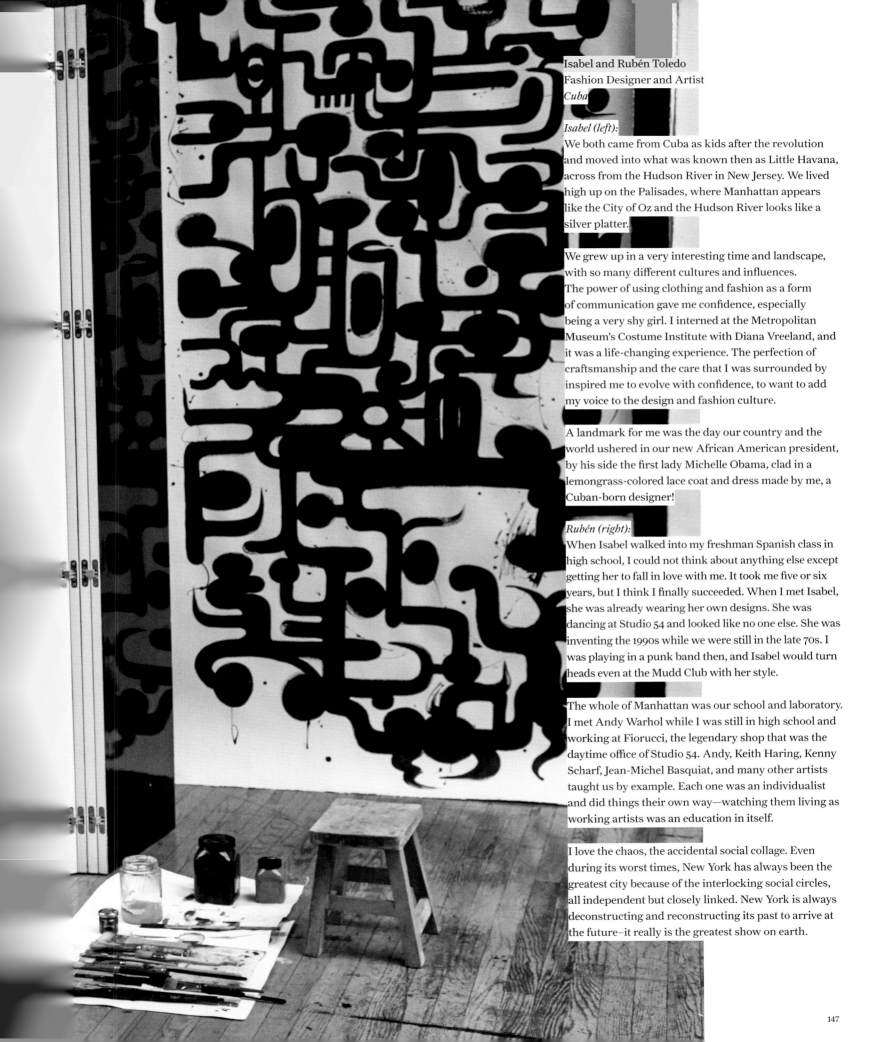

Isabel and Rubén Toledo
Fashion Designer and Artist
Cuba

Isabel (left):
We both came from Cuba as kids after the revolution and moved into what was known then as Little Havana, across from the Hudson River in New Jersey. We lived high up on the Palisades, where Manhattan appears like the City of Oz and the Hudson River looks like a silver platter.

We grew up in a very interesting time and landscape, with so many different cultures and influences. The power of using clothing and fashion as a form of communication gave me confidence, especially being a very shy girl. I interned at the Metropolitan Museum's Costume Institute with Diana Vreeland, and it was a life-changing experience. The perfection of craftsmanship and the care that I was surrounded by inspired me to evolve with confidence, to want to add my voice to the design and fashion culture.

A landmark for me was the day our country and the world ushered in our new African American president, by his side the first lady Michelle Obama, clad in a lemongrass-colored lace coat and dress made by me, a Cuban-born designer!

Rubén (right):
When Isabel walked into my freshman Spanish class in high school, I could not think about anything else except getting her to fall in love with me. It took me five or six years, but I think I finally succeeded. When I met Isabel, she was already wearing her own designs. She was dancing at Studio 54 and looked like no one else. She was inventing the 1990s while we were still in the late 70s. I was playing in a punk band then, and Isabel would turn heads even at the Mudd Club with her style.

The whole of Manhattan was our school and laboratory. I met Andy Warhol while I was still in high school and working at Fiorucci, the legendary shop that was the daytime office of Studio 54. Andy, Keith Haring, Kenny Scharf, Jean-Michel Basquiat, and many other artists taught us by example. Each one was an individualist and did things their own way—watching them living as working artists was an education in itself.

I love the chaos, the accidental social collage. Even during its worst times, New York has always been the greatest city because of the interlocking social circles, all independent but closely linked. New York is always deconstructing and reconstructing its past to arrive at the future–it really is the greatest show on earth.

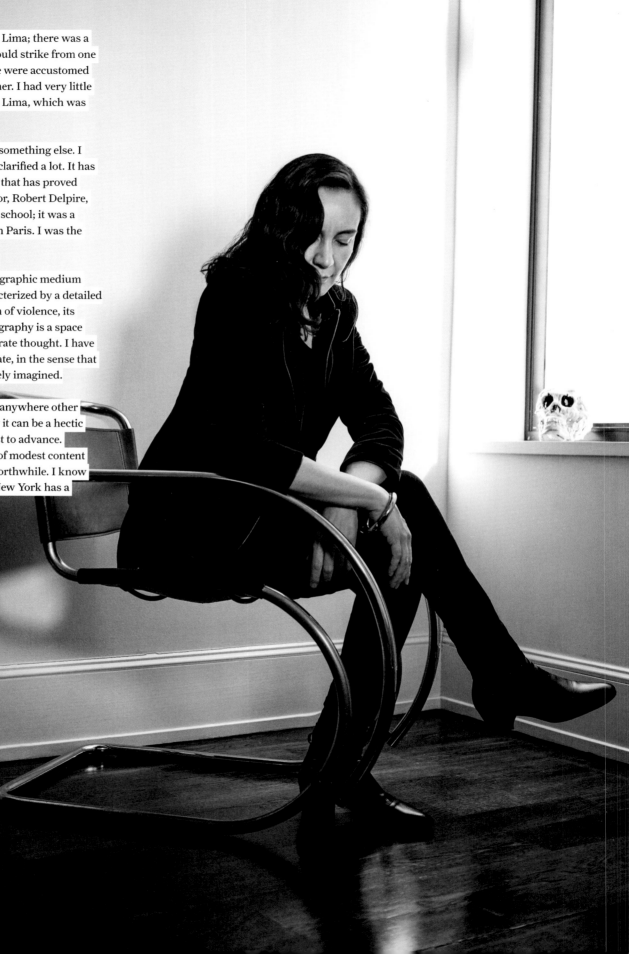

Milagros de la Torre
Photographer
Peru

I grew up during an intense time in Lima; there was a sense of underlying violence that could strike from one minute to the next. Nonetheless, we were accustomed to it. My mother was a history teacher. I had very little contact with the arts while living in Lima, which was the main reason I emigrated.

When I left Peru, I was looking for something else. I got accepted to art school, and that clarified a lot. It has been quite an expedition so far, one that has proved worthwhile. I was lucky—my mentor, Robert Delpire, curated my first exhibition after art school; it was a small show in the Palais de Tokyo in Paris. I was the "young child" at the museum.

I have been working with the photographic medium since 1991. My work has been characterized by a detailed research process in the examination of violence, its effects and residual traumas. Photography is a space with the capacity to evoke and generate thought. I have always perceived my work as intimate, in the sense that each piece or series has been privately imagined.

Honestly, I cannot see myself living anywhere other than New York at this point. I know it can be a hectic place; we are all trying to do our best to advance. Despite every day's battle, a feeling of modest content after giving your best makes it all worthwhile. I know some would not agree, but for me, New York has a positive attitude and energy.

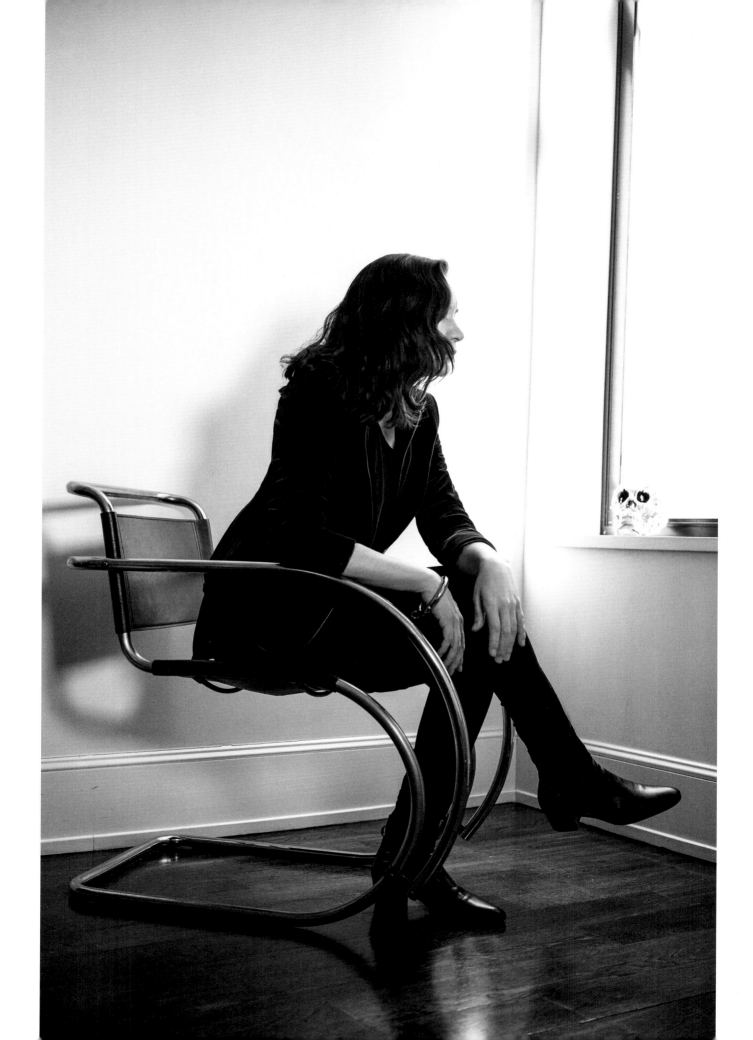

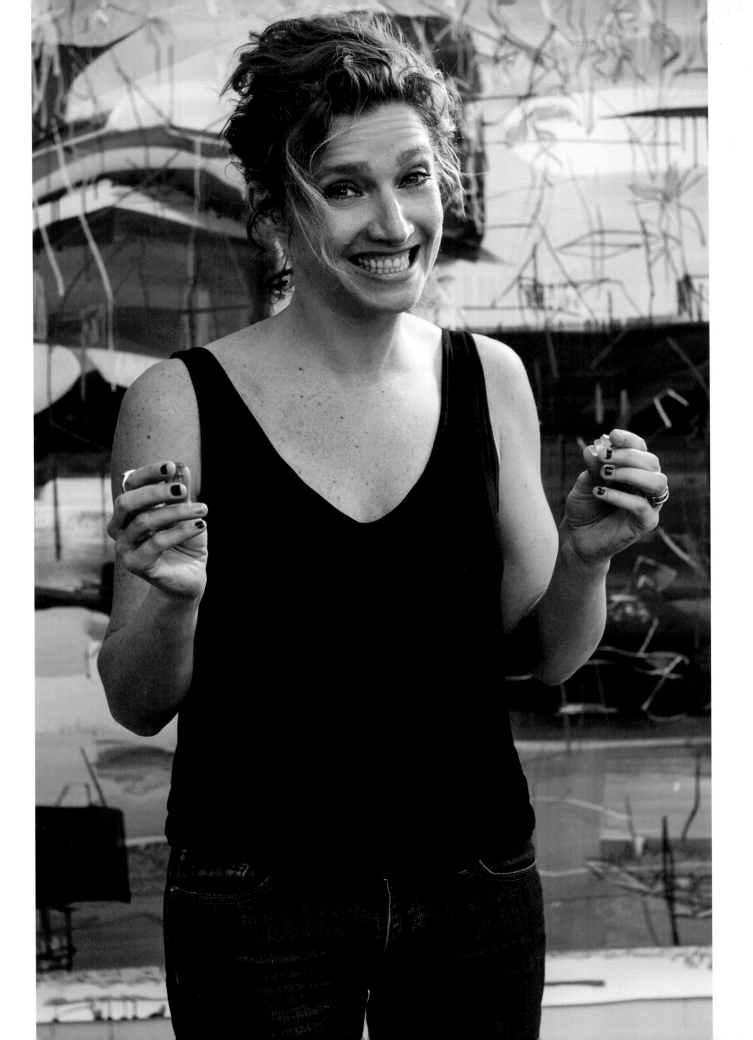

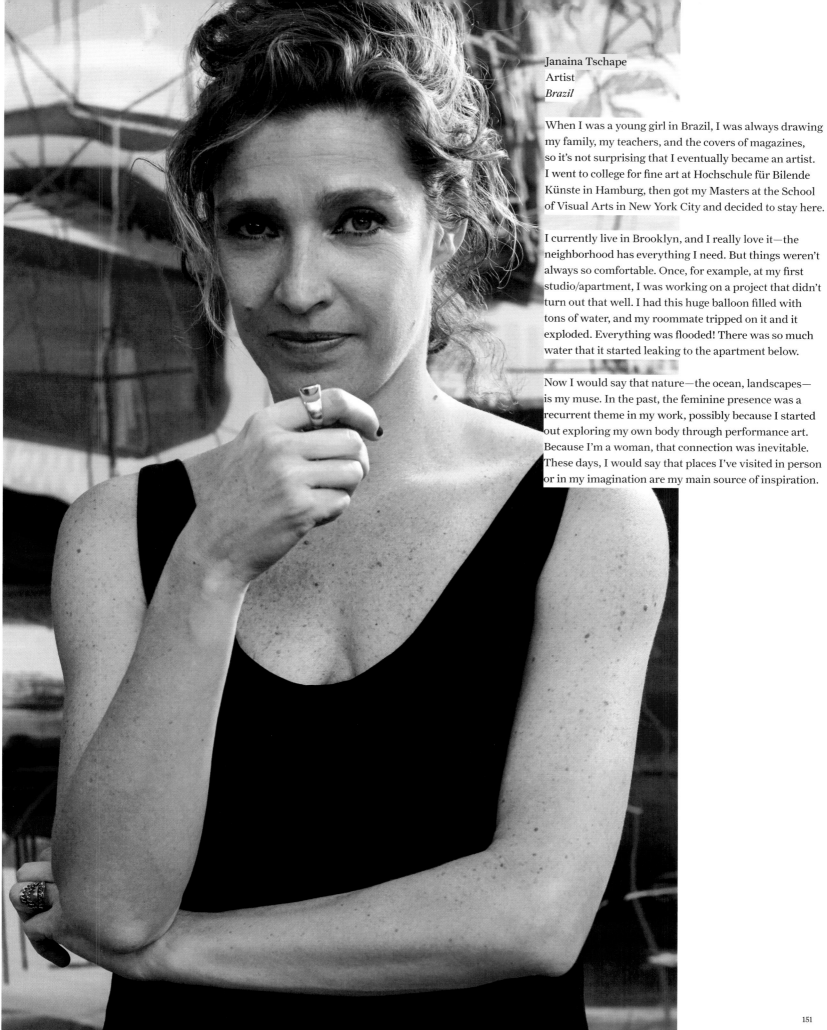

Janaina Tschape
Artist
Brazil

When I was a young girl in Brazil, I was always drawing my family, my teachers, and the covers of magazines, so it's not surprising that I eventually became an artist. I went to college for fine art at Hochschule für Bilende Künste in Hamburg, then got my Masters at the School of Visual Arts in New York City and decided to stay here.

I currently live in Brooklyn, and I really love it—the neighborhood has everything I need. But things weren't always so comfortable. Once, for example, at my first studio/apartment, I was working on a project that didn't turn out that well. I had this huge balloon filled with tons of water, and my roommate tripped on it and it exploded. Everything was flooded! There was so much water that it started leaking to the apartment below.

Now I would say that nature—the ocean, landscapes—is my muse. In the past, the feminine presence was a recurrent theme in my work, possibly because I started out exploring my own body through performance art. Because I'm a woman, that connection was inevitable. These days, I would say that places I've visited in person or in my imagination are my main source of inspiration.

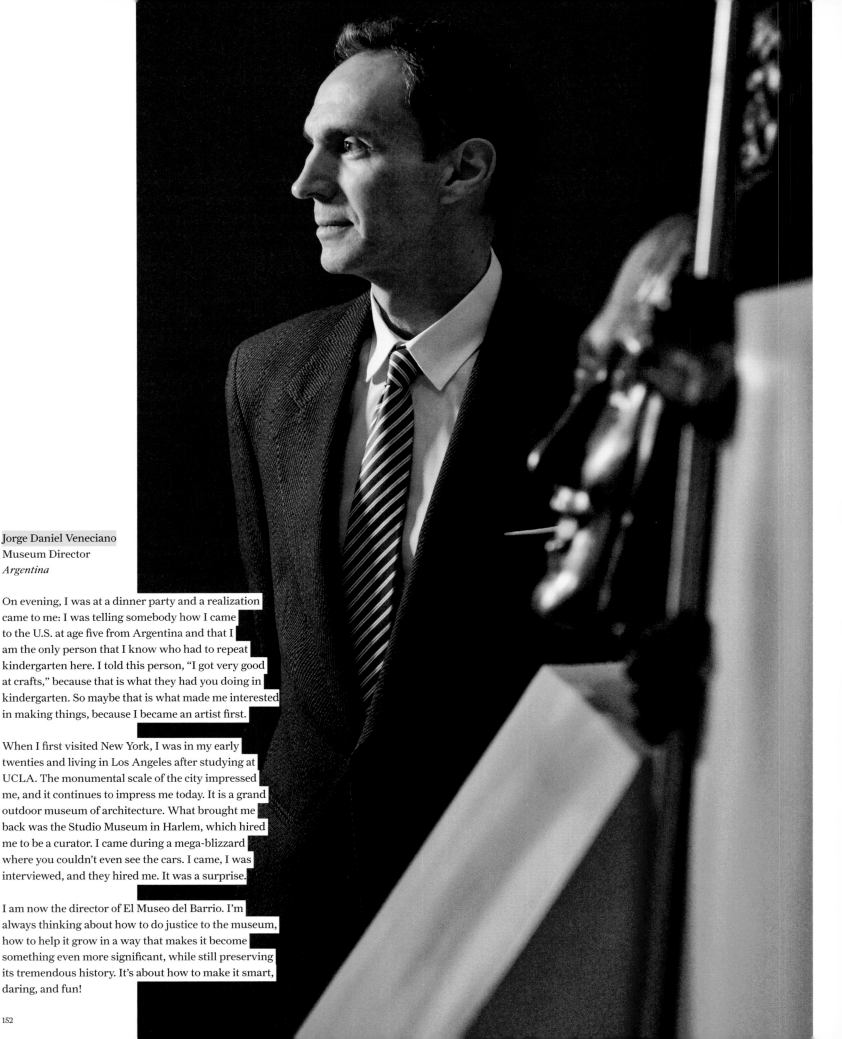

Jorge Daniel Veneciano
Museum Director
Argentina

On evening, I was at a dinner party and a realization came to me: I was telling somebody how I came to the U.S. at age five from Argentina and that I am the only person that I know who had to repeat kindergarten here. I told this person, "I got very good at crafts," because that is what they had you doing in kindergarten. So maybe that is what made me interested in making things, because I became an artist first.

When I first visited New York, I was in my early twenties and living in Los Angeles after studying at UCLA. The monumental scale of the city impressed me, and it continues to impress me today. It is a grand outdoor museum of architecture. What brought me back was the Studio Museum in Harlem, which hired me to be a curator. I came during a mega-blizzard where you couldn't even see the cars. I came, I was interviewed, and they hired me. It was a surprise.

I am now the director of El Museo del Barrio. I'm always thinking about how to do justice to the museum, how to help it grow in a way that makes it become something even more significant, while still preserving its tremendous history. It's about how to make it smart, daring, and fun!

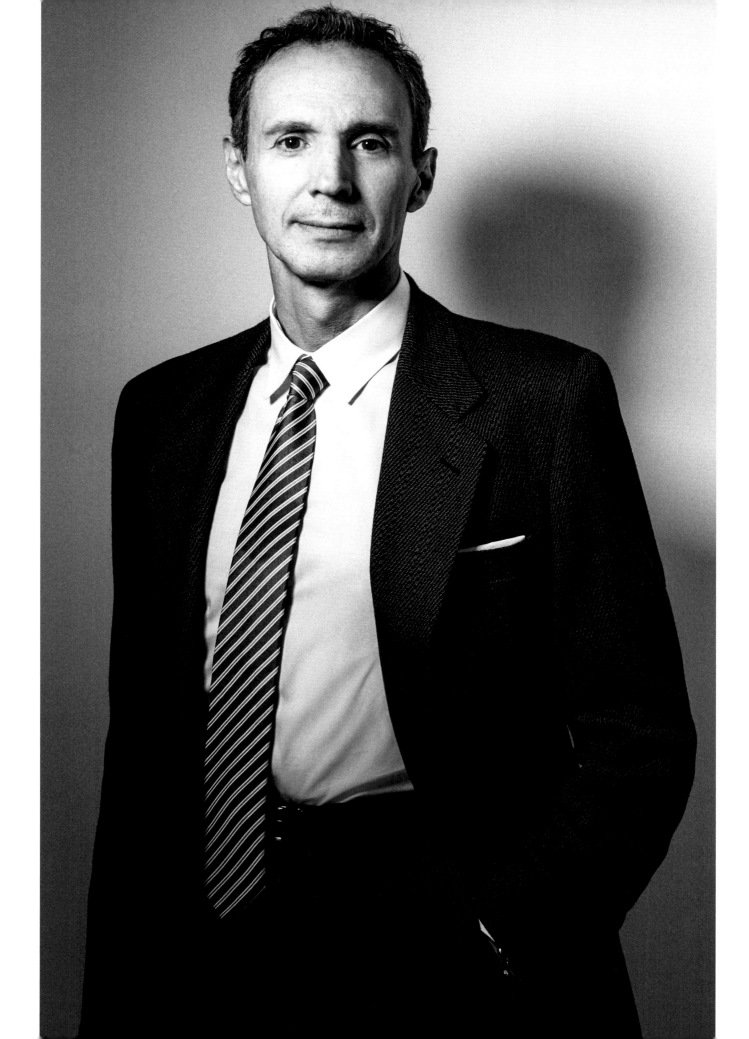

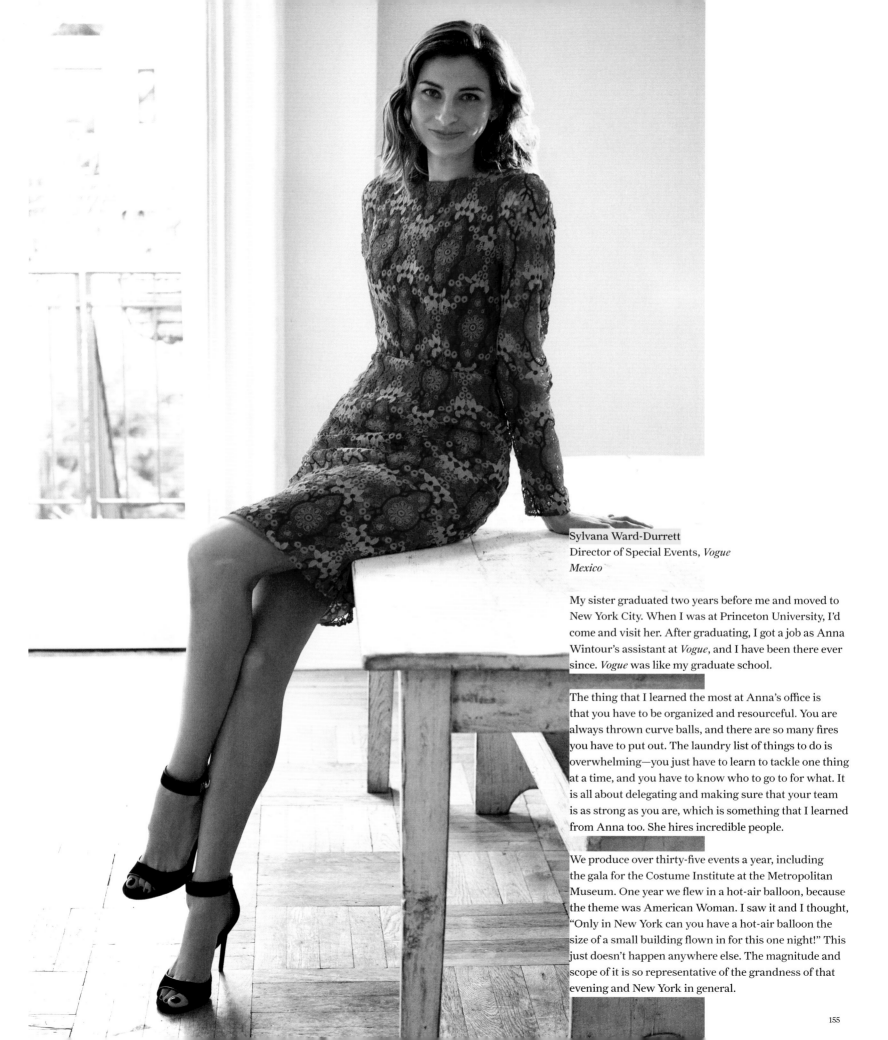

Sylvana Ward-Durrett
Director of Special Events, *Vogue*
Mexico

My sister graduated two years before me and moved to New York City. When I was at Princeton University, I'd come and visit her. After graduating, I got a job as Anna Wintour's assistant at *Vogue*, and I have been there ever since. *Vogue* was like my graduate school.

The thing that I learned the most at Anna's office is that you have to be organized and resourceful. You are always thrown curve balls, and there are so many fires you have to put out. The laundry list of things to do is overwhelming—you just have to learn to tackle one thing at a time, and you have to know who to go to for what. It is all about delegating and making sure that your team is as strong as you are, which is something that I learned from Anna too. She hires incredible people.

We produce over thirty-five events a year, including the gala for the Costume Institute at the Metropolitan Museum. One year we flew in a hot-air balloon, because the theme was American Woman. I saw it and I thought, "Only in New York can you have a hot-air balloon the size of a small building flown in for this one night!" This just doesn't happen anywhere else. The magnitude and scope of it is so representative of the grandness of that evening and New York in general.

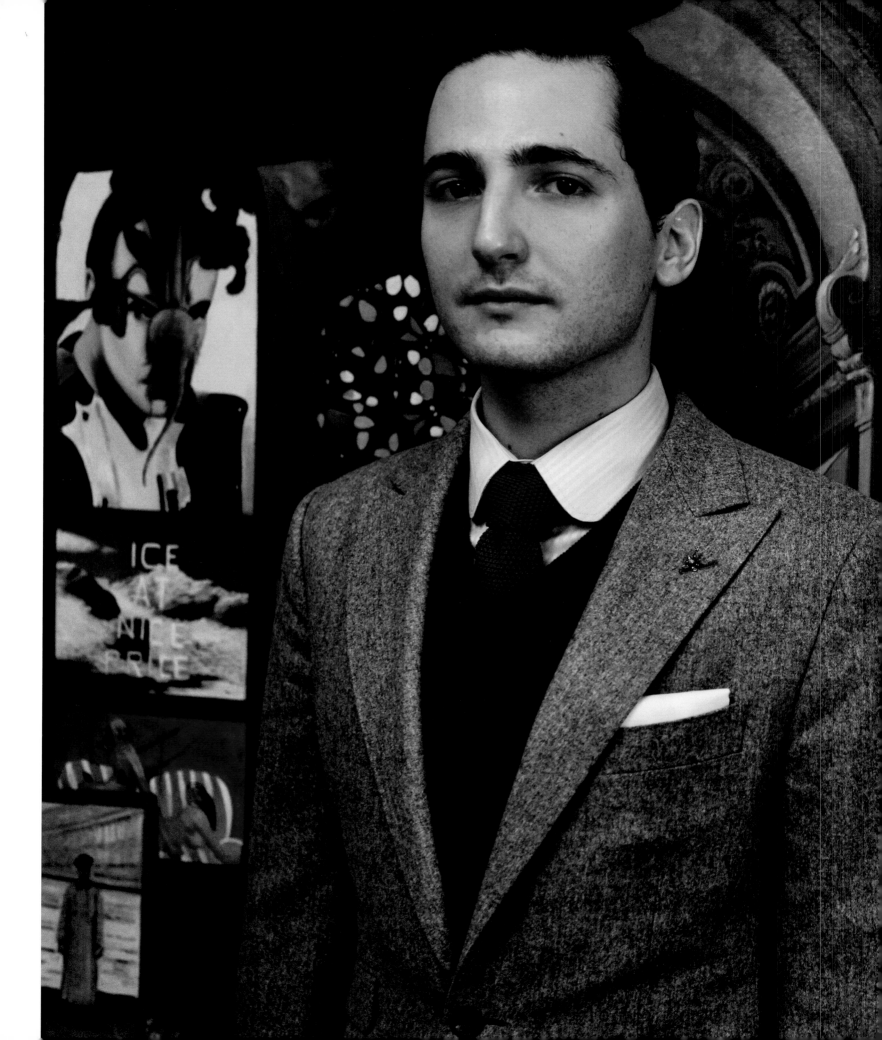

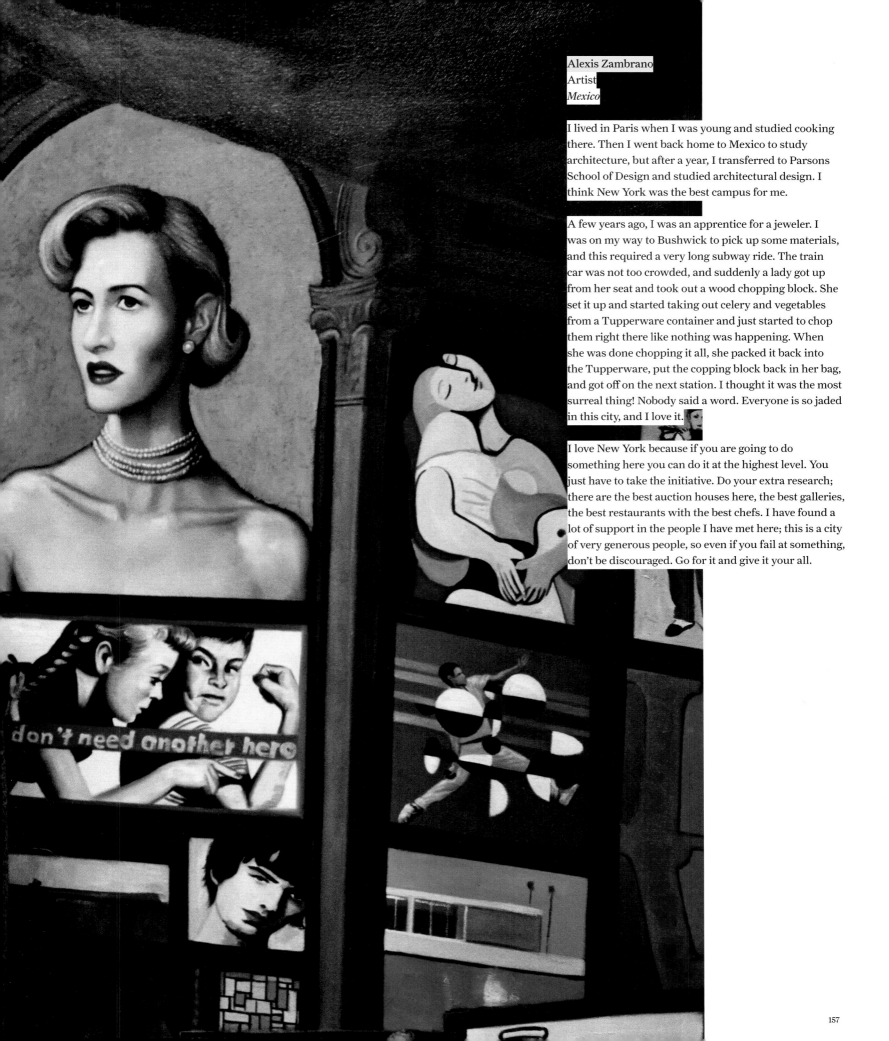

Alexis Zambrano
Artist
Mexico

I lived in Paris when I was young and studied cooking there. Then I went back home to Mexico to study architecture, but after a year, I transferred to Parsons School of Design and studied architectural design. I think New York was the best campus for me.

A few years ago, I was an apprentice for a jeweler. I was on my way to Bushwick to pick up some materials, and this required a very long subway ride. The train car was not too crowded, and suddenly a lady got up from her seat and took out a wood chopping block. She set it up and started taking out celery and vegetables from a Tupperware container and just started to chop them right there like nothing was happening. When she was done chopping it all, she packed it back into the Tupperware, put the copping block back in her bag, and got off on the next station. I thought it was the most surreal thing! Nobody said a word. Everyone is so jaded in this city, and I love it.

I love New York because if you are going to do something here you can do it at the highest level. You just have to take the initiative. Do your extra research; there are the best auction houses here, the best galleries, the best restaurants with the best chefs. I have found a lot of support in the people I have met here; this is a city of very generous people, so even if you fail at something, don't be discouraged. Go for it and give it your all.

Acknowledgments

Many, many talented and dedicated people have been instrumental in bringing this project to fruition. First, a debt of gratitude is owed to Ben Rodriguez-Cubeñas, program director at the Rockefeller Brothers Fund, for being a champion and supporter of *Nuevo New York*. From the very beginning, Ben recognized the important role that a book like this could play in telling the Latin American immigrant story and shedding light on the many contributions of immigrants to New York City's artistic and cultural life.

We would also like to thank the Rockefeller Brothers Fund and the Charles E. Culpepper Arts and Culture Program for being the main supporters and sponsors of *Nuevo New York*. The Rockefeller Brothers Fund is a private family foundation helping to advance social change that contributes to a more just, sustainable, and peaceful world. It was created in 1940 by the sons of John D. Rockefeller, Jr.—John D. 3rd, Nelson, Winthrop, Laurance, and David—as a vehicle by which they could share advice and research on charitable activities and coordinate their philanthropic efforts to better effect

Many thanks are also owed to Mayra Mangal, who conducted the interviews with all the participants, and to Victoria Campa, who was instrumental in facilitating many of the complex logistics of this project. Amy Wilkins provided us with invaluable guidance and editorial direction in turning the material for *Nuevo New York* into a book, and Robin Brunelle created the beautiful design. The New York Foundation for the Arts has been essential for their administrative support. Special thanks also go to Tatiana Chebotareva for retouching the photographs in this book.

Finally, we would like to thank all the other people who were involved in bringing *Nuevo New York* to life: Yaz and Valentín Hernández, Gloria Zolezzi de Neumann, Hans R. Neumann, Bridget Fleming, Zenaida Barraza de Rivera, Adriel Rivera-Barraza, Alex Galan, Andrea Albertini, Eleonora Pasqui, Ivan Aguirre, Francisco Daza, Oscar Fernandez, Mayra Hernandez, Calita Rivera de Nevarez, Theodore C. Max, Silvia Margarita Furstenberg, Abelardo Marcondes, Helio Campos, Ivan Sikic, Eduardo Valderrama, Armand Limnander, Fernando Paz, Izack Morales, Marta Sanz Esteve, Santiago Lameiro, Madeline Gilmore, Alexa Rodulfo, Luis Guillermo Duque, Cecilia Romero, Tinna Empera, Takashi Ashizawa, Claudia Torres-Rondon, Stacy Child, Paul Merritt, Mayela Vazquez, Martin-Christopher Harper, Boda Svoboda, Veronica Leone, Elena Serra, Nicolas Gomez, and Courtney Richter.

About the Authors

Hans Neumann was born in 1981 in Lima, Peru, and moved to new York in 2004, beginning his career assisting fashion photographers including fellow Peruvian Mario Testino. Neumann shoots editorial photography for clients such as *Interview*, *W*, and Condé Nast. He also shoots for J.Crew, Stuart Weitzman, David Yurman, Armani Exchange, and Maybelline.

Born in Durango, Mexico, Gabriel Rivera-Barraza is the founder and president of GRB Communications, which develops and positions emergent Latin talents. He consults for a select group of artists and international brands, including the Spanish luxury fashion house Delpozo. He was also the chair of the Young International Circle for El Museo del Barrio, New York, where he has led fundraising activities.

Nuevo New York
Hans Neumann and Gabriel Rivera-Barraza

Published by Damiani srl
www.damianieditore.com
info@damianieditore.com

Designer: Robin Brunelle, Matsumoto Incorporated, New York
Managing Editor: Amy Wilkins, Matsumoto Incorporated, New York
Color separations, printing, and binding by Grafiche Damiani–Faenza Group, Italy

ISBN 978-88-6208-495-6